ATOMHAWK

DESIGN

3DTOTAL PUBLISHING

1 Shaw Street, Worcester, WR1 3QQ, United Kingdom
Correspondence: publishing@3dtotal.com
Website: www.3dtotal.com

First published in the United Kingdom, 2011, by 3DTotal Publishing
Softcover / Slipcase Edition

ISBN: 978-0-9551530-2-0

Atomhawk Design
www.atomhawk.com

Cover Design/Image
Steven Pick. Cover image based on reference supplied by Marcus J. Ranum and featuring Miss Mosh

Printing & Binding
Everbest Printing (China)
www.everbest.com

Visit www.3dtotal.com for a complete list of available book titles.

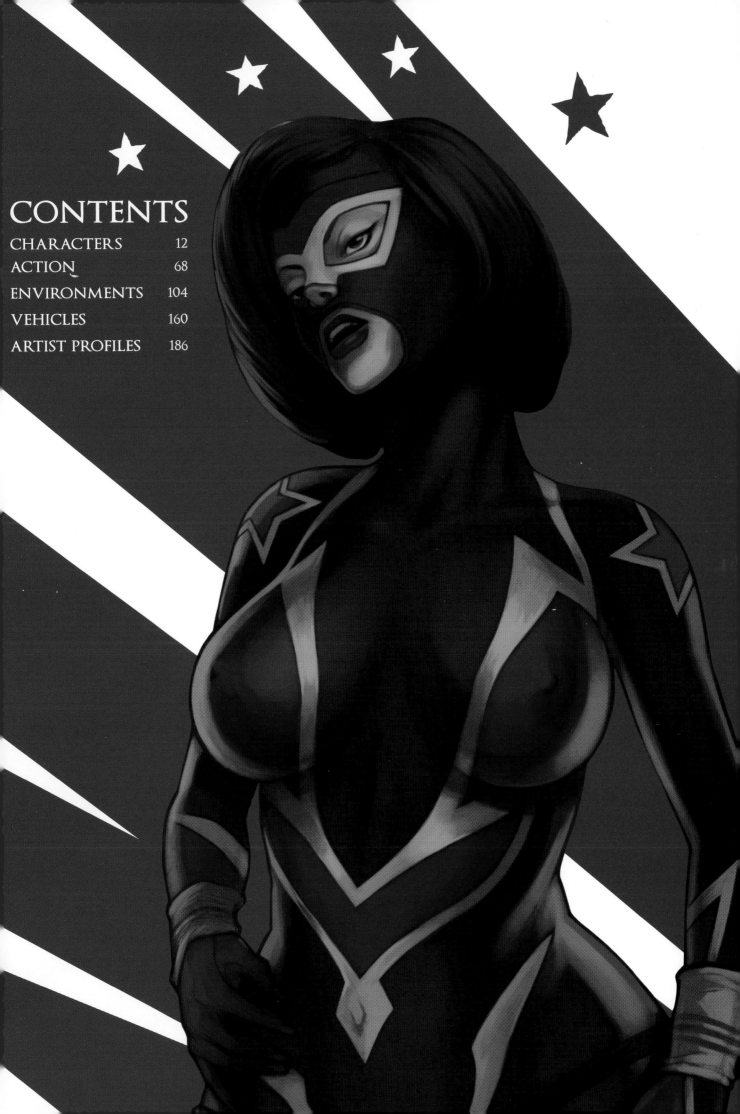

CONTENTS

FOREWORD

From 2004 to 2008 I was working for Midway Games in Chicago as a visual art director on the game *Stranglehold*, and later as creative visual director for the studio. Whilst I was there I was leading the Chicago concept group, and was involved in many different projects taken up by the different Midway studios. It was during this period that I was introduced to the work of a group of artists working at Midway Games in Newcastle, England, on a game called *Wheelman*. I remember being at my computer reviewing the different projects that were to be presented during our annual company summit, and as I was scrolling down the presentations my finger suddenly froze. The concepts I was looking at were stunning. The environment pieces were strong, dynamic and demonstrated an excellent understanding of composition, mood and light. They were also very clear and had all the visual information necessary for production. Similarly the character concepts and story panels showed a remarkable sense of realism and storytelling. They were both dynamic and well executed. I instantly found myself wishing that this team was working with me in Chicago.

A few months later Midway Games was no more and as everyone went their different ways looking for new opportunities, I found myself wondering what would happen to these artists. It didn't take long for me to find out. I was settling into Dallas to art direct *Rage* for id Software when I was contacted by this same group and told of the creation of Atomhawk Design. I was very impressed and excited to find out that these talented artists had decided to take a big risk and start a studio from scratch in a difficult economy. Having been part of the creation of

a new studio in the past I was also very aware of how difficult and challenging such a decision can be.

The game industry is large and competitive and when one company creates a successful IP it doesn't take long for the competition to try to emulate that success. To be successful, however, and to make sure their games don't get labeled as "inferior look-alikes", companies constantly need to find ways to technically and visually stand out. This is why concept art has become an indispensable part of the entertainment industry. Good concept art is about conveying interesting ideas and setting up compelling visions. As an art director I am always looking for those artists that not only have great skills, but can also provide me with solid and original concepts to bring strength, excitement and uniqueness to a project.

In just a few years Atomhawk has managed to do just that. Not only have these artists anchored themselves firmly in an uncertain industry, but they've managed to do it with great skill. The art in this book not only showcases a variety of subjects and ideas, but also demonstrates a keen sense of storytelling. This is what concept art is all about: skills, technique and originality; a good understanding of the production pipeline and the needs of the clients; the ability to create unique characters, bring compelling designs to vehicles and create environments with a strong narrative. In short, it is about creating visual excitement and establishing a unique, compelling vision.

Atomhawk Design has proved that it can produce great work that stands out from the crowd. As an art director I can only be excited. As a concept artist these guys will keep me on my toes. I have no doubt that our paths will cross again and look forward to the day when I will have the opportunity to work with such a talented group. Until then, I remain a big fan.

STEPHAN MARTINIERE
http://www.martiniere.com/
stephan@martiniere.com

Dervish House © Stephan Martiniere

ATOMHAWK DESIGN

Atomhawk Design was founded by Cumron Ashtiani, Peter Thompson, Corlen Kruger and Steven Pick in August 2009, just two weeks after the closure of Midway Studios - Newcastle, where 70 jobs were lost.

I don't want to dwell on what was a negative experience, but I feel it should be mentioned because while it was very hard at the time, that moment went on to be one of the best and most liberating events of my life, and I think the rest of the guys will agree.

When it was announced in spring 2009 that our head office in the US, Midway Games, Inc., had gone into Chapter 11 Bankruptcy, it was clear to everyone at Midway Studios - Newcastle that we may have reached the end of the road. As the studio art director at the Newcastle facility, I worked hard to help our studio head, Craig Duncan, and the rest of the directors to find a buyer or a way to finance the studio ourselves in the months leading up to its closure. The odds were against us because while we had a very experienced team with a great game IP in development called *Necessary Force*, the global economy was at the peak of recession.

Whilst most of my thoughts at the time were, "How can we save our game studio?" I naturally also started to think about what I would do if things didn't work out, and I soon found that I was spending more and more time considering the idea.

As an art director working in game development, I often had to outsource concept artwork to freelancers, as many of the studios I worked for often had limited resources in this area. The problem with concept art is that it is often only needed at the start of a project (pre-production), and then at the end for marketing artwork, so most studios don't have large concept teams due to the financial overhead. The same issues existed for user interface design and presentational services like video production

work; a lot of studios don't need a constant supply of these specialist skill sets, and so many make do with multi-discipline artists rather than experts in these areas.

However Midway was different. As a large, global game developer working on big budget console titles, I was very lucky to have some of the best specialists in these areas on my team. I started to realize that we were very well positioned to take those unique skills out into the industry as a specialist art services studio, or "art guns for hire" as one of my workmates described it - way cooler!

I remember sending Pete Thompson (Senior Concept Artist), Corlen Kruger (Senior Concept Artist) and Steve Pick (Senior UI Artist), an e-mail asking them if they would join me for a pint in The Gold Medal - a local pub located a short drive away from the studio. To put this event into some perspective, these guys are simply some of the best artists I have worked with in my 13 years in the business, and so I wasn't sure what to expect when I told them about the plan. I obviously thought it was a great idea as it was my plan, but there was some fear that they may think I was mental or even worse, just not be interested.

I told them the plan over a few beers (cider for Steve) while sitting in the June sunshine. I went through the pros and cons and the guys asked questions, and in the end everyone was very excited. We started to boost each other's enthusiasm, and at that point it seemed like we had already committed. However that was a problem in itself as we also had to think about our colleagues at Midway. In the end we agreed that our first priority was to the game studio as a whole, but if that was to fall through then we would focus on our new venture.

In the few weeks that followed our first trip to the pub, we waited for news of Midway's fate and worked hard on the prototype of *Necessary*

Force. We went back to The Gold Medal on several occasions to discuss a number of topics including what our new company name should be - Glass Fortress, Red House and Tiny White were some of the suggestions I remember. Glass Fortress was probably giving the wrong message; a fortress made of glass wouldn't be very effective. Red House was too corporate, and Tiny White was a bit too cheeky (opposite of Massive Black!). As always I turned to the mighty Google for answers, and found a random name generator on some equally random website. Three clicks - Rubber Diamond... No! Nuclear Horse... No! Then Atom Hawk popped up. We all liked it as it was unique and had the right message: an atom is incredibly powerful and a hawk is a small, but very skilled and elegant, bird of prey. All of these descriptions related to our aspirations for our new studio, and so it was agreed and the two words became one - Atomhawk.

Meanwhile as we moved into July, things were going from bad to worse at Midway. As a management team we started to talk very seriously about the possibility that the studio may not make it. We held on to some hope as we believed we still had several weeks before the US courts decided what would become of our US parent company through either a sale, a dissolution or other outcomes. As it transpired, things moved faster than expected and during the week starting July 13th 2009, the majority of Midway Games, Inc. was sold to Warner Bros with the exception of the company's European operations. On July 14th, Midway Studios - Newcastle was officially closed down. We all remember that day very clearly as we were forced to hastily clear out our desks and then relocated to another local pub where the four of us met up. Atomhawk was now very much a possibility, but the window of opportunity was smaller than expected as none of us had been paid our last month's salary or severance - so while we had originally assumed we would have enough money to start up, we now needed cash

as soon as possible or else we would all have to start considering other jobs to pay the bills.

It was clear to me at this point that we needed to act quickly, and so the day after we all lost our jobs, I was making calls to banks, venture capitalists and anyone else who lends money. I even sold my car back to the dealership I got it from to raise cash. However it was not looking good; trying to raise enough to finance a new company is hard at the best of times, but trying to raise it in the middle of a recession is next to impossible. Everyone wanted a business plan, financial projections certified by an accountant, a significant amount of personal security from me (house, wife and even my first born!), all of which was going to take more time than we had. Luckily Craig Duncan came up with some contacts that had offered to help finance our original plan to save Midway Studios - Newcastle. He put me in touch with The Tyne and Wear Development Company, who assigned Paul Buie to our project. Paul was great; we went over our business plan and he also managed to get an accountant to put my "back of a fag packet" finances into a proper financial report.

Meanwhile Pete, Corlen and Steve were doing what they did best: producing great looking artwork, starting with our company logo and some portfolio pieces to put on our website. Considering we were all unemployed, we were certainly very busy.

With a properly-sorted business plan and the financial reports, I then went to talk to the last two people who could help finance the start-up: John Bradford at N-Star Finance and my wife, Karen. I say Karen as by this point I was so driven to make this happen that I wanted to discuss how much of our own finances we could put into the company, on top of the proceeds from selling my car. Both conversations went surprisingly well. John agreed to finance us on the condition that I financed part of it, and Karen

also agreed to let me put our own necks on the line. That and also helping me with the business plan makes Karen the best wife in the world (all while being nine months pregnant!). On July 27th, Atomhawk Design was incorporated - exactly the same day as my daughter Leila was born. The pressure was on as now I had two babies to look after.

By the end of July 2009, we had our finances sorted and an excellent website, logo and portfolio on the way. The next step was to find some office space to work in and get some equipment. We were offered office space by Gateshead Council, who we had been talking to for some time and really wanted to help us (thanks to Mark Carrigan). The office was small, but ridiculously cheap, and offered everything we needed.

I remember the excitement of starting up on our first day... it was a lovely, warm August morning when we all met in the car park of the Greenesfield Business Centre. I had a shed load of PCs in the boot of my wife's car (I had already sold my own car) that I had assembled in my living room the night before. I'd spent the evening testing what would become our office network while watching EastEnders and doting on Leila.

We were up and running in an hour... incredible!

In the months that followed, we soon realized that having no company reputation was definitely an issue when courting new clients. In our case, we were very lucky that companies like Ubisoft Reflections, Ninja Theory, Sumo Digital and Eutechnyx gave us a chance to show what we could do regardless of profile, as most knew us individually from previous companies we had worked at. If it wasn't for them putting their trust in us, then we wouldn't have survived.

By December 2009, the business was starting to really take off. We'd attracted some very big

clients, one of which was the Warner Bros-owned Netherrealm Studio, which incidentally was made up of ex-Midway Chicago employees. Our reputation was growing thanks to the awesome talent of the team and we were constantly busy. We soon realized that with all the extra work, we needed more room so we could expand, and fast. We moved from the Greenesfield Centre to the shinier, high-tech Gateshead International Business Centre down the road - three times bigger than our old office.

Spring 2010 gave us the opportunity to start hiring some new talent. We were very lucky to hire Stephane Stamboulis, Senior Concept Artist, who moved all the way from Sweden to join us. Steph was quickly followed by Dan Gilmore, a talented designer who had recently graduated from Northumbria University.

Over the summer of 2010, our client pool continued to grow and, more importantly, became regular. As the warmer months drew to a close, the team had doubled from its original size with the additions of Amy Hill, who also worked with us previously at Midway as the HR manager, and the very talented concept artist, Charlie Bowater.

Today as I write this rambling introduction, we have worked with 15 different clients from all over the world, and remain very ambitious. The games and digital media industries continue to move towards a flexible workforce model, much like the film industry. We are seeing more and more studios bringing in specialist firms like ours to provide the very best work as and when it is needed. This has led to us being able to work on some of the very best and most exciting projects in the world, for which we all consider ourselves very privileged.

We very much hope you enjoy the artwork in this book, and I hope that this is the first of many to come!

CUMRON ASHTIANI
and the Atomhawk team

CHARACTER
CONCEPTS

As individual artists and as a group, we have always strived to try and
create iconic character designs that stand out from the crowd. Often
starting with thumbnails and silhouettes, we quickly work out what basic
forms and poses suit the character profile, and also give them a unique
shape that distinguishes them from other characters.

This is especially important for video games, where different character
types must be identified at a glance; enemy types are a great example of
this. Once the basic shape and poses are nailed down, we start to work
in more detail to get a feel for proportion and personality. We often create
breakouts of key details and facial expressions that sum up the character.

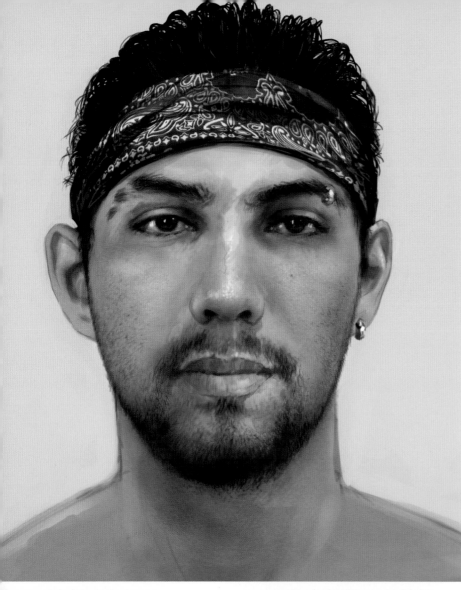

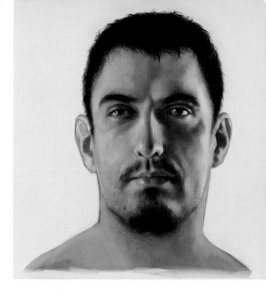

(Above Left) **Street Racer, character head shot concept.**
Art: Pete Thompson | Art Director: Cumron Ashtiani

(Right) **Francesco the Street Racer, character design.**
Art: Pete Thompson | Art Director: Cumron Ashtiani

(Far Right) **Fernando the Street Racer, character design.**
Art: Pete Thompson | Art Director: Cumron Ashtiani

(Below) **A pretty brutal cut scene involving a hammer and an unpaid debt. Set in a casino, one of the main boss characters (Paulo Lial) gets revenge "Las Vegas style".**
Art: Pete Thompson | Art Director: Cumron Ashtiani

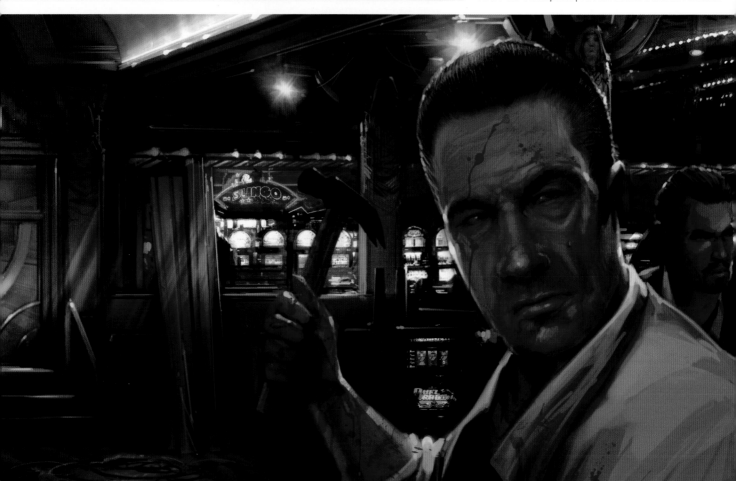

(Left) **The information broker - a well-dressed flashy arrogant type who would not hesitate to fabricate a bunch of lies, and then inform the local mafia or the Policia of your whereabouts in Barcelona.**
Art: Pete Thompson | **Art Director**: Cumron Ashtiani

(Below) **A Key Moment is a visual guide to help the cut scene team get a good idea of how the final version should look. We played with light streaming in through the blinds and red wallpaper to frame the distant characters.**
Art: Pete Thompson | **Art Director**: Cumron Ashtiani

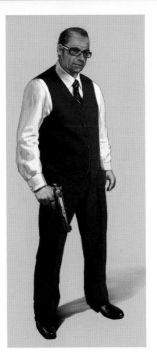
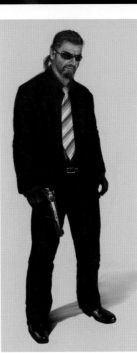

(Left) **Bad guy Enemy Non-Player Character (NPC) design. The typical Spanish bad guy look was needed for our enemy cannon fodder characters. A fair bit of research went into designing the look, using mostly Steven Segal and the _Die Hard_ movies as a starting point.**
Art: Pete Thompson | **Art Director**: Steve Dietz

(Far Left) **Barcelona pedestrian concept for _Wheelman_.**
Art: Pete Thompson | **Art Director**: Cumron Ashtiani

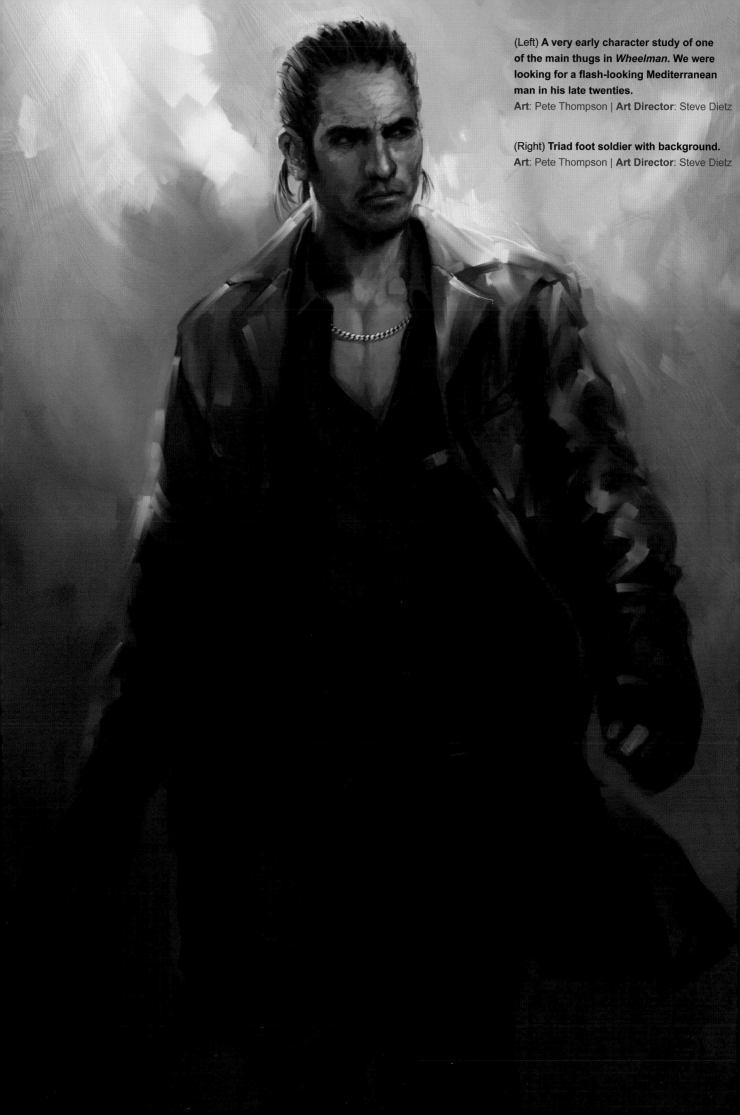

(Left) **A very early character study of one of the main thugs in *Wheelman*. We were looking for a flash-looking Mediterranean man in his late twenties.**
Art: Pete Thompson | **Art Director**: Steve Dietz

(Right) **Triad foot soldier with background.**
Art: Pete Thompson | **Art Director**: Steve Dietz

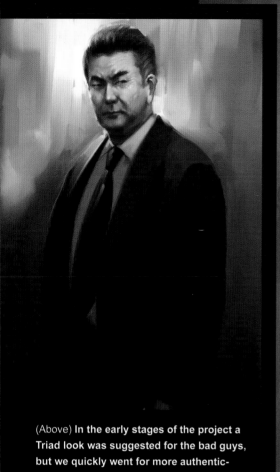

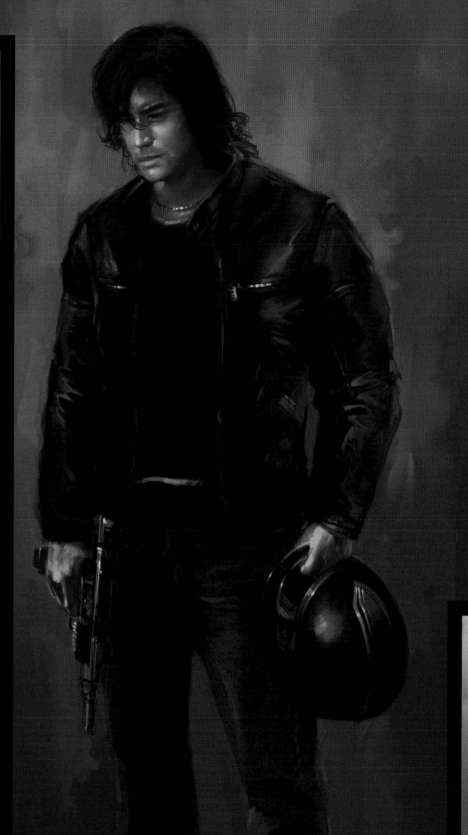

(Above) **In the early stages of the project a Triad look was suggested for the bad guys, but we quickly went for more authentic-looking Spanish locals.**
Art: Pete Thompson | Art Director: Steve Dietz

(Below) **Triad foot soldier concept.**
Art: Pete Thompson | Art Director: Steve Dietz

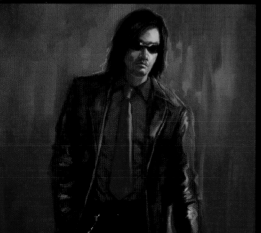

(Left) **Triad biker leader concept.**
Art: Pete Thompson | **Art Director**: Steve Dietz

(Below) **Vin Diesel "Milo" character concept designs.**
In the world of Hollywood movie/game crossovers, a lead
character has to go through many changes and tweaks until both
parties are happy with the final look.
Art: Pete Thompson | **Art Director**: Cumron Ashtiani

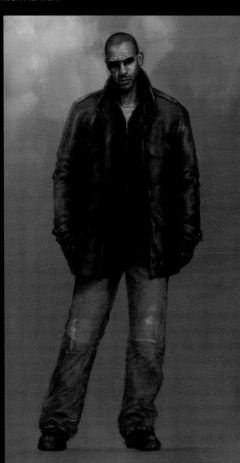
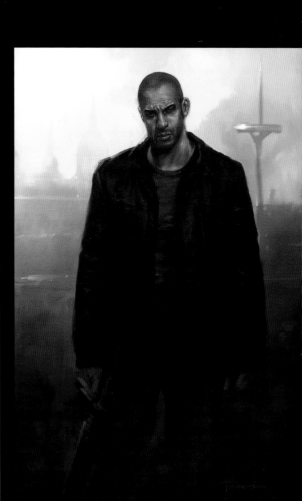

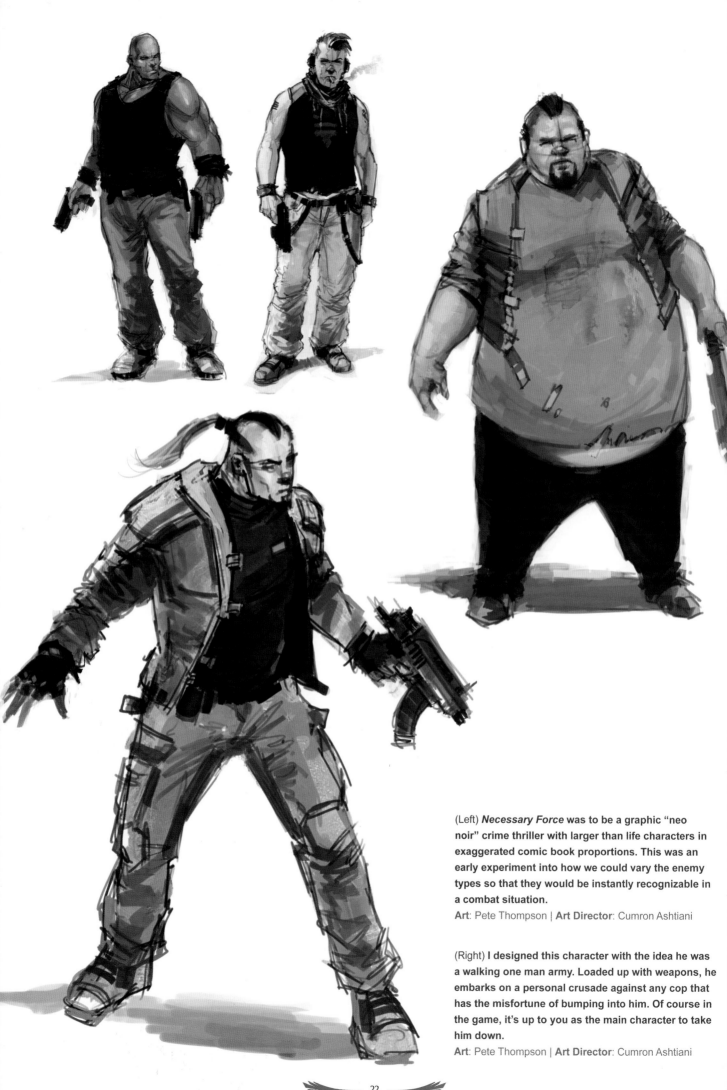

(Left) *Necessary Force* was to be a graphic "neo noir" crime thriller with larger than life characters in exaggerated comic book proportions. This was an early experiment into how we could vary the enemy types so that they would be instantly recognizable in a combat situation.

Art: Pete Thompson | **Art Director**: Cumron Ashtiani

(Right) I designed this character with the idea he was a walking one man army. Loaded up with weapons, he embarks on a personal crusade against any cop that has the misfortune of bumping into him. Of course in the game, it's up to you as the main character to take him down.

Art: Pete Thompson | **Art Director**: Cumron Ashtiani

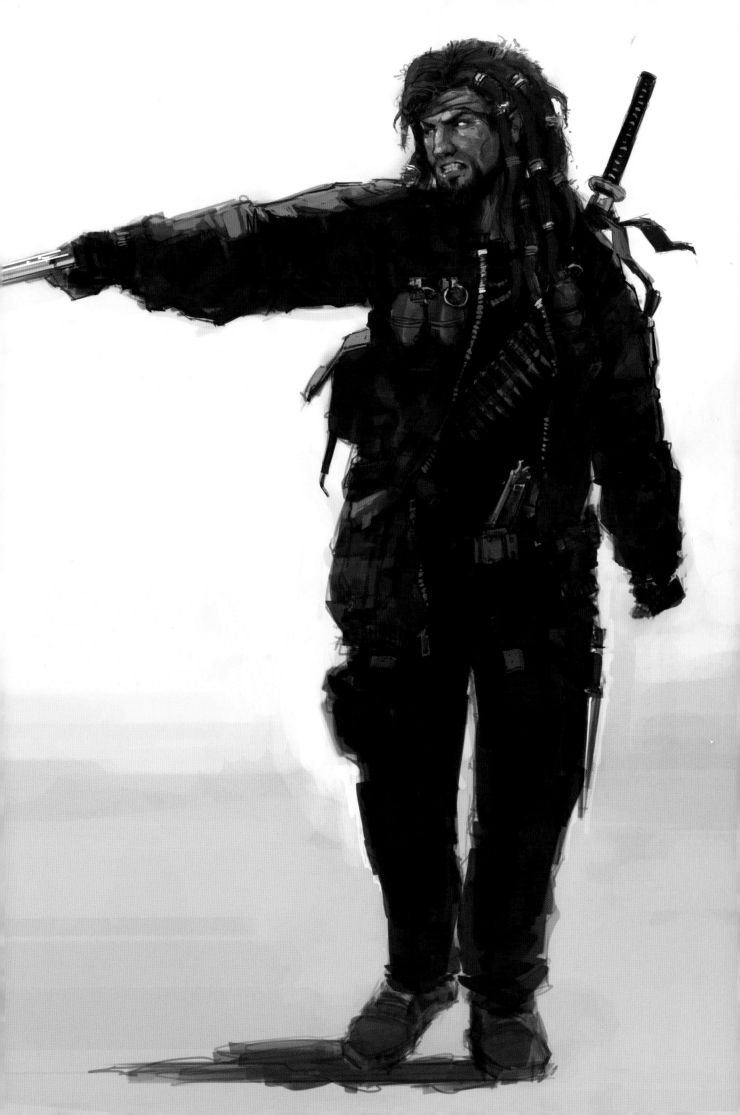

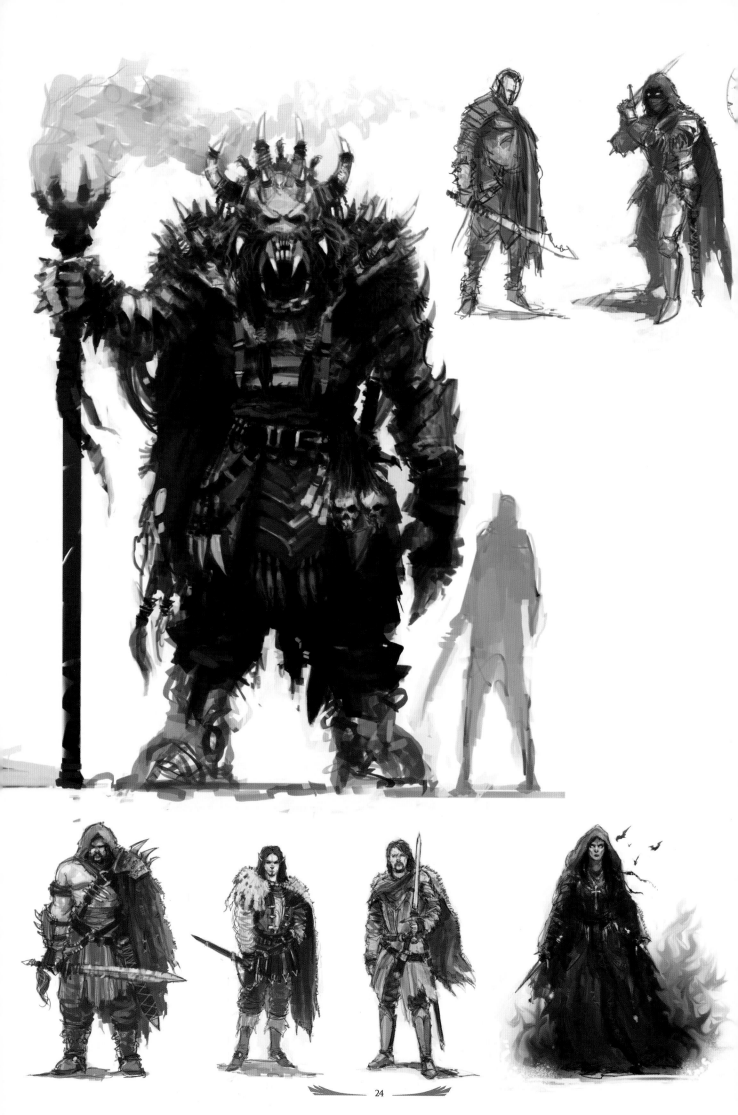

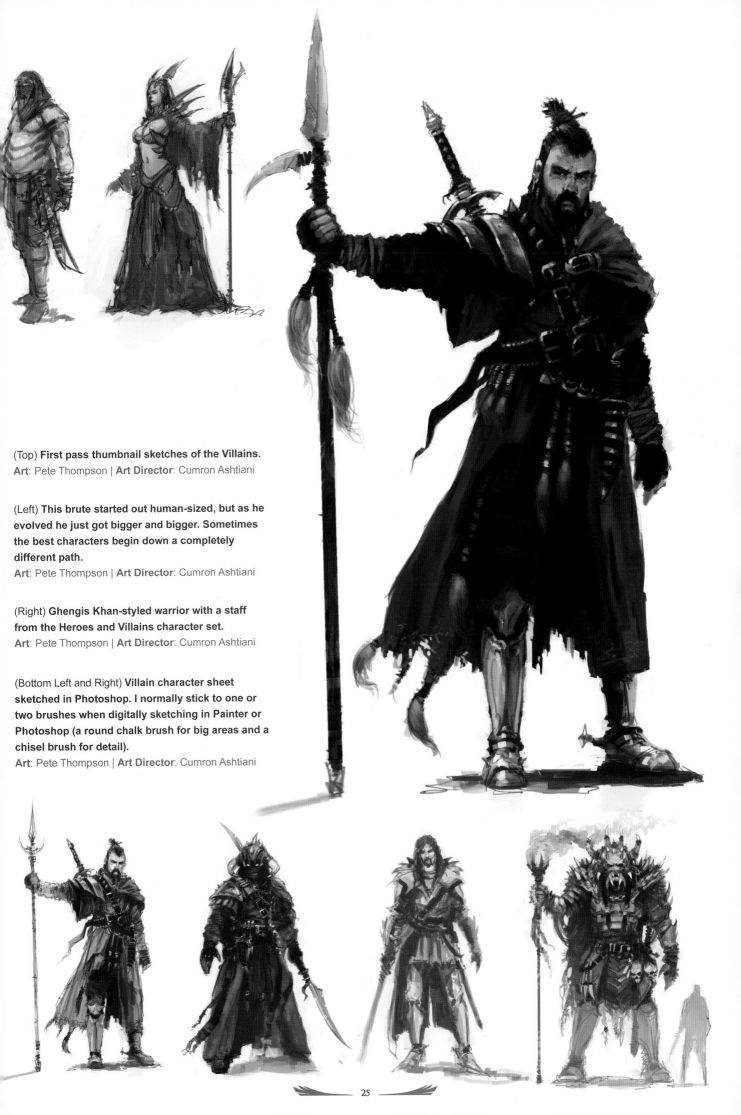

(Top) **First pass thumbnail sketches of the Villains.**
Art: Pete Thompson | Art Director: Cumron Ashtiani

(Left) **This brute started out human-sized, but as he evolved he just got bigger and bigger. Sometimes the best characters begin down a completely different path.**
Art: Pete Thompson | Art Director: Cumron Ashtiani

(Right) **Ghengis Khan-styled warrior with a staff from the Heroes and Villains character set.**
Art: Pete Thompson | Art Director: Cumron Ashtiani

(Bottom Left and Right) **Villain character sheet sketched in Photoshop. I normally stick to one or two brushes when digitally sketching in Painter or Photoshop (a round chalk brush for big areas and a chisel brush for detail).**
Art: Pete Thompson | Art Director: Cumron Ashtiani

(Above) **Cover art for Vendetta's debut album "Tyranny of Minority".**
Art: Pete Thompson

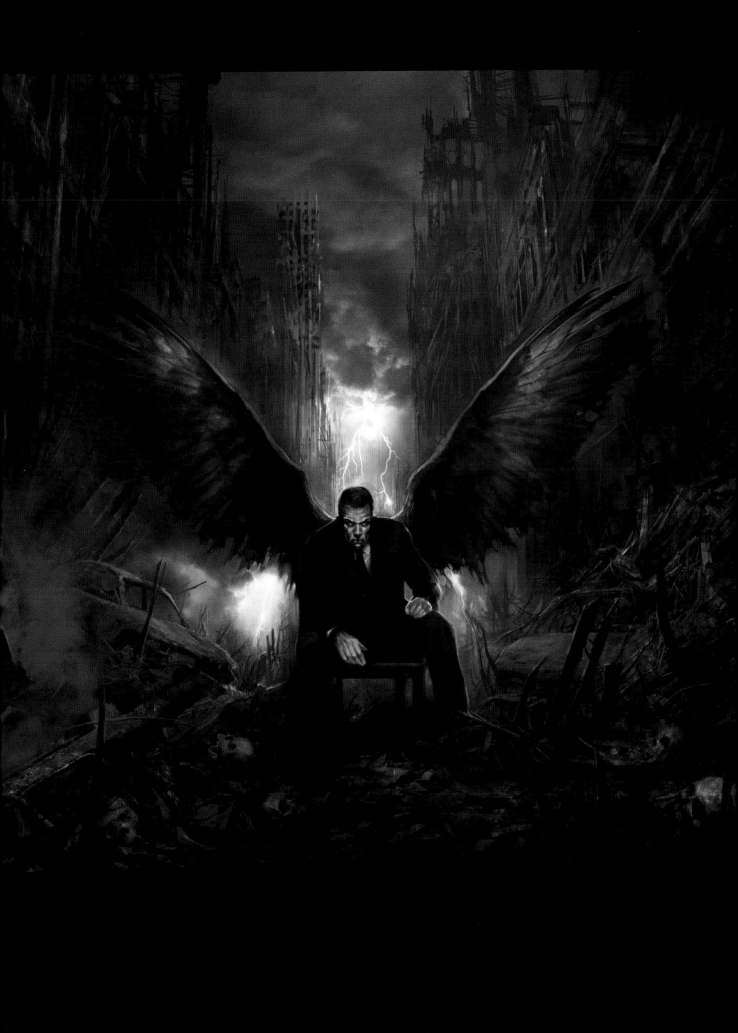

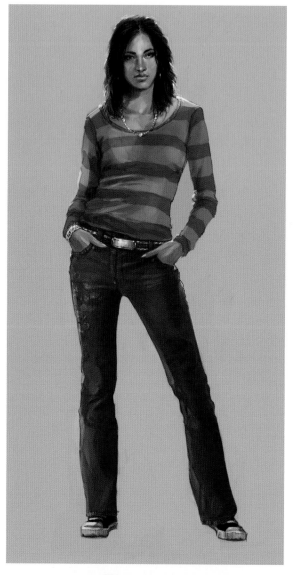

(Right) **Personal work.**
Art: Steph Stamb

(Below) **Barcelona pedestrian concept for** *Wheelman*.
Art: Pete Thompson | **Art Director**: Cumron Ashtiani

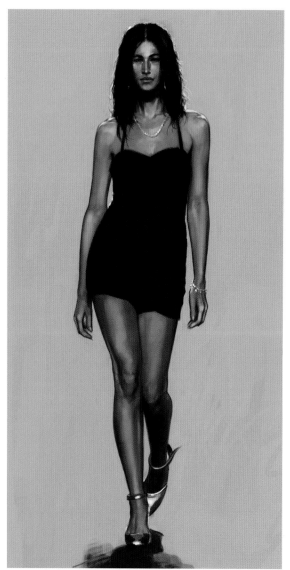

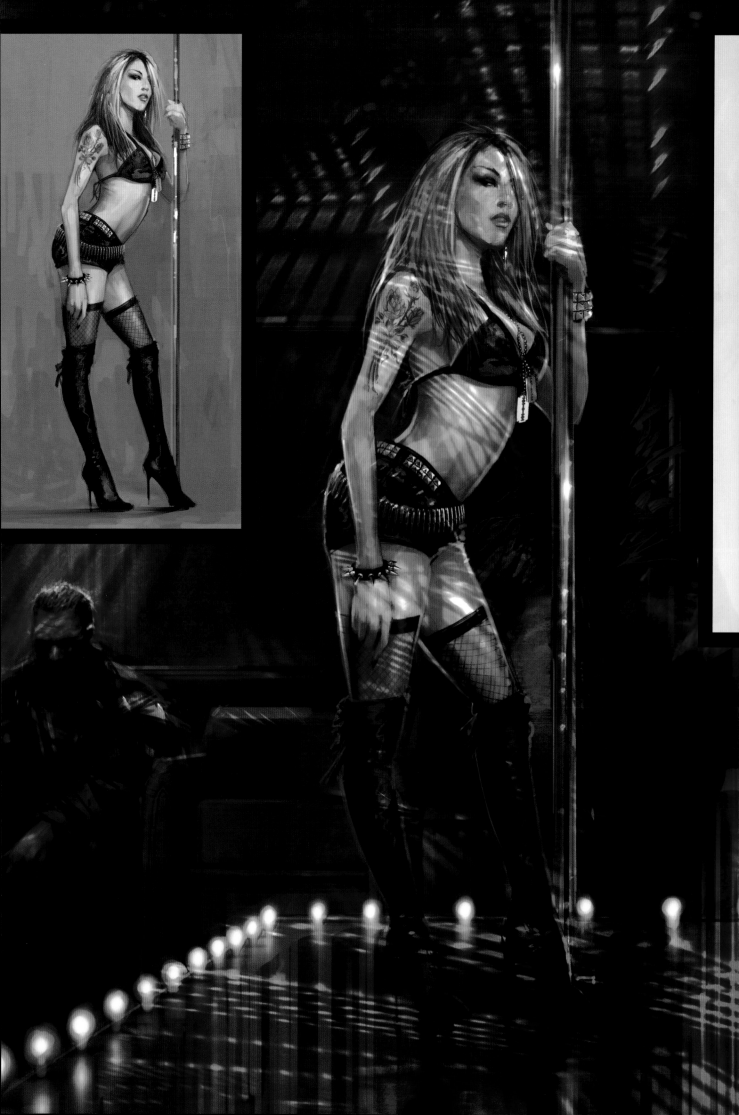

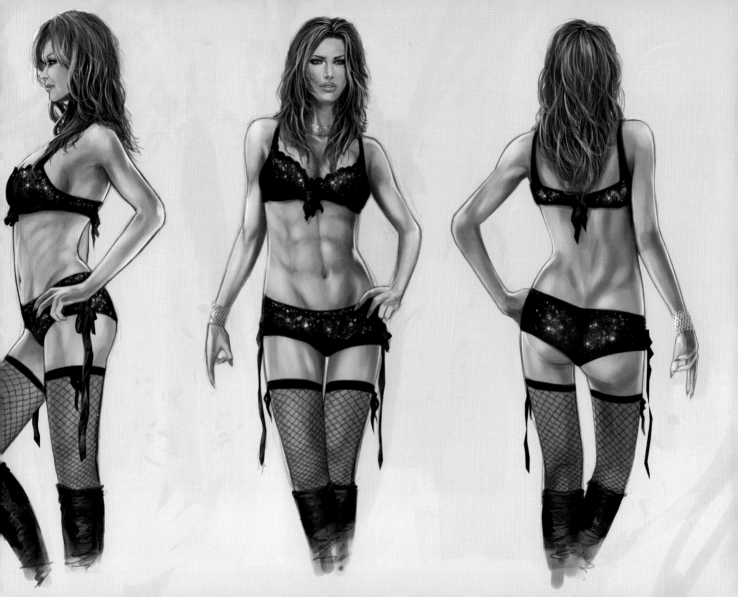

Wheelman.
Art: Pete Thompson | **Art Director**: Cumron Ashtiani

(Below) **Alternate pole dancer design.**
Art: Pete Thompson | **Art Director**: Cumron Ashtiani

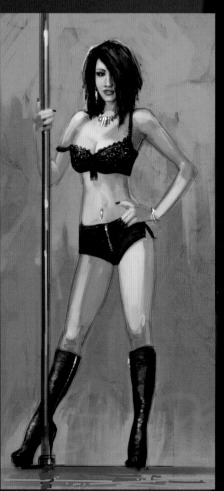
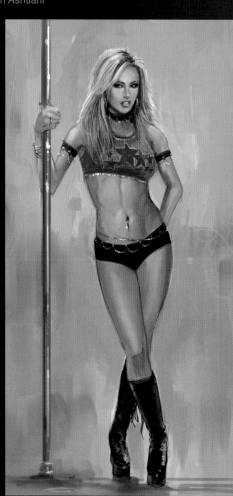

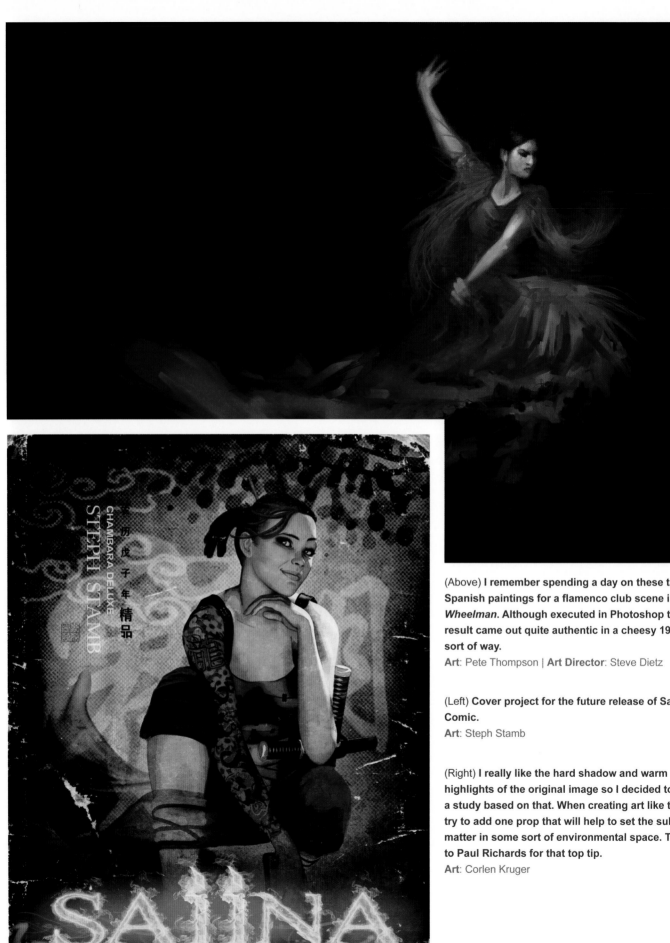

(Above) **I remember spending a day on these tacky Spanish paintings for a flamenco club scene in** *Wheelman*. **Although executed in Photoshop the result came out quite authentic in a cheesy 1960's sort of way.**
Art: Pete Thompson | **Art Director**: Steve Dietz

(Left) **Cover project for the future release of Saiina Comic.**
Art: Steph Stamb

(Right) **I really like the hard shadow and warm highlights of the original image so I decided to do a study based on that. When creating art like this I try to add one prop that will help to set the subject matter in some sort of environmental space. Thanks to Paul Richards for that top tip.**
Art: Corlen Kruger

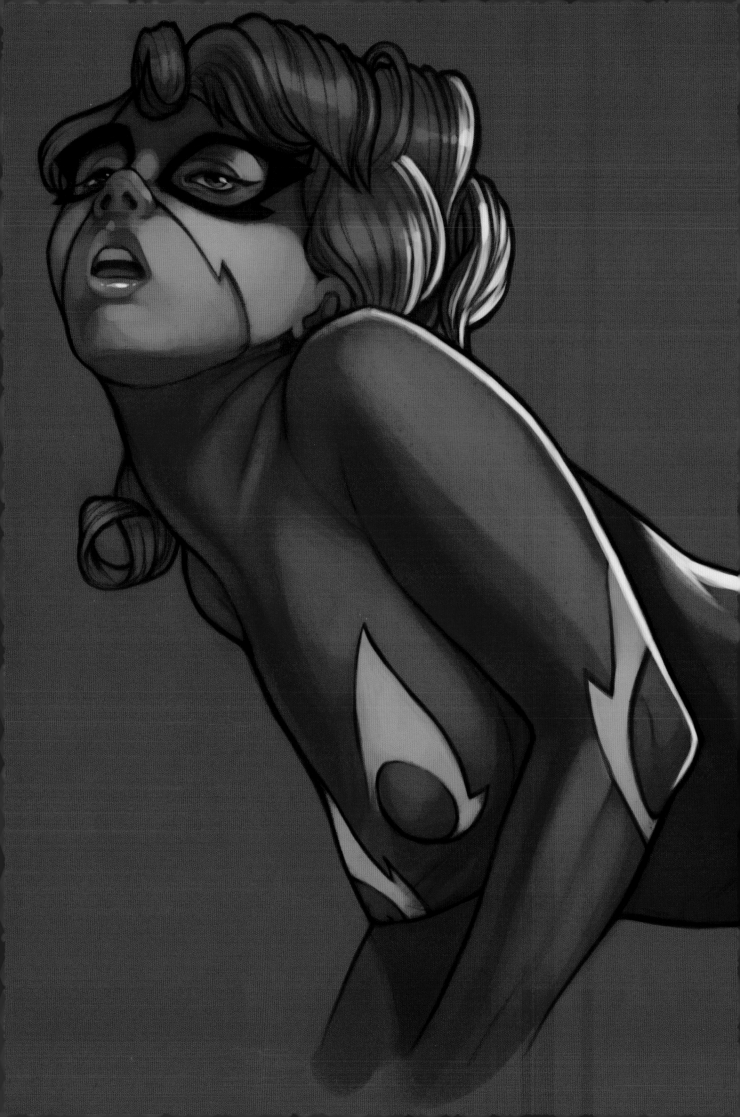

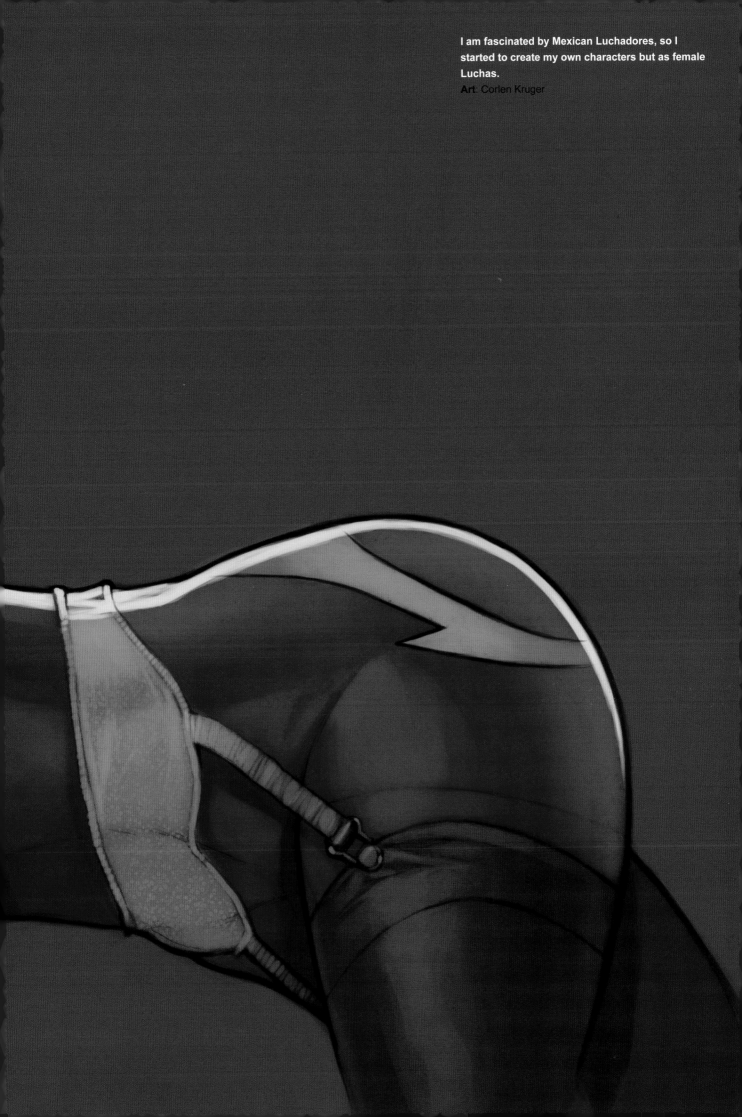

I am fascinated by Mexican Luchadores, so I started to create my own characters but as female Luchas.
Art: Corlen Kruger

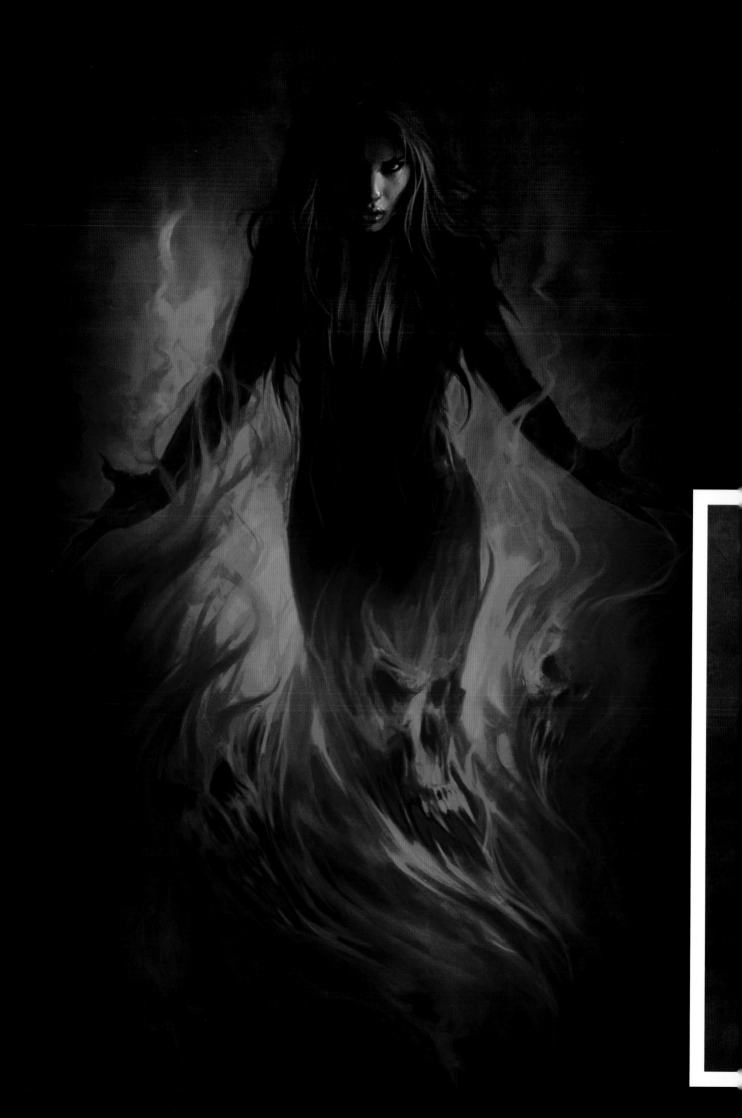

(Left) **This piece brings together all the lessons I`ve learnt from doing countless paint-overs throughout my career. When I use photo references as a starting point, I stop myself from reverting back to the original photo and carry on painting using my own imagination.**
Art: Pete Thompson | **Art Director**: Cumron Ashtiani

(Bottom Right) **Anime-styled piece featuring some female robot Luchadore characters I created a while ago.**
Art: Corlen Kruger

(Below) **This artwork made it into the** *Eye Candy From Stranger's* **art book.**
Art: Corlen Kruger

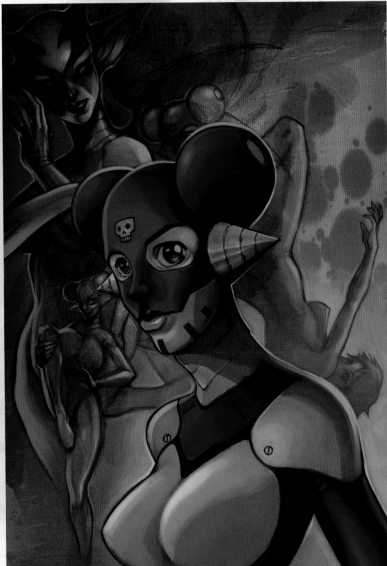

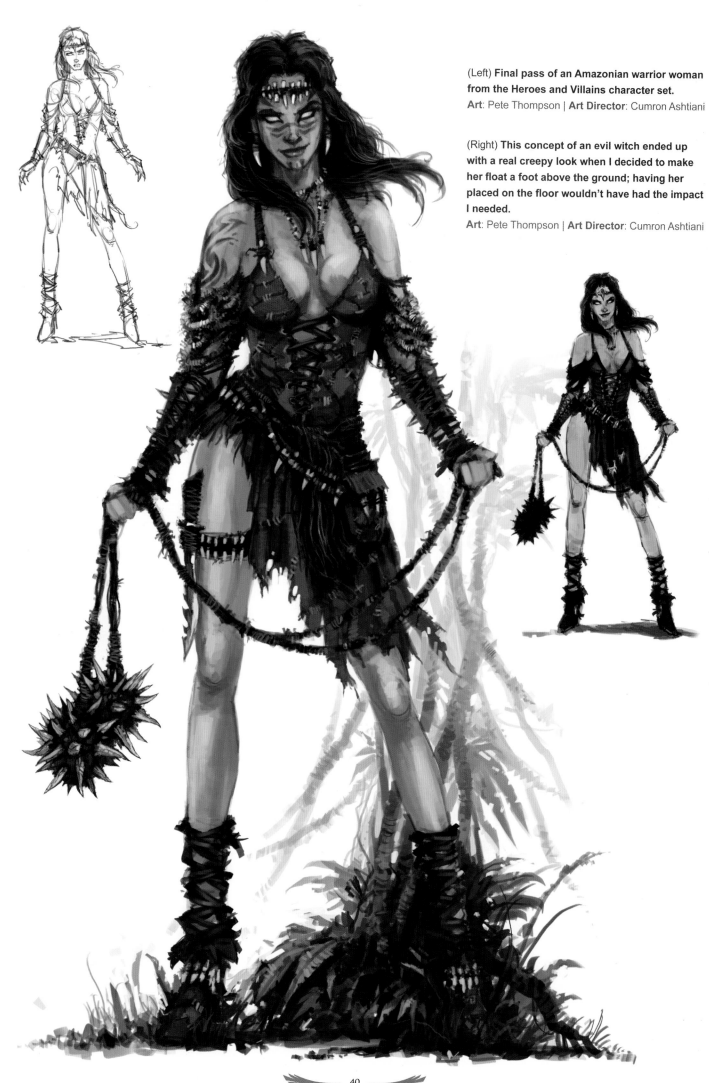

(Left) **Final pass of an Amazonian warrior woman from the Heroes and Villains character set.**
Art: Pete Thompson | Art Director: Cumron Ashtiani

(Right) **This concept of an evil witch ended up with a real creepy look when I decided to make her float a foot above the ground; having her placed on the floor wouldn't have had the impact I needed.**
Art: Pete Thompson | Art Director: Cumron Ashtiani

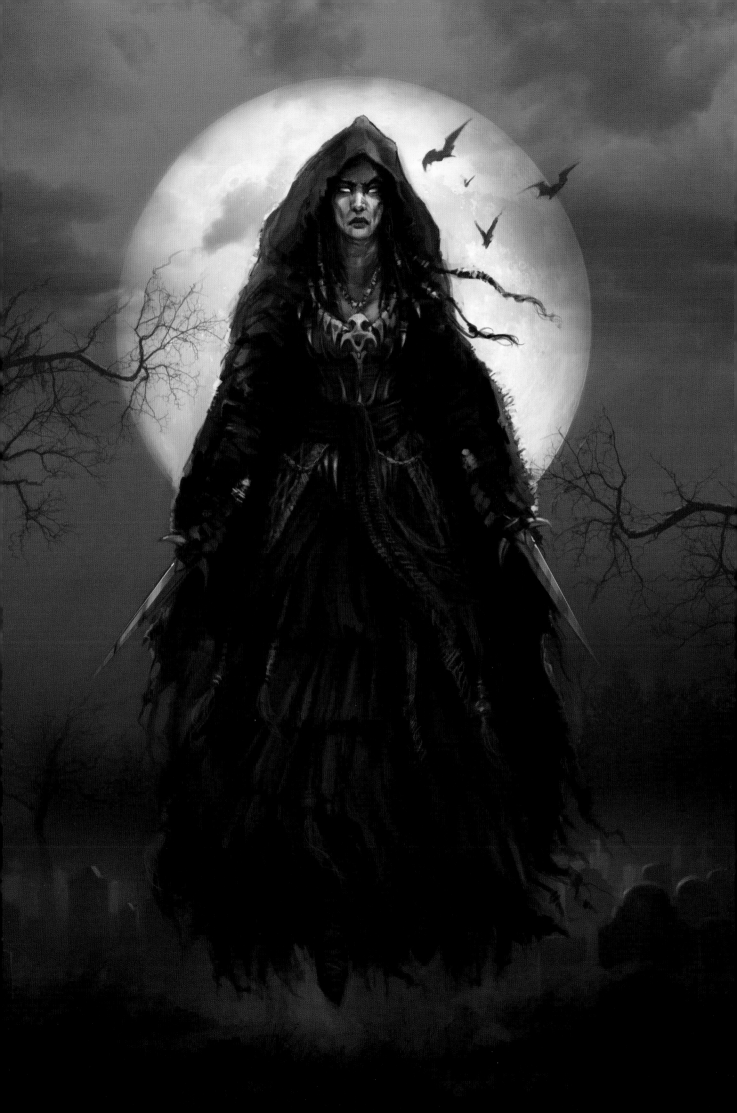

THERE'S NO ESCAPE FROM

THE HOUSE OF SECRETS

CK HOUSE OF SECRETS

NO. 96
MAR.
30535
CORLEN CK SCOPE

SERUM OF SATAN

52 BIG pages
DON'T TAKE LESS
ONLY
25¢

GREATEST
SCREAMFEST!

Deadlier than DRACULA!

I was doing another vampire-inspired pin-up, and I decided I needed to get her on some sort of interesting backdrop, so I moved a few elements from *The House of Secrets* around to get what you see before you now.

Art: Corlen Kruger

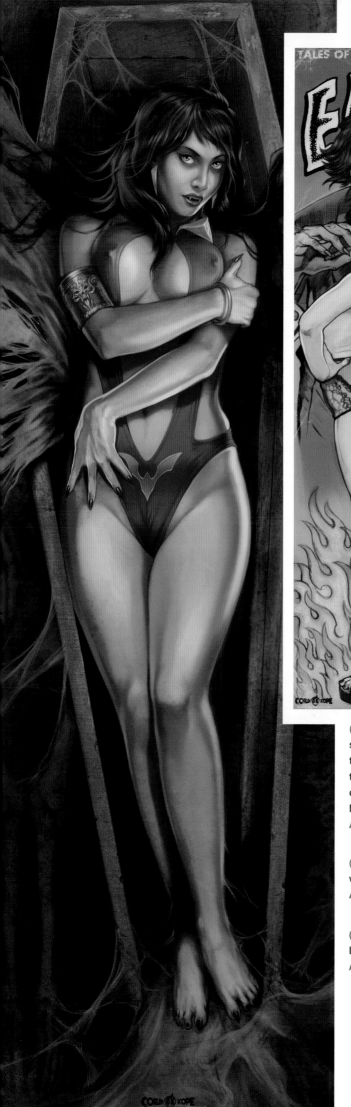

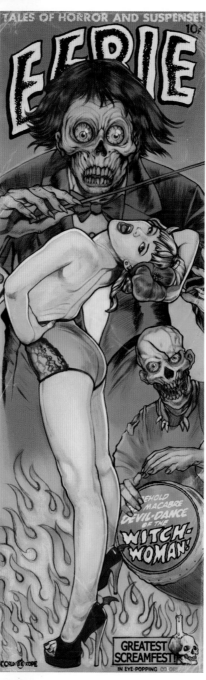

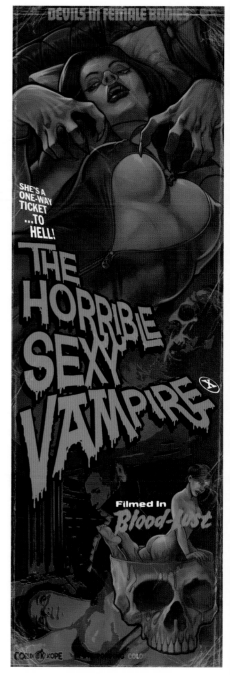

(Above) **I wanted to try something a little different here. Basically it's still the same B-Movie poster format that I use, but what I wanted to try this time is a combination of classical horror comics and pin-ups. I took the idea from an old Eerie comic and then added all my goodies to it, to create Dance Macabre. The pose that I worked from is by the lovely Miss-Mosh.**
Art: Corlen Kruger

(Top Right) **This is part of a series of long-format posters I have created. I wanted them to have the look and feel of 1960's and 1970's film posters.**
Art: Corlen Kruger

(Left) **Based on the comic book female fatale Vampirella. I wanted to do a large almost door-sized poster of her, but in a more realistic style.**
Art: Corlen Kruger

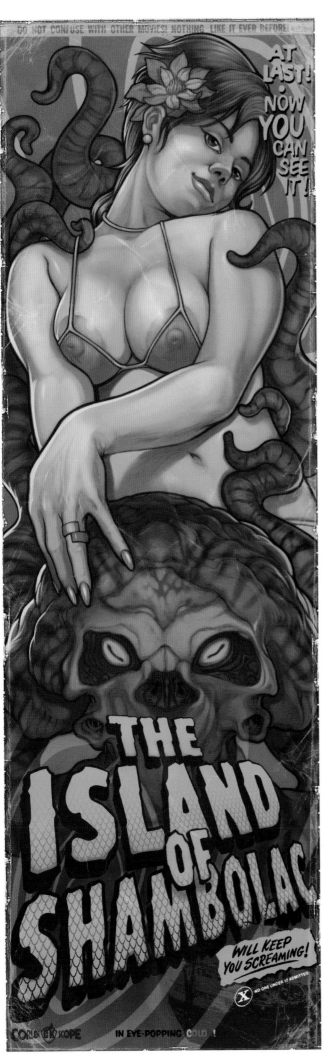

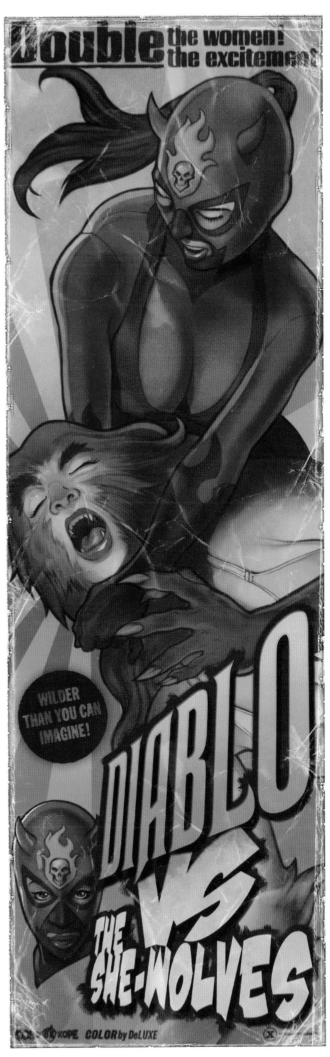

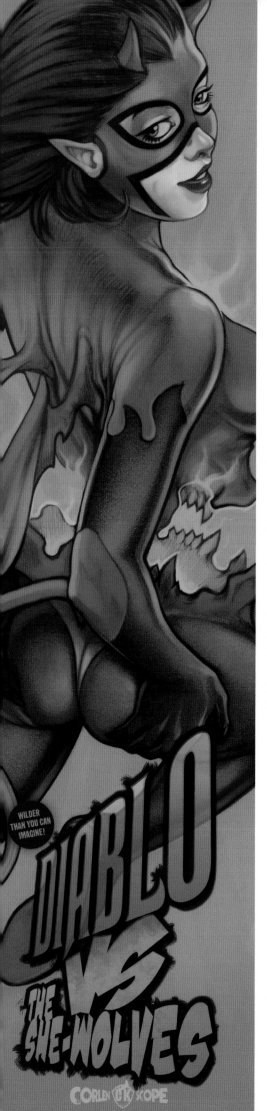

(Right) **Some of my long-format posters have also been reworked to fit onto skateboard decks.**
Art: Corlen Kruger

(Left) **This is part of a series of long-format posters I have created. I wanted them to have the look and feel of 1960's and 1970's film posters.**
Art: Corlen Kruger

(Bottom Right) **Inspired by Ted V. Mikel's** *The Astro Zombies*, **I wanted to create a small homage to his film but also add my own take on this.**
Art: Corlen Kruger

(Below) **Based on the softcore movie** *The Danish Connection*, **I did this one really to pay homage to Rene Bond. She is really beautiful and a total fox of her day.**
Art: Corlen Kruger

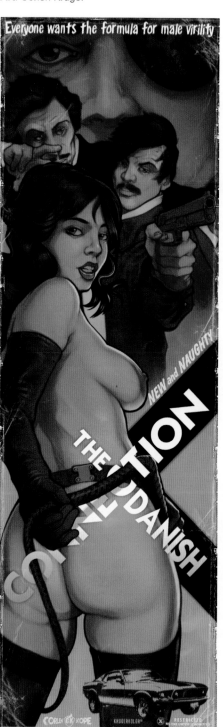

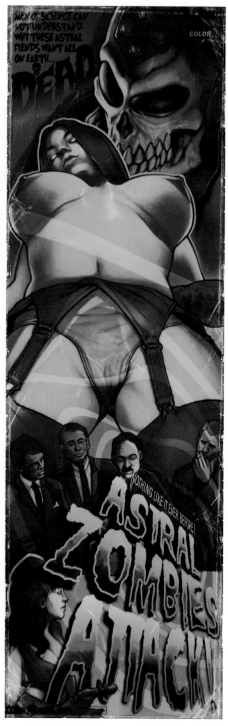

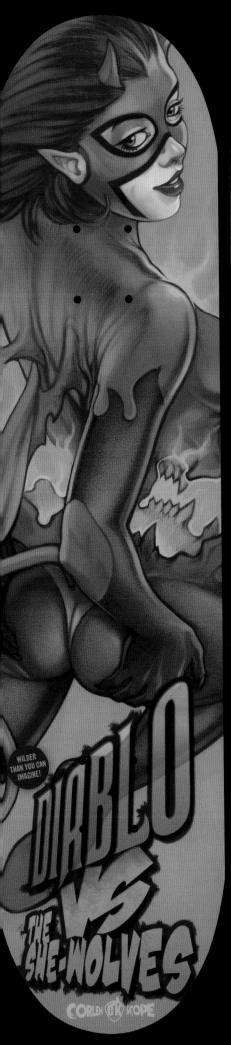

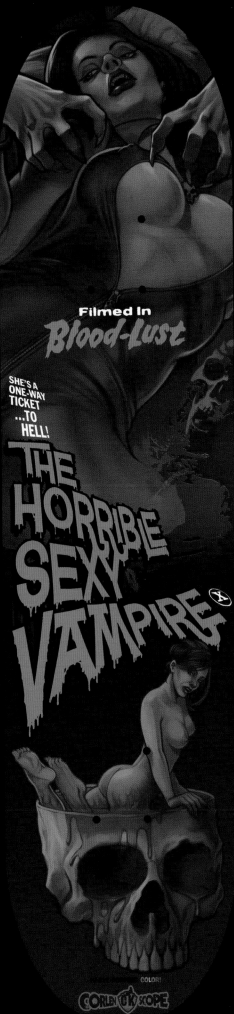

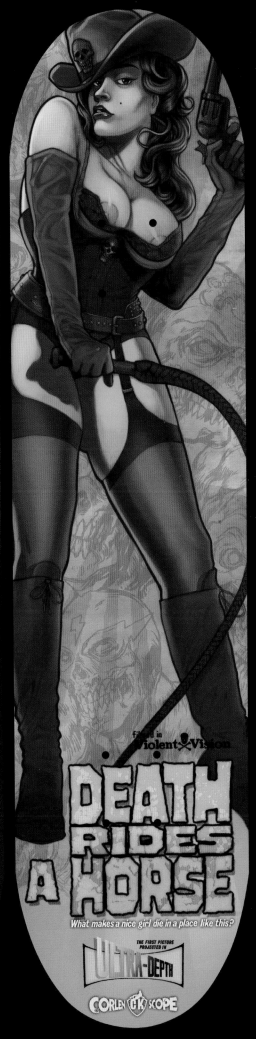

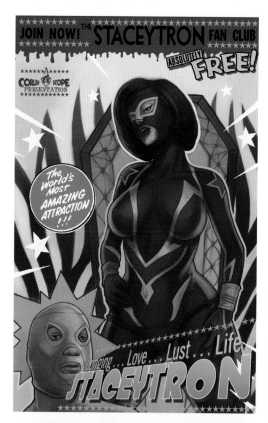

(Right) So this is something I had wanted to do for some time - take an old horror comic cover and redo it in my style. I really liked this one; the original artwork was done by Joe Orlando. I just loved the motion he captured of the botanist being grabbed by his plant experiment gone horribly wrong. After I did the artwork I replaced the original text and logos of the comic book.

Art: Corlen Kruger

(Left) This poster was inspired by some very kind and inspirational words from a fellow deviant artist Stacey Owens aka Staceytron. I decided to make her up as a Luchadore as a poster to encourage people to join the staceytron fan club. As Staceytron likes to keep her identity a secret I did the same by keeping her identity hidden under the mask, I used some of her deviantart photos to get the body shape the same, but also added some artistic license.

Art: Corlen Kruger

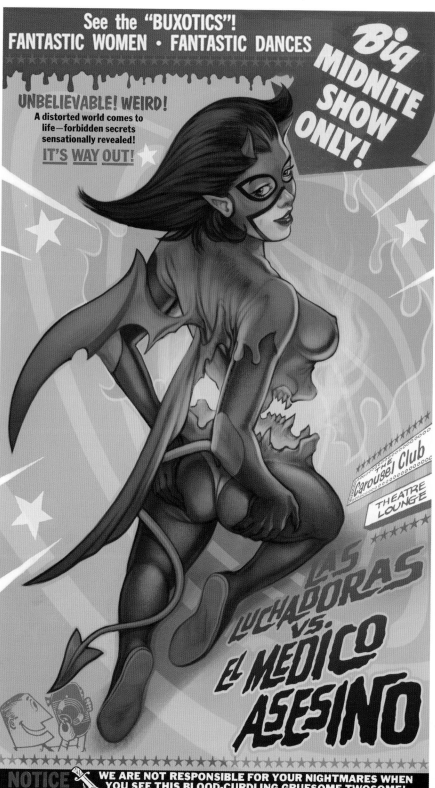

(Above) This was done as part of a collaborated effort for the NightOwl Monster Masks website re-launch. I decided to design a spoof film poster and use the Shock Monster mask as the hero character and main star of this feature.

Art: Corlen Kruger

(Right) I wanted to turn this Lucha pin-up into some sort of poster - I think the text at the bottom reads 'The Lucha's vs Doctor Death/ Doom' though I'm not totally sure. Regardless, it worked for the layout.

Art: Corlen Kruger

THE HOUSE OF **MYSTERY**

THE LINE OF **DC** SUPER-STARS

CELEBRATE A CARNIVAL OF FEAR WITH THE "BALLOON VENDOR!"

30¢
NO. 242
JUNE
30530

DO YOU DARE ENTER... THE HOUSE OF **MYSTERY**

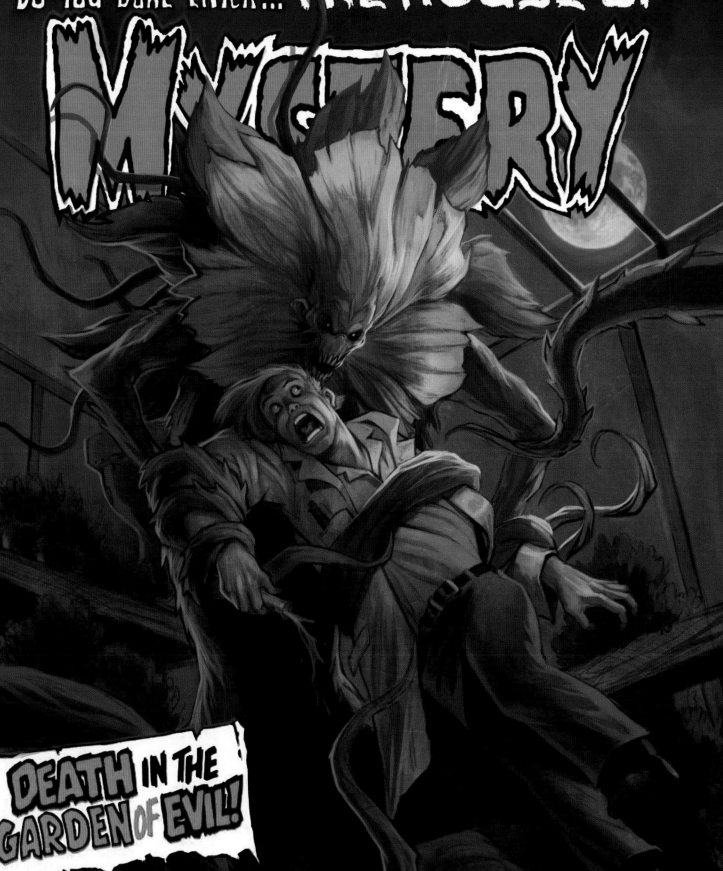

DEATH IN THE GARDEN OF EVIL!

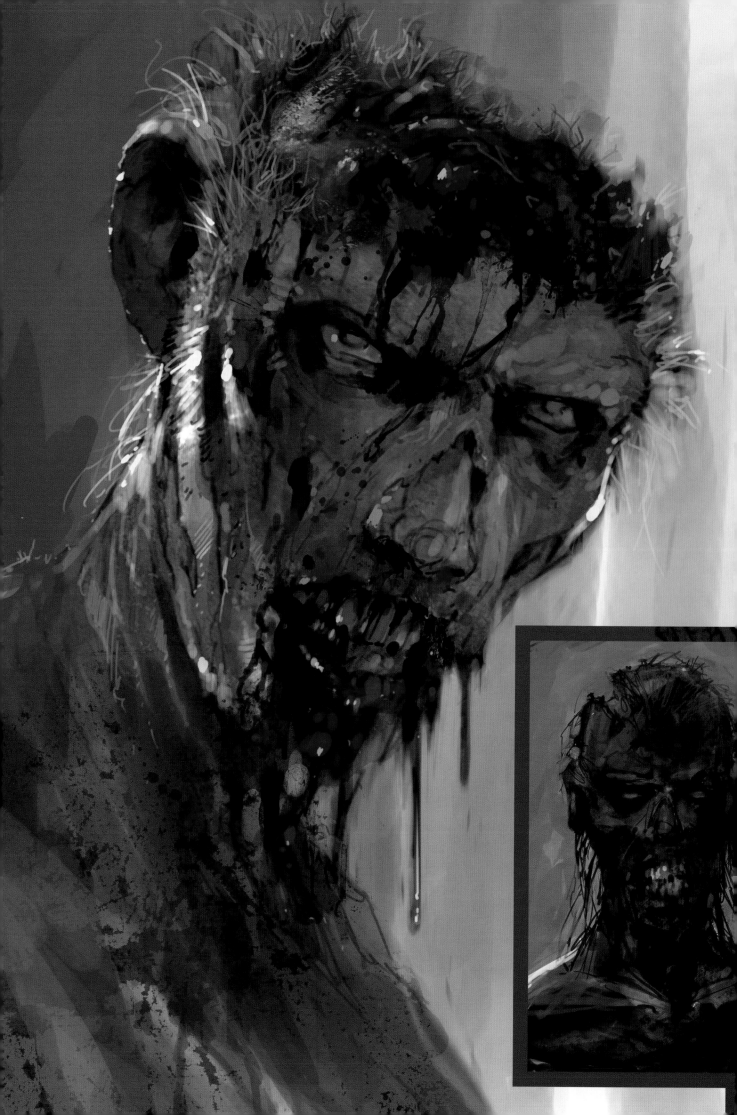

Art: Pete Thompson | Art Director: Cumron Ashtiani

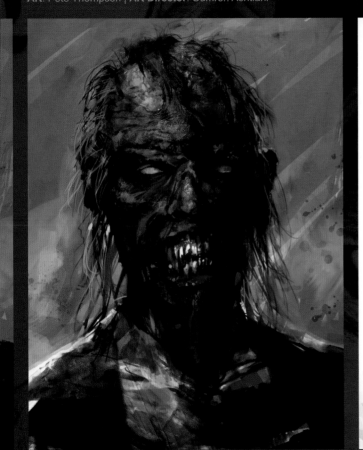

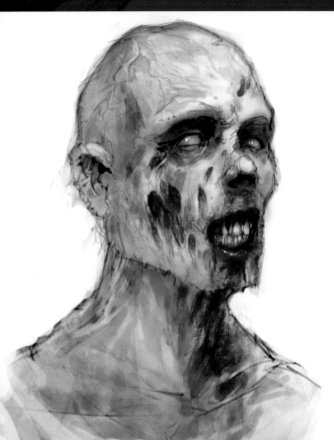

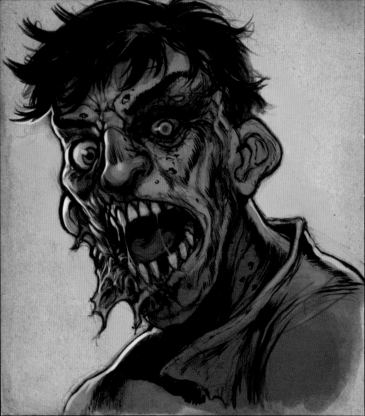

(Above) **Sketchbook sketch done up with a brush pen. I
also wanted to experiment with an old color ink-like wash
- the same style you used to see in the old EC comics,
before the introduction of computer coloring techniques.**
Art: Corlen Kruger

(Top Right) **Pen and ink sketch, scanned in and painted over
digitally, whilst still trying to keep the original ink lines.**
Art: Corlen Kruger

(Right) **This was commissioned by the band Warfear - they wanted all the
band members portrayed as zombies, but set in the *Left 4 Dead* universe.
The theme was a take on *Left 4 Dead*, but adding the band members as
the undead. I decided to go for an EC-style comic look, but a little more
modernized; less halftones and more intense color as well as texture
use. I used halftones more extensively on the background because I
wanted the zombies to be the focus of the piece. I also made the creatures
look and point outwards to break up the composition and make it less
centralized.**
Art: Corlen Kruger

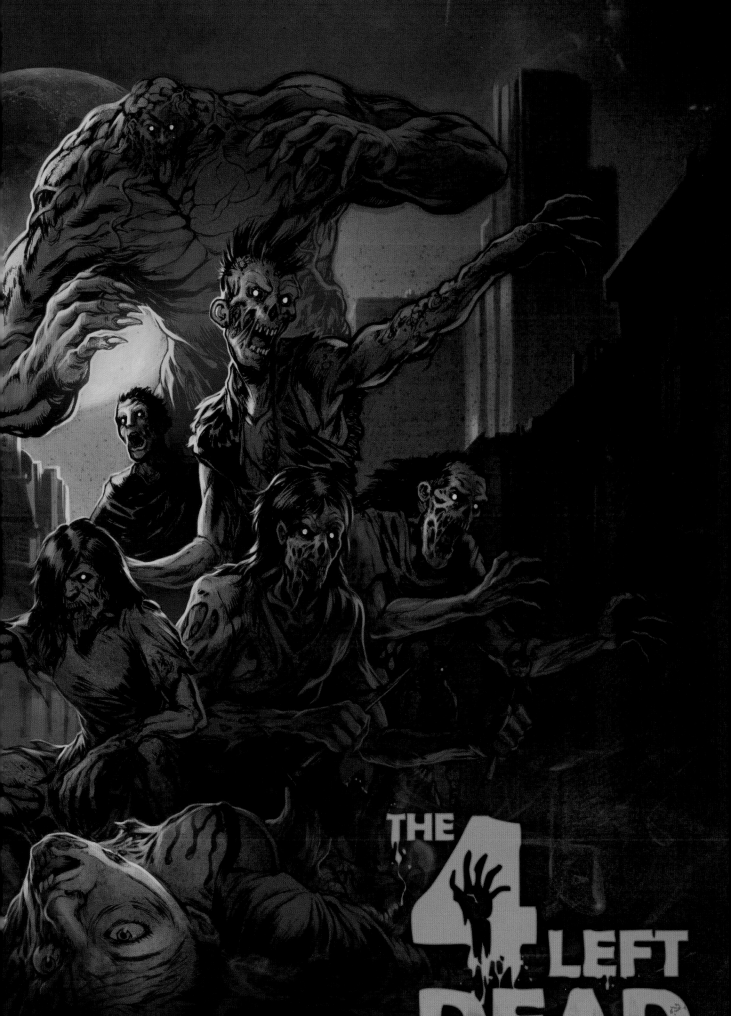

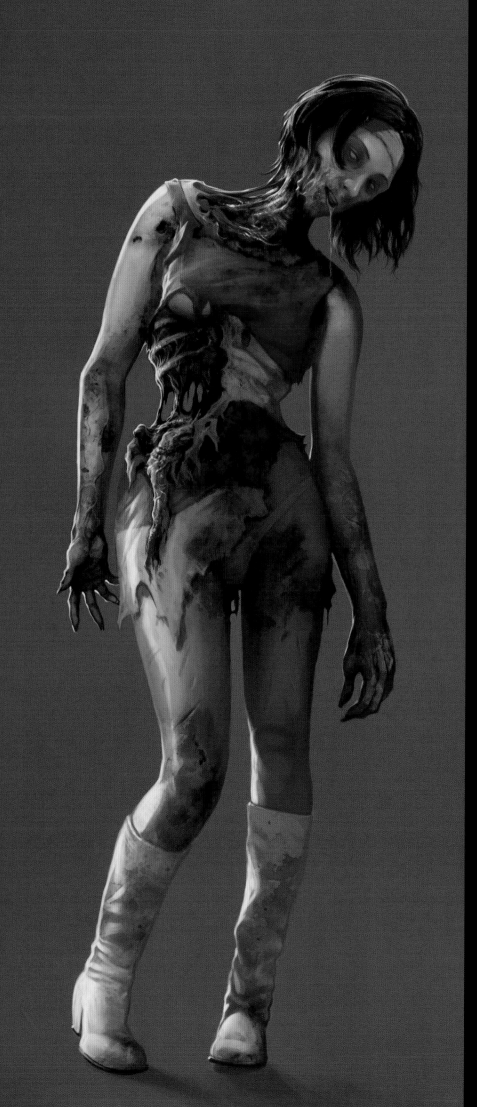

(Left) **A zombie prostitute.**
Art: Corlen Kruger | **Art Director**: Cumron Ashtiani

(Right) **After the first phase (below) I decided to create more of an atmosphere by adding more zombies and placing them in a setting. I also explored dynamic lighting effects; if you take a closer look at the main zombie's mouth, you can see how I have suggested light through the flesh by painting some warm red on the inside of his mouth.**
Art: Corlen Kruger

(Below) **First phase of a zombie concept. I did a very quick ink sketch and started a digital paintover.**
Art: Corlen Kruger

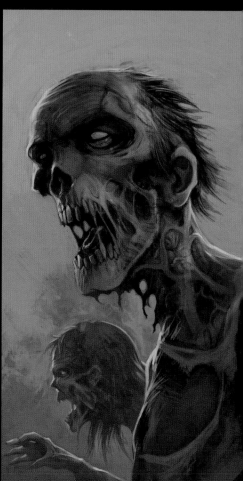

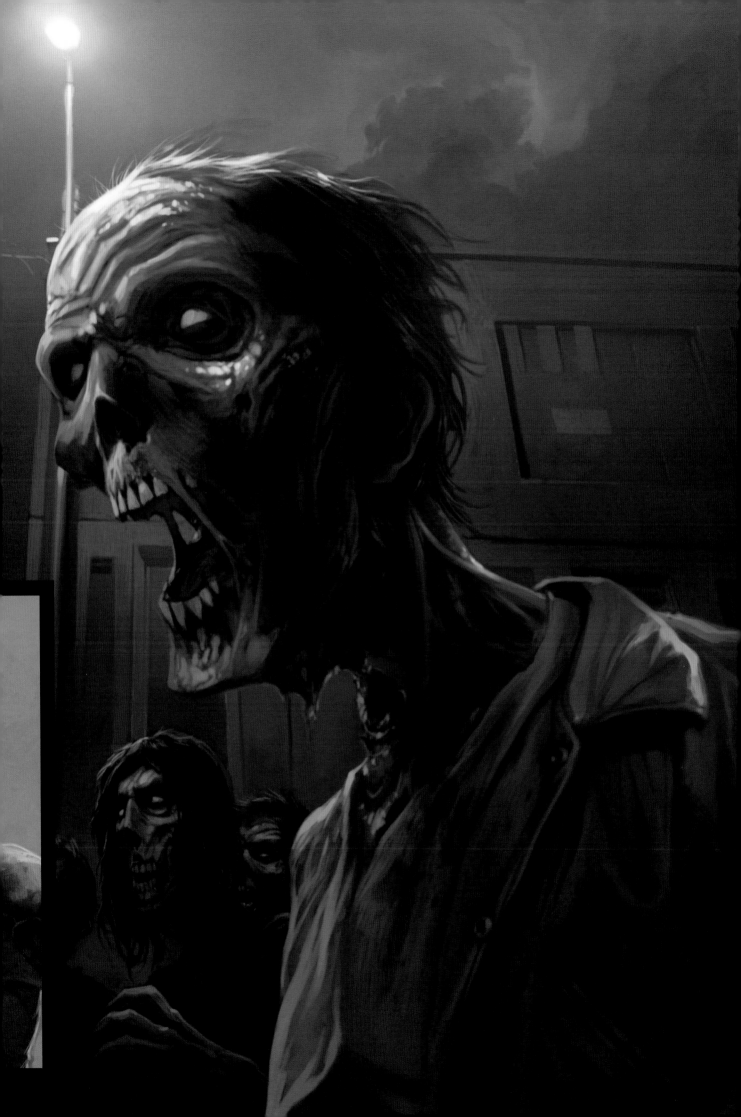

(Right) **This started as a digital doodle and was heading for the bin fast. Then I started to see the love in his eyes and kept going. He is a hybrid mix between a ghoul and a vampire. Okay he only really has vampire ears, so he is more of a ghoul with pointy ears. This piece was done entirely in Photoshop.**
Art: Corlen Kruger

(Bottom Right) **Inspired by the classic movie** *The Fly*, **I decided to create a B-Movie monster of my own, but mine would be crossed with a praying mantis. Done originally as an ink sketch, I scanned it into Photoshop and used a variety of textures to create his unique skin and eyes.**
Art: Corlen Kruger

(Below) **Digital creature creation done using Photoshop.**
Art: Corlen Kruger | **Art Director**: Cumron Ashtiani

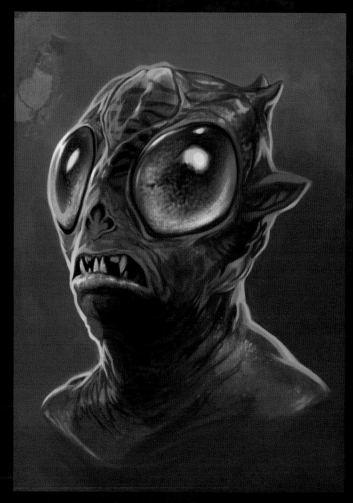

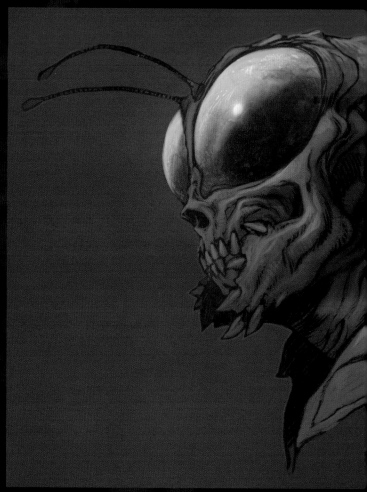

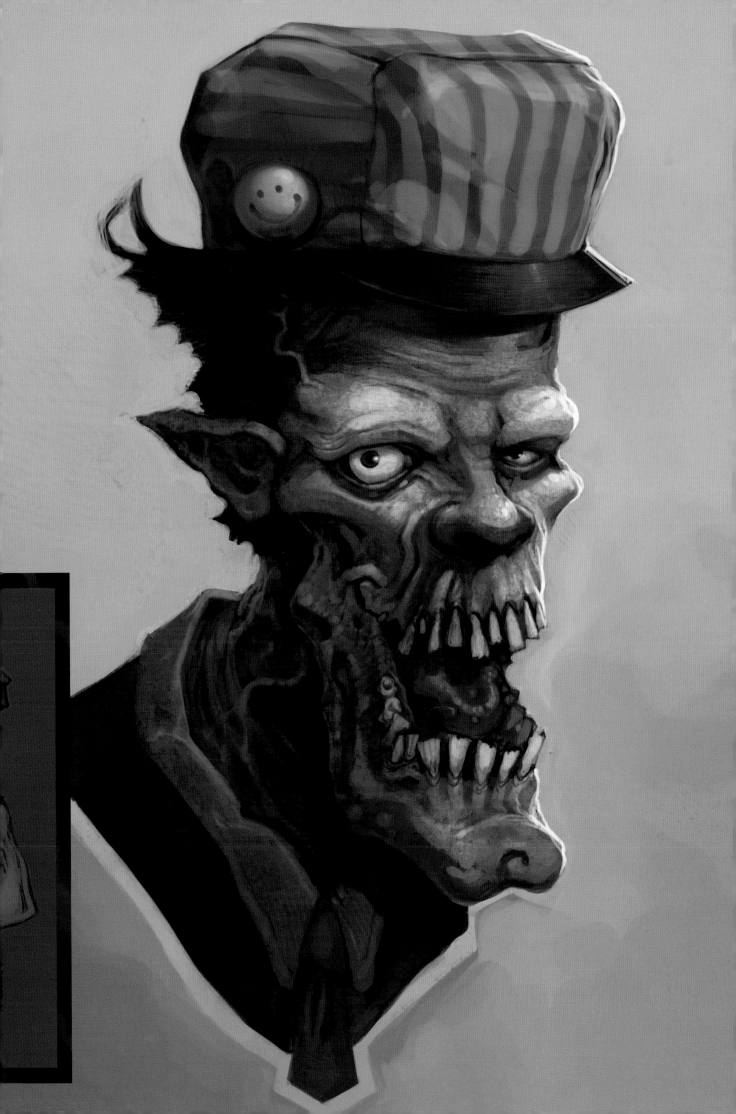

I still find drawing small sketches in a sketchbook is the best way to keep ideas fresh. It also serves as a great source for inspiration on those days when I can't seem to think of anything creative.

DARK HORIZION

DARK HARVEST

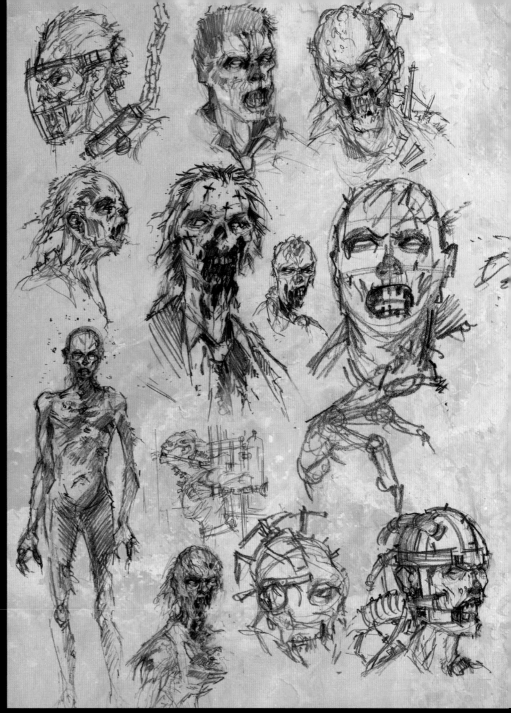

(Above) **Zombie concept thumbs sketched in Painter.**
Art: Pete Thompson | Art Director: Cumron Ashtiani

(Right and Below) **Further sketches of women and monsters.**
Art: Corlen Kruger

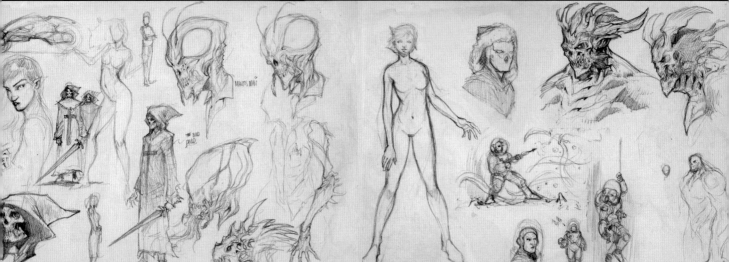

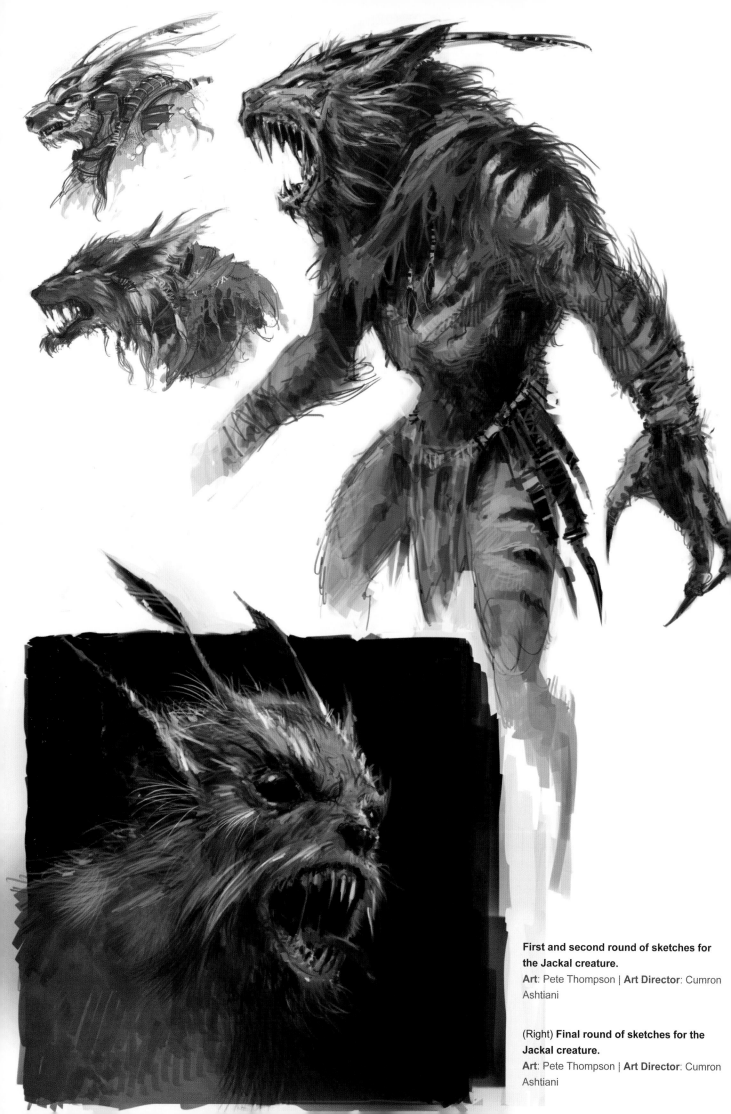

First and second round of sketches for the Jackal creature.
Art: Pete Thompson | **Art Director**: Cumron Ashtiani

(Right) **Final round of sketches for the Jackal creature.**
Art: Pete Thompson | **Art Director**: Cumron Ashtiani

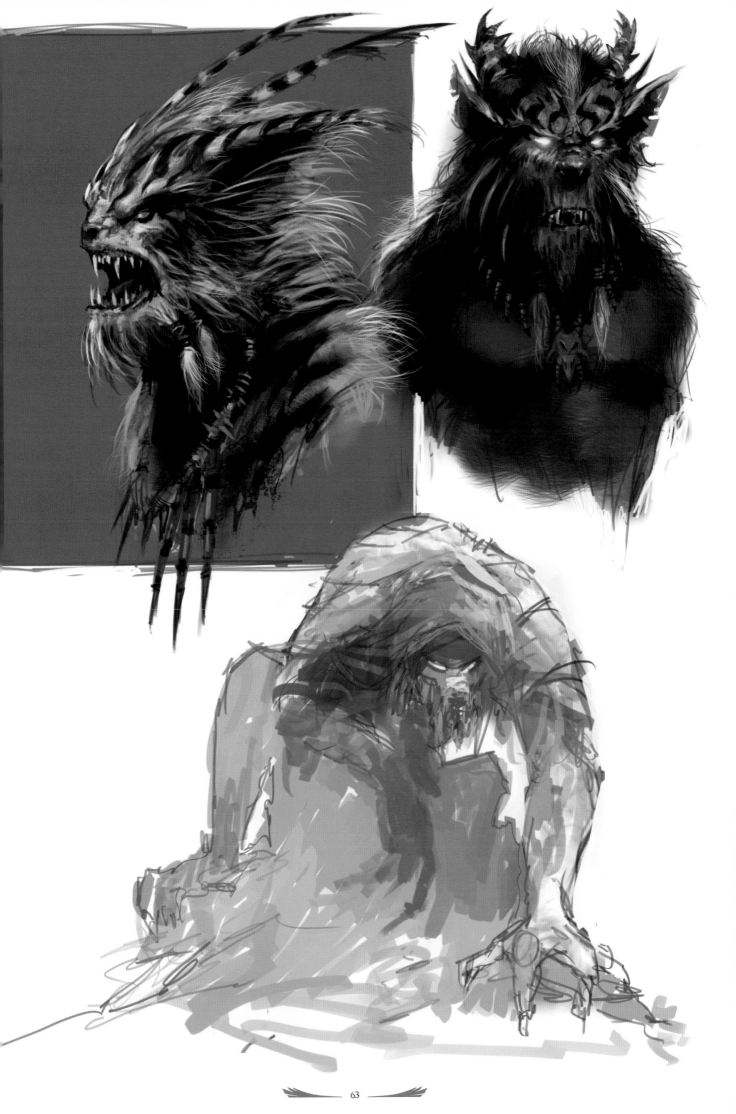

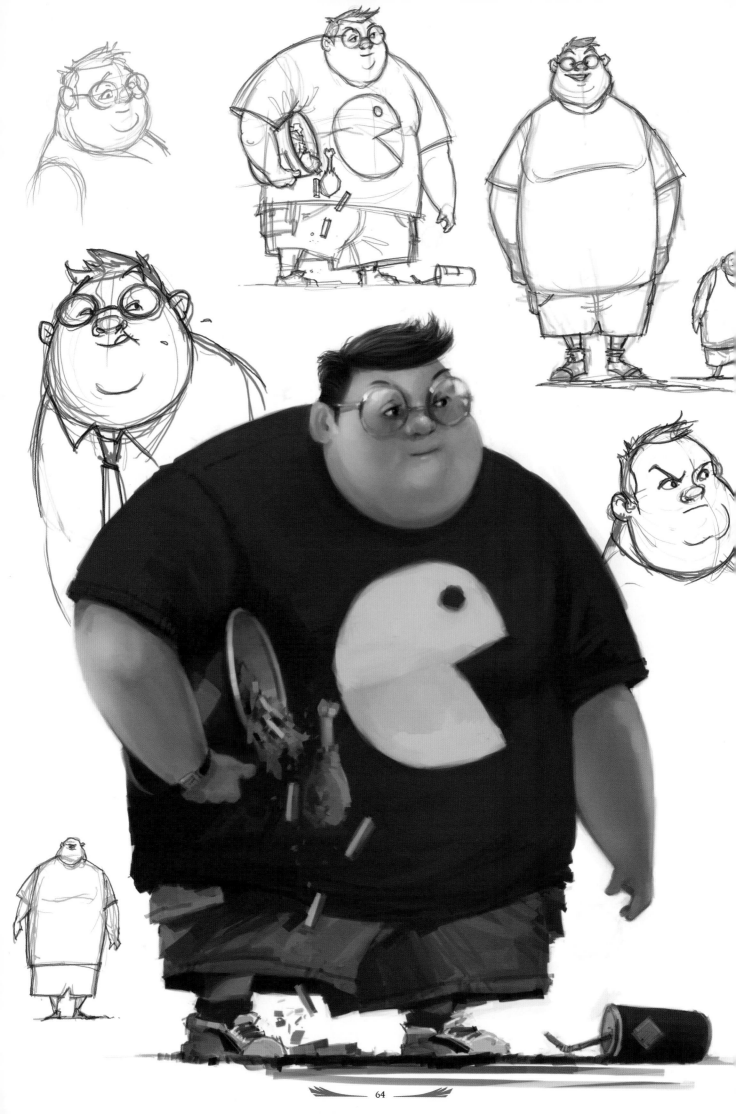

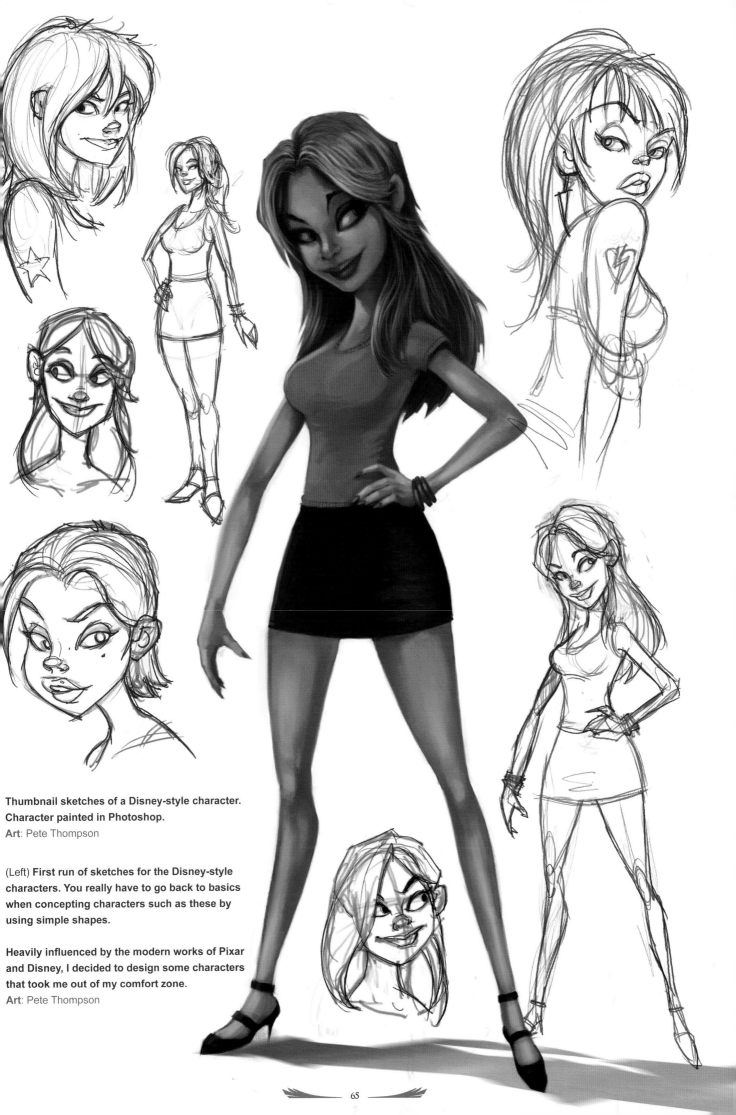

Thumbnail sketches of a Disney-style character.
Character painted in Photoshop.
Art: Pete Thompson

(Left) First run of sketches for the Disney-style
characters. You really have to go back to basics
when concepting characters such as these by
using simple shapes.

Heavily influenced by the modern works of Pixar
and Disney, I decided to design some characters
that took me out of my comfort zone.
Art: Pete Thompson

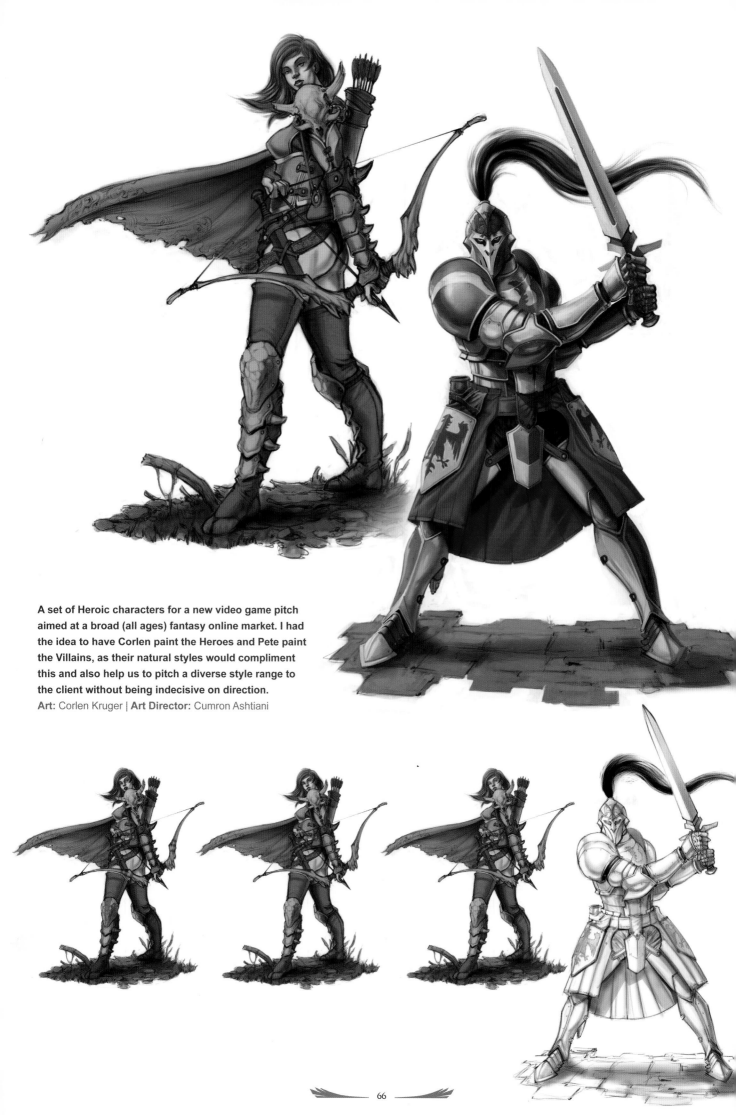

A set of Heroic characters for a new video game pitch aimed at a broad (all ages) fantasy online market. I had the idea to have Corlen paint the Heroes and Pete paint the Villains, as their natural styles would compliment this and also help us to pitch a diverse style range to the client without being indecisive on direction.

Art: Corlen Kruger | **Art Director:** Cumron Ashtiani

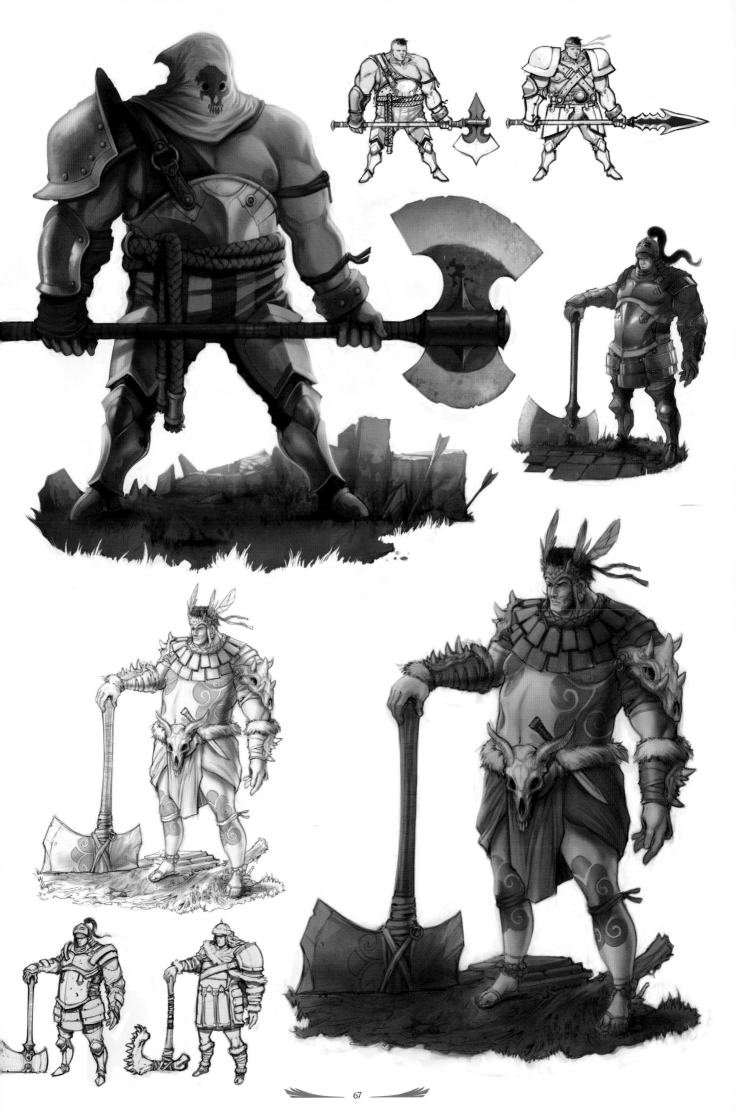

ACTION
CONCEPTS

This chapter covers a broad spectrum of images ranging from storyboards to key moments to highly polished marketing artwork. We believe that every image/frame must tell a story and while this is clear when working on storyboards, the same applies to more advanced imagery.

Key Moment images are an illustrated snapshot of the action, much like a frame of a storyboard that is taken into more detail. They encompass what the viewer/player will be seeing and feeling at the time they experience the moment in the final production. Key Moment stills can really help sell the mood, lighting and indicate the complexity of a scene for production estimation - things that are hard to judge from a line work storyboard.

We apply the same principals to marketing artwork, which is often highly polished with increased complexity. While the image needs to tell a story, it also often needs to encompass everything about the brand. This is challenging but rewarding work as bringing the many elements of an intellectual property together into one cohesive image can take much iteration.

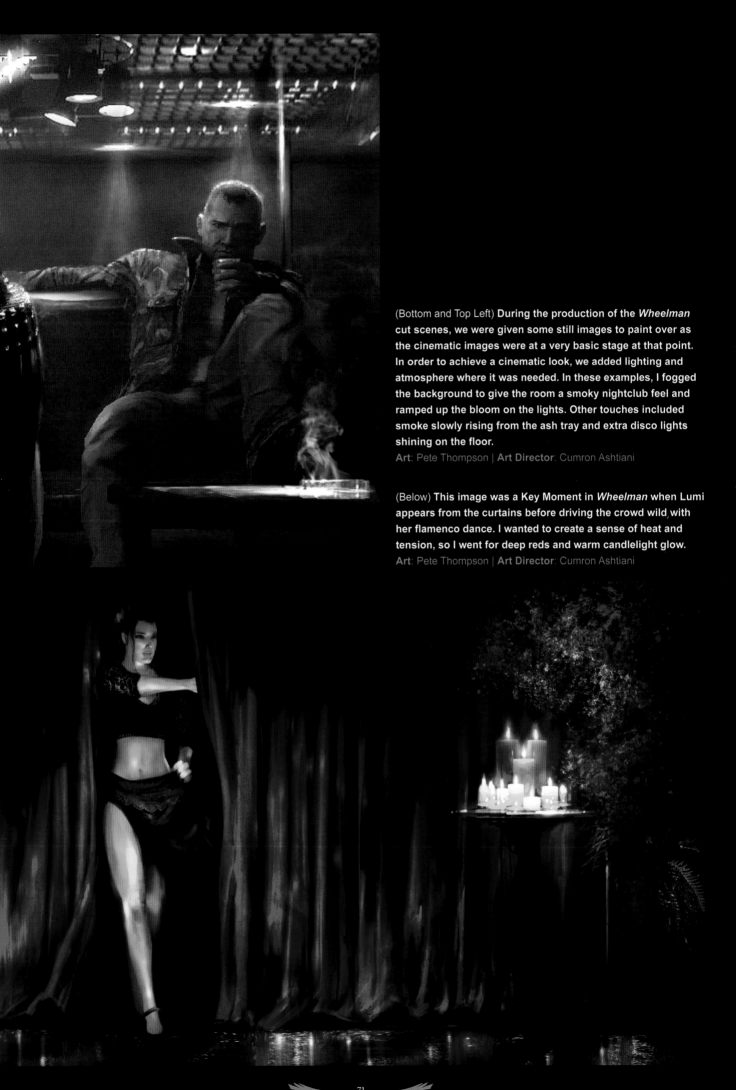

(Bottom and Top Left) **During the production of the** *Wheelman* **cut scenes, we were given some still images to paint over as the cinematic images were at a very basic stage at that point. In order to achieve a cinematic look, we added lighting and atmosphere where it was needed. In these examples, I fogged the background to give the room a smoky nightclub feel and ramped up the bloom on the lights. Other touches included smoke slowly rising from the ash tray and extra disco lights shining on the floor.**
Art: Pete Thompson | Art Director: Cumron Ashtiani

(Below) **This image was a Key Moment in** *Wheelman* **when Lumi appears from the curtains before driving the crowd wild with her flamenco dance. I wanted to create a sense of heat and tension, so I went for deep reds and warm candlelight glow.**
Art: Pete Thompson | Art Director: Cumron Ashtiani

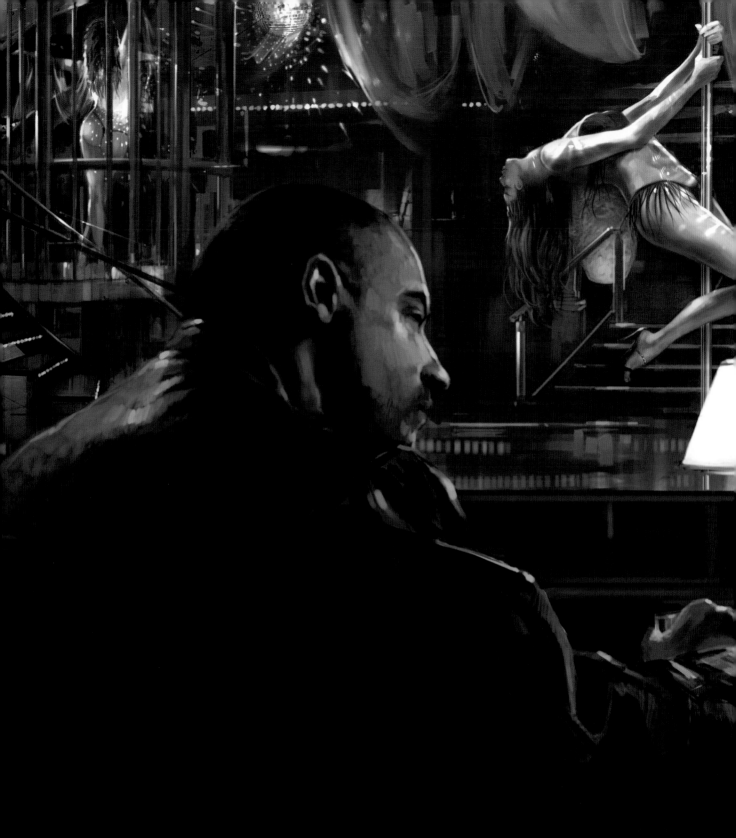

(Above) **Early draft Key Moment set in a dancing club.**
Art: Pete Thompson | Art Director: Steve Dietz

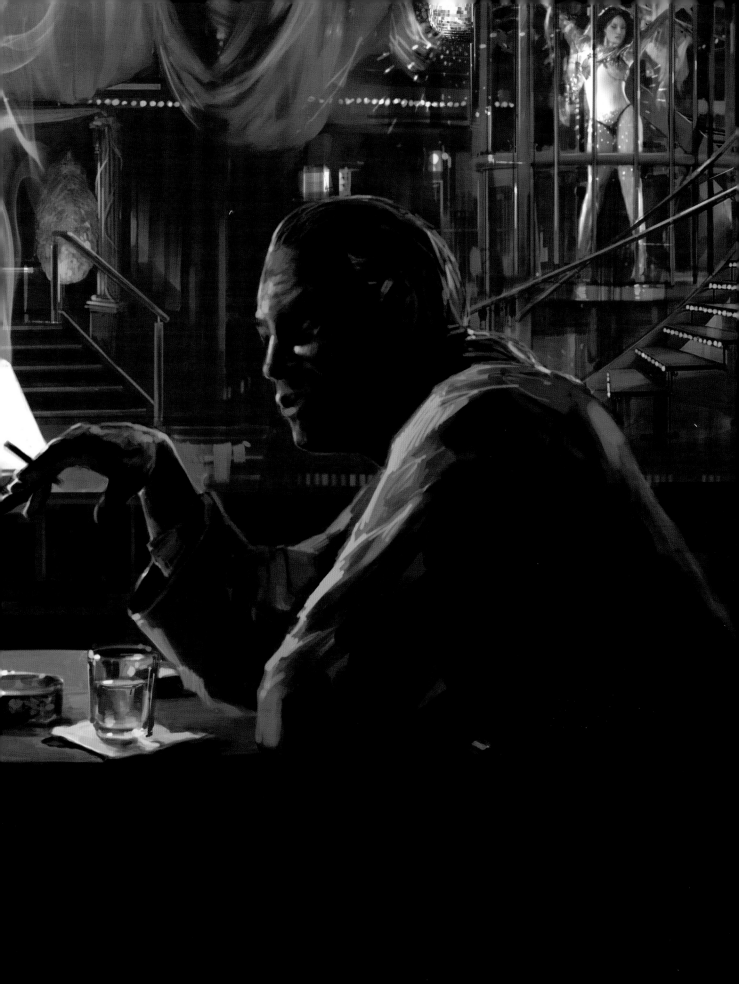

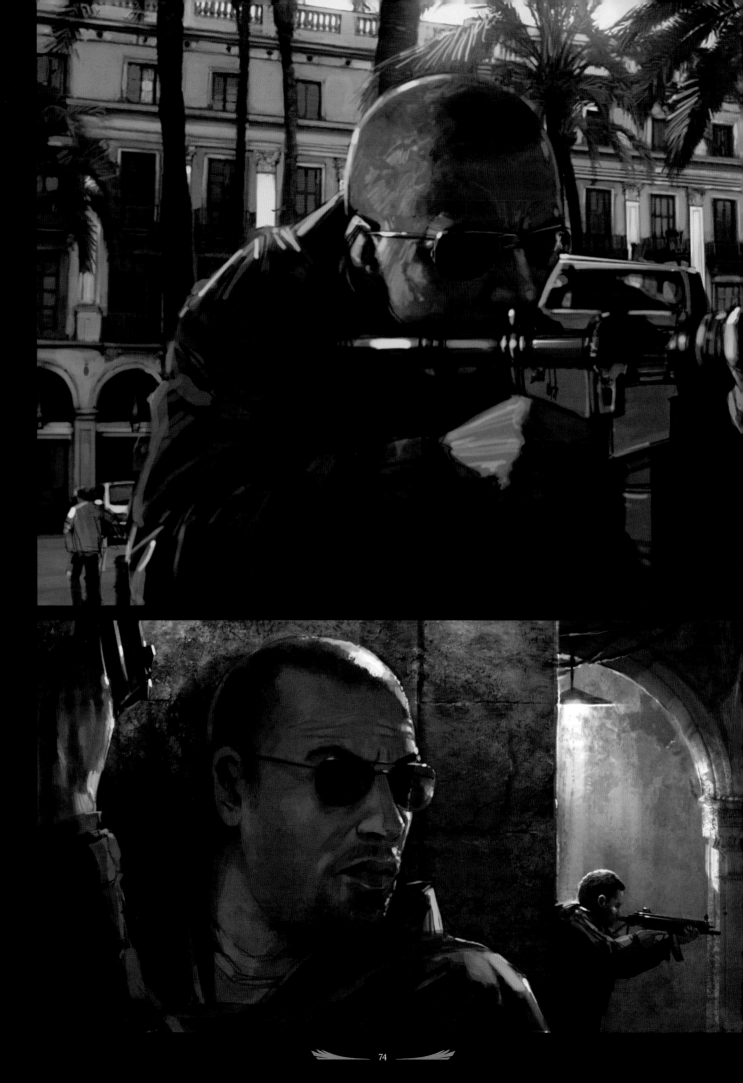

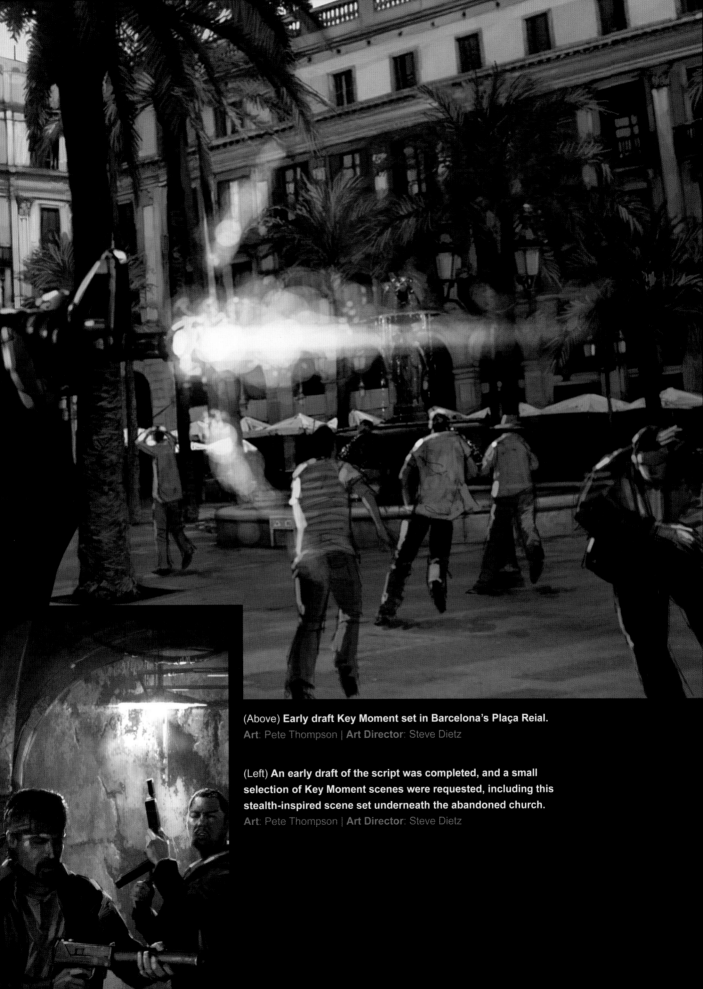

(Above) **Early draft Key Moment set in Barcelona's Plaça Reial.**
Art: Pete Thompson | **Art Director**: Steve Dietz

(Left) **An early draft of the script was completed, and a small selection of Key Moment scenes were requested, including this stealth-inspired scene set underneath the abandoned church.**
Art: Pete Thompson | **Art Director**: Steve Dietz

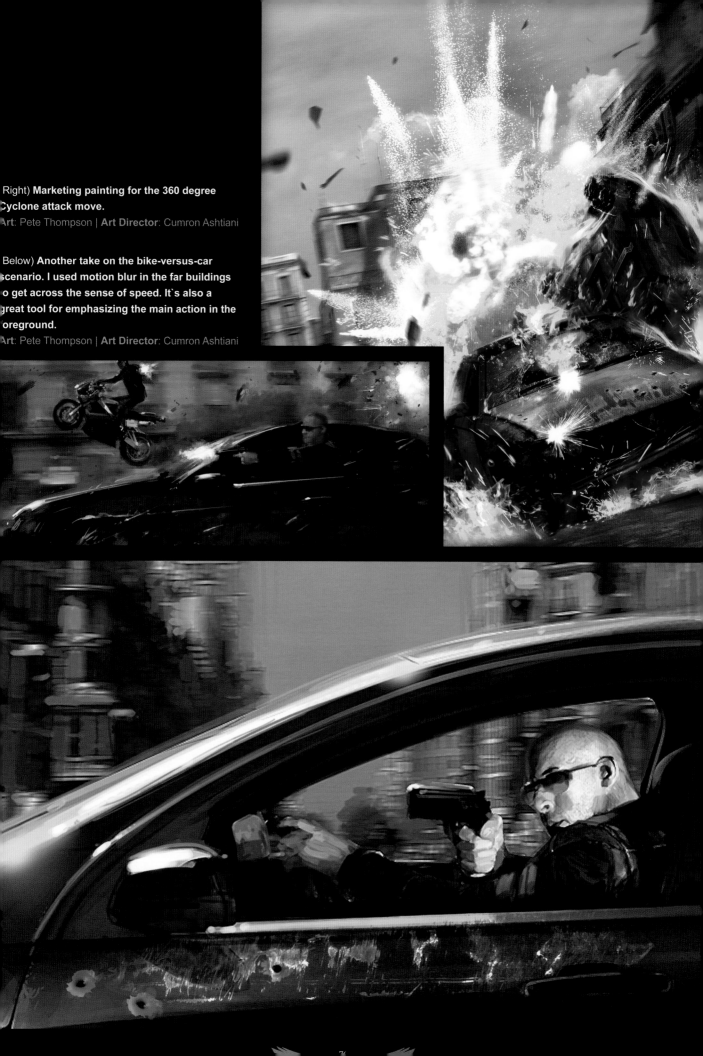

Right) **Marketing painting for the 360 degree Cyclone attack move.**
Art: Pete Thompson | **Art Director**: Cumron Ashtiani

Below) **Another take on the bike-versus-car scenario. I used motion blur in the far buildings to get across the sense of speed. It`s also a great tool for emphasizing the main action in the foreground.**
Art: Pete Thompson | **Art Director**: Cumron Ashtiani

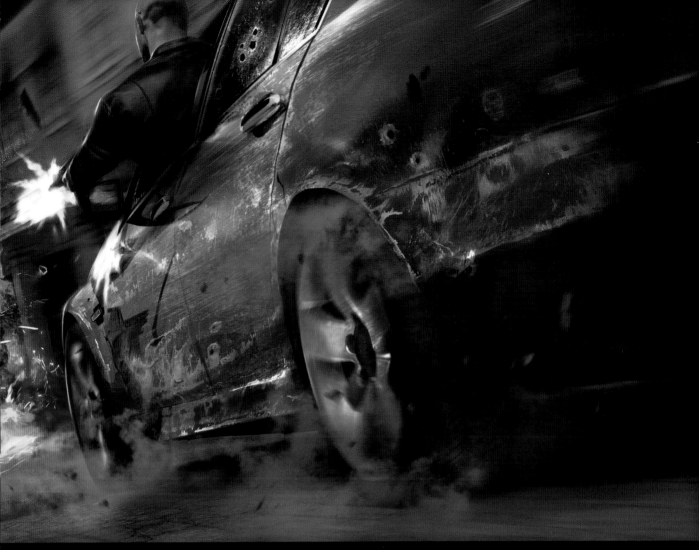

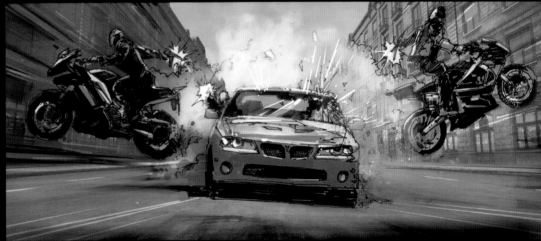

(Above) **A rough sketch showing the action as two bikers with machine guns try and take out the hero's vehicle.**
Art: Pete Thompson | **Art Director**: Cumron Ashtiani

(Left) **A Cyclone spin involves braking hard and spinning the vehicle 360 degrees so that you are in the correct position to shoot out the enemy car behind you. We went through a number of sketches and concepts to get the best out of this cool feature.**
Art: Pete Thompson | **Art Director**: Cumron Ashtiani

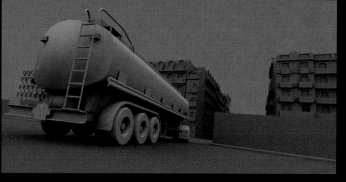

(Above) **As scripts and production changes nearly always happen on a regular basis, we sometimes have to go back to a concept and re-imagine the scenario. For this particular concept, our hero was jumping from an exploding gas tanker, but the game designers deemed the idea not exciting enough! So we re-painted it with a car colliding with the tanker's side as he was jumping.**
Art: Pete Thompson | **Art Director**: Cumron Ashtiani

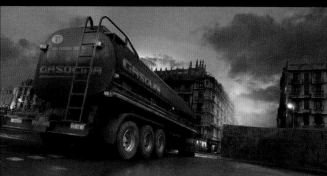

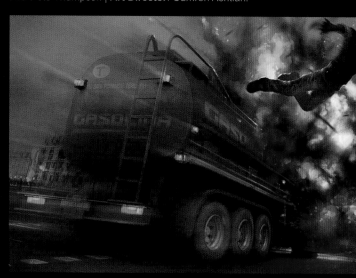

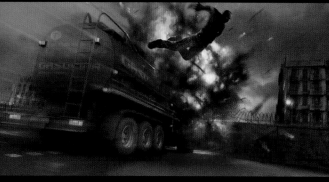

(Above) **Work in progress of the tanker jump scene showing the cut scene 3D model and paint-over process.**
Art: Pete Thompson | **Art Director**: Cumron Ashtiani

(Right) **The final pass of the tanker jump action image.**
Art: Pete Thompson | **Art Director**: Cumron Ashtiani

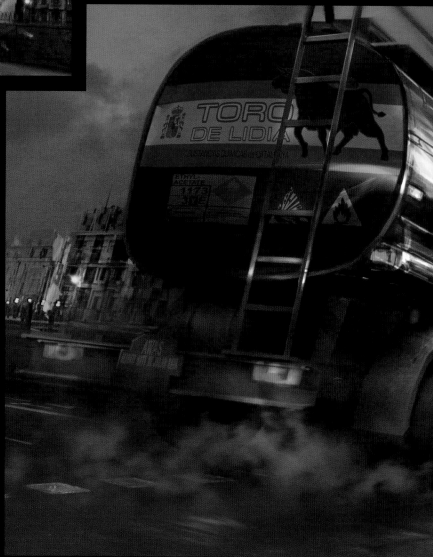

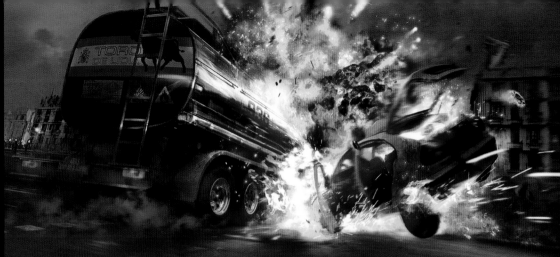
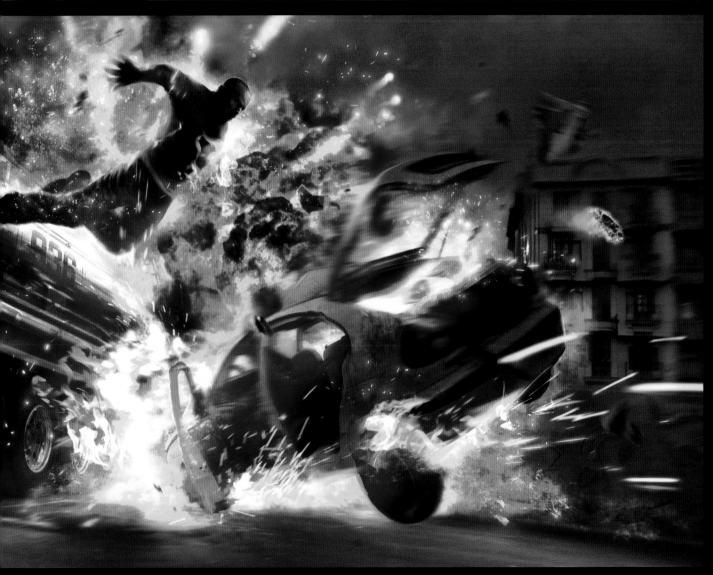

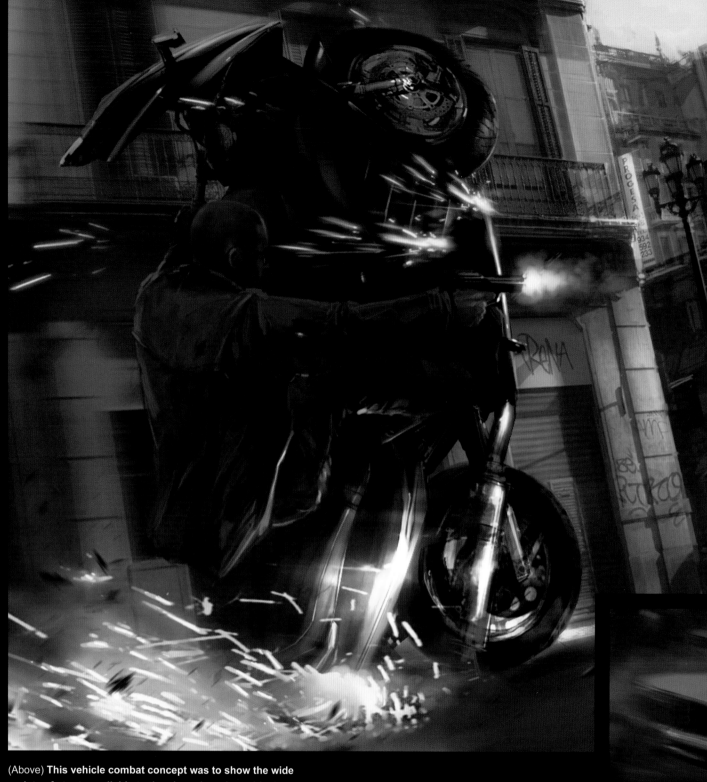

(Above) **This vehicle combat concept was to show the wide variety of stunts available to the player in order to block and dodge bullets from your opponent.**
Art: Pete Thompson | **Art Director**: Steve Dietz

(Right) **Vin Diesel using the bike as a form of cover, which is one of the special moves we came up with in the early phase of pre-production of the game.**
Art: Pete Thompson | **Art Director**: Steve Dietz

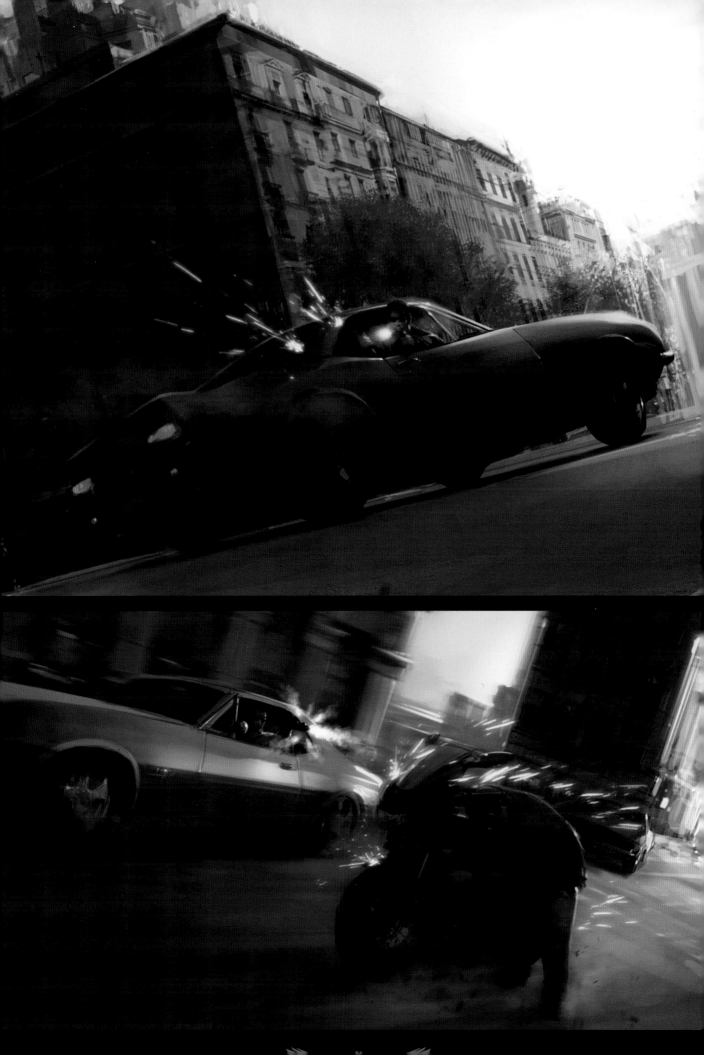

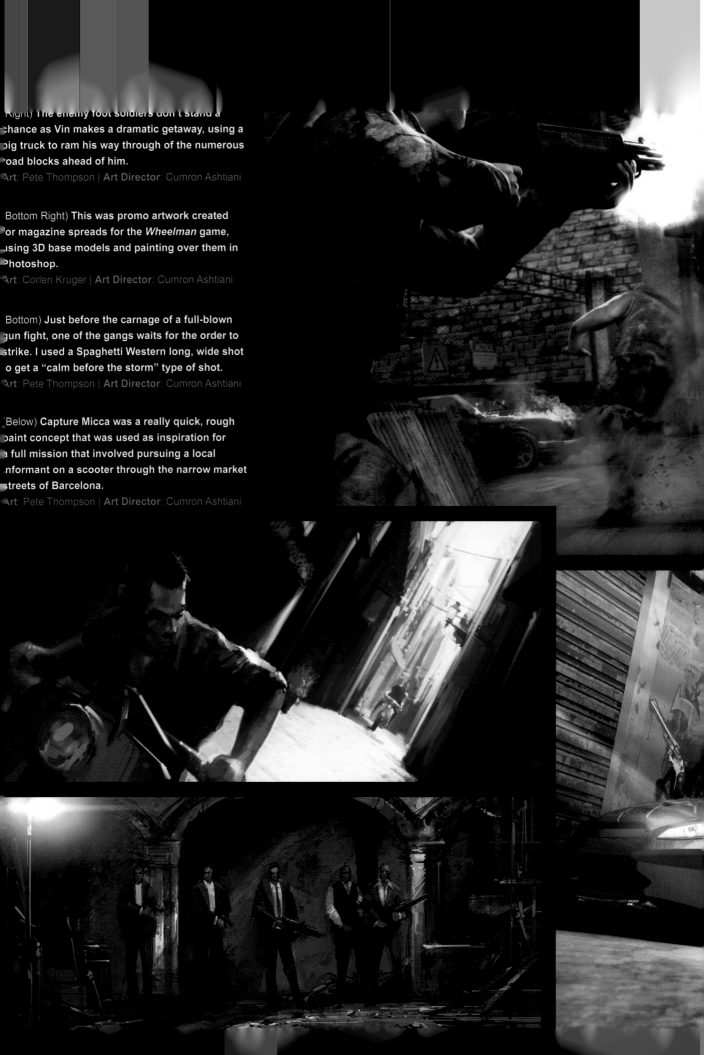

Right) The enemy foot soldiers don't stand a chance as Vin makes a dramatic getaway, using a big truck to ram his way through of the numerous road blocks ahead of him.
Art: Pete Thompson | Art Director: Cumron Ashtiani

Bottom Right) **This was promo artwork created for magazine spreads for the** *Wheelman* **game, using 3D base models and painting over them in Photoshop.**
Art: Corlen Kruger | Art Director: Cumron Ashtiani

Bottom) **Just before the carnage of a full-blown gun fight, one of the gangs waits for the order to strike. I used a Spaghetti Western long, wide shot to get a "calm before the storm" type of shot.**
Art: Pete Thompson | Art Director: Cumron Ashtiani

Below) **Capture Micca was a really quick, rough paint concept that was used as inspiration for a full mission that involved pursuing a local informant on a scooter through the narrow market streets of Barcelona.**
Art: Pete Thompson | Art Director: Cumron Ashtiani

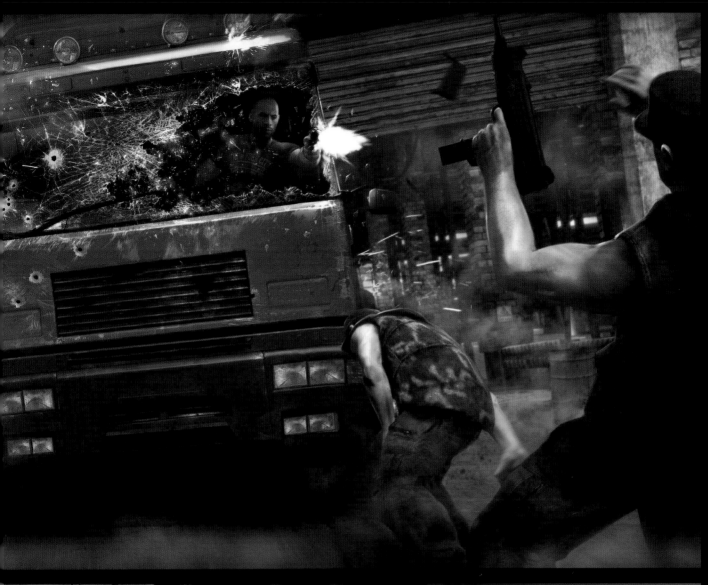

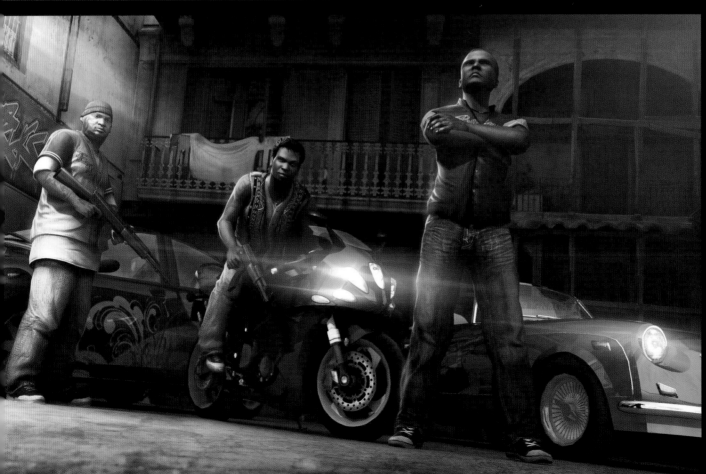

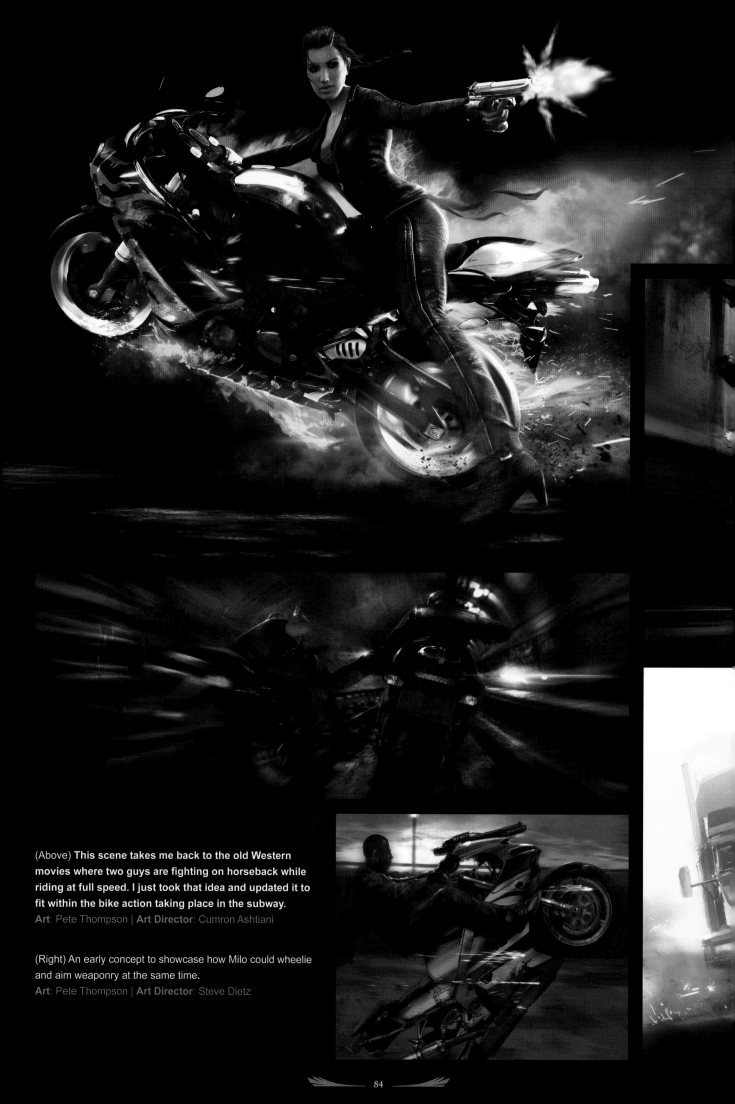

(Above) **This scene takes me back to the old Western movies where two guys are fighting on horseback while riding at full speed. I just took that idea and updated it to fit within the bike action taking place in the subway.**
Art: Pete Thompson | Art Director: Cumron Ashtiani

(Right) An early concept to showcase how Milo could wheelie and aim weaponry at the same time.
Art: Pete Thompson | Art Director: Steve Dietz

(Left) **One of the marketing images used to introduce the female interest in** *Wheelman*: **a fiery Flamenco dancer and part-time bank robber by the name of Lumi.**
Art: Pete Thompson | Art Director: Cumron Ashtiani

(Bottom) **This image started out as a loose painterly action concept, but was resurrected into a fully-blown marketing image. I tightened up the paint and added many layers of real flame and explosive effects. The whiteout on the top left was requested for logo or text space.**
Art: Pete Thompson | Art Director: Cumron Ashtiani

(Below) **The underground bike mission was one of the most complex missions ever devised in** *Wheelman*. **So a full concept was needed to convey what was going to happen during key moments of the gameplay.**
Art: Pete Thompson | Art Director: Cumron Ashtiani

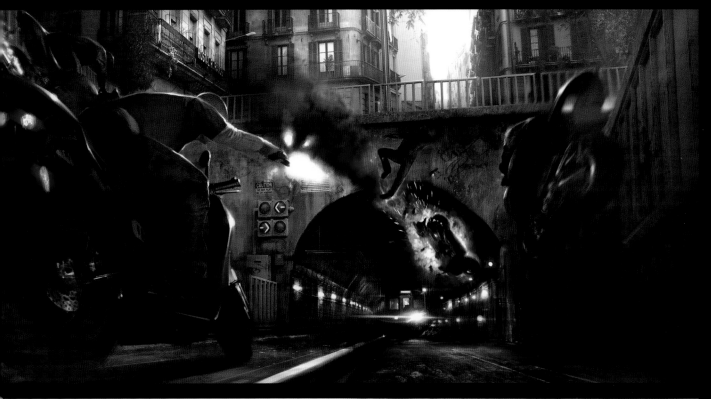

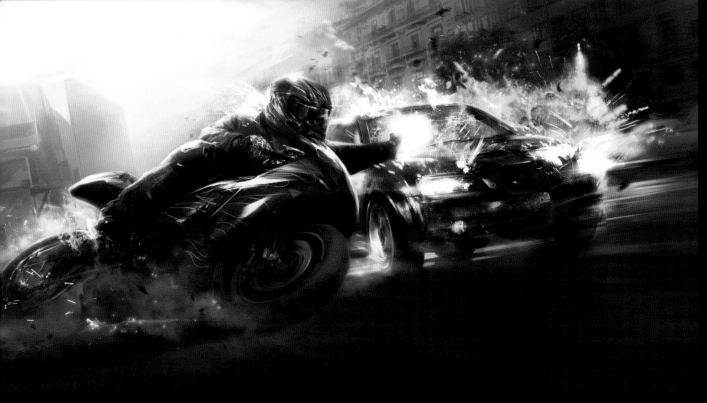

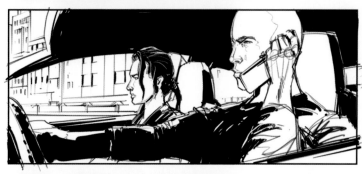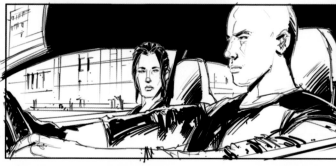
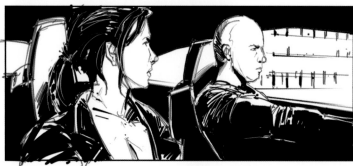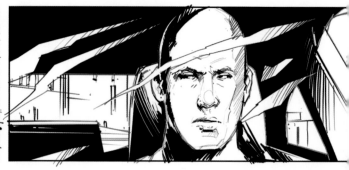
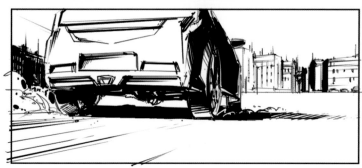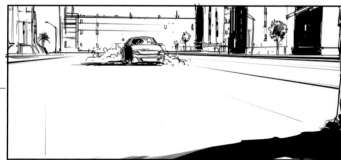
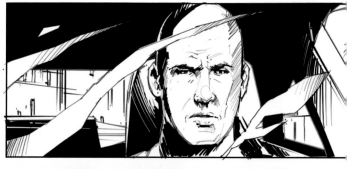
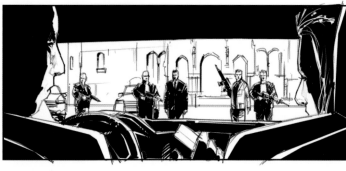

(Above) *Wheelman* **storyboards. Art**: Pete Thompson | **Art Director**: Cumron Ashtiani

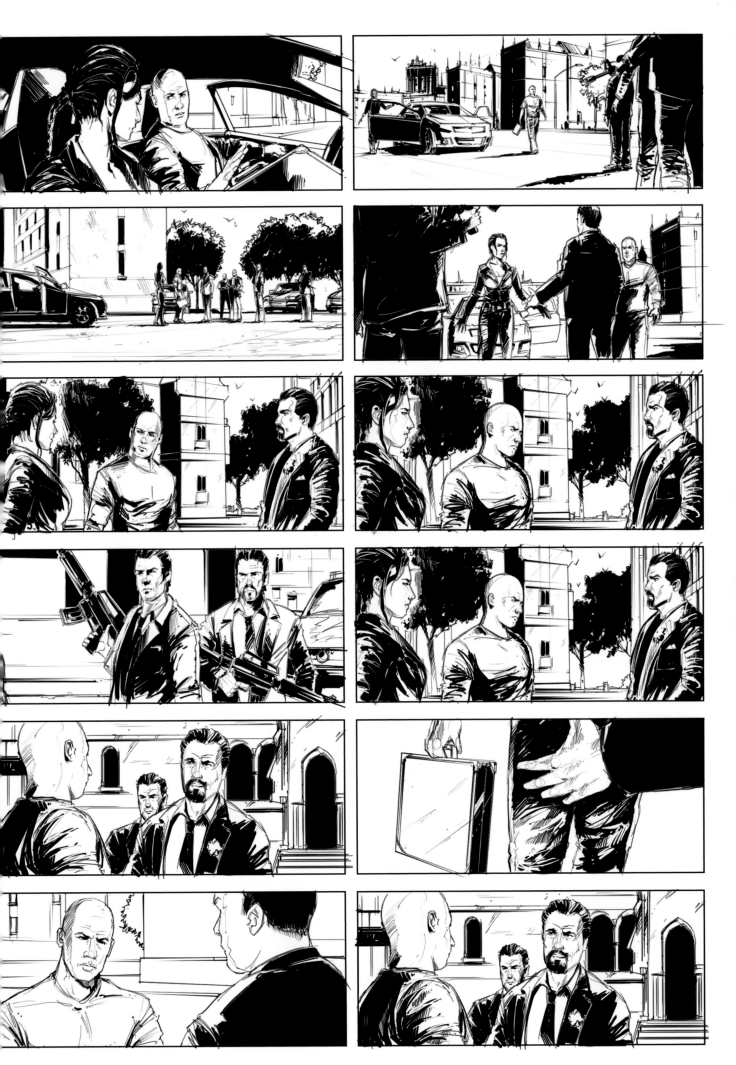

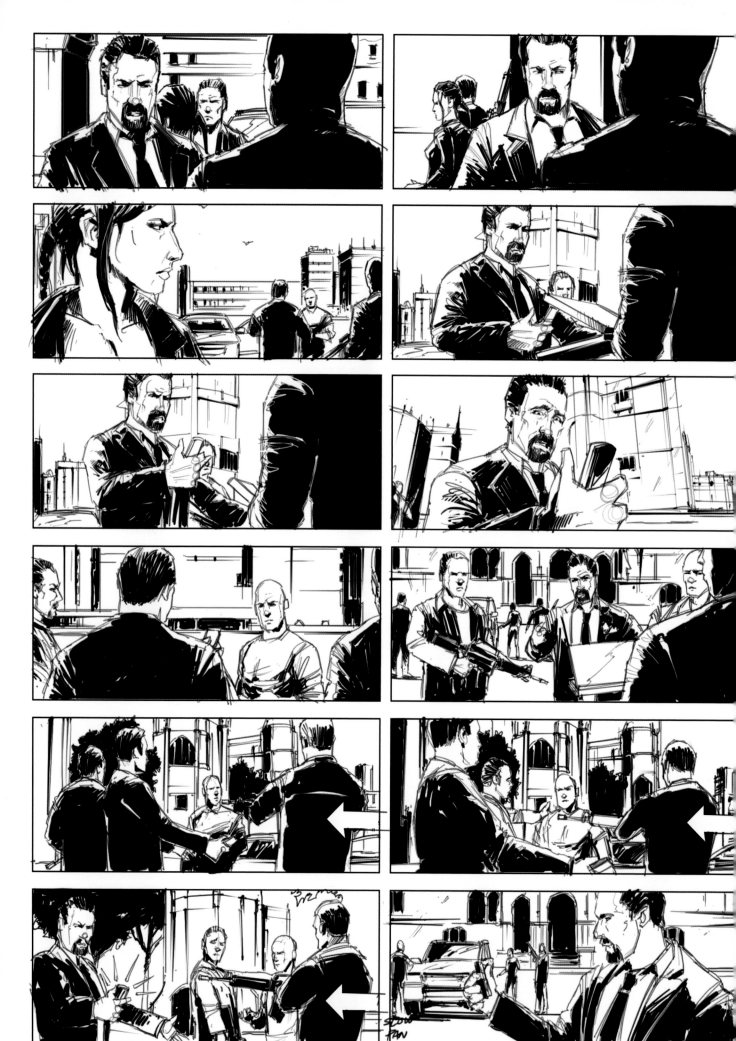

(Above) *Wheelman* storyboards. **Art**: Pete Thompson | **Art Director**: Cumron Ashtiani

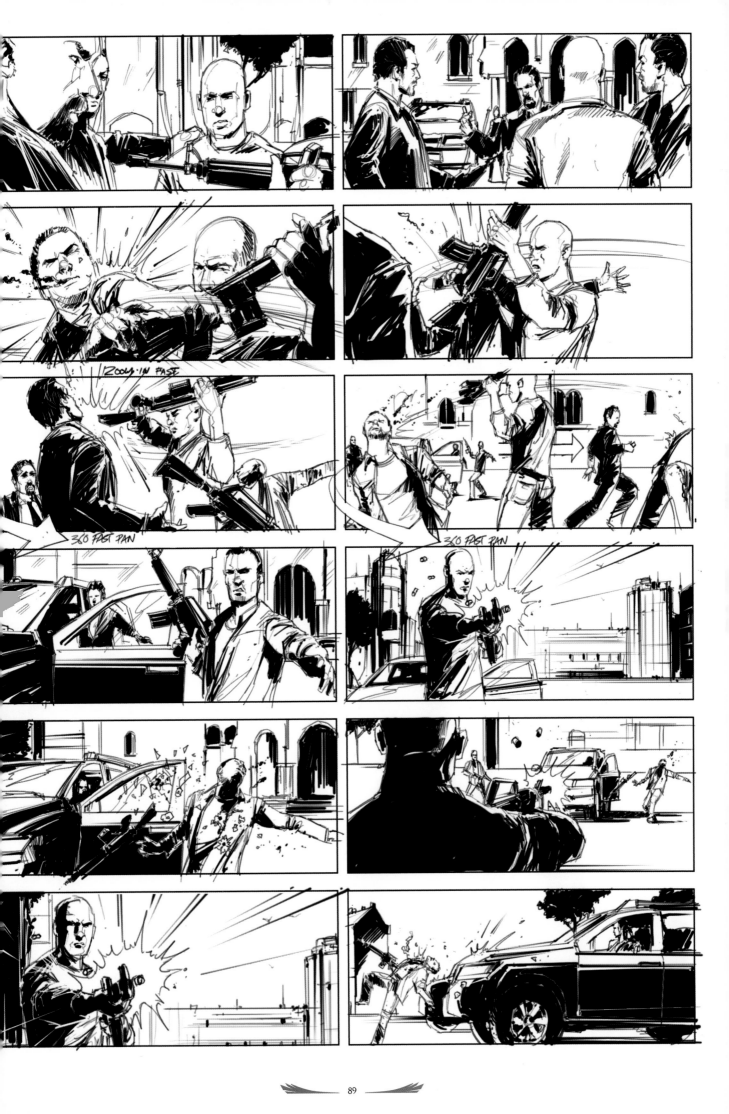

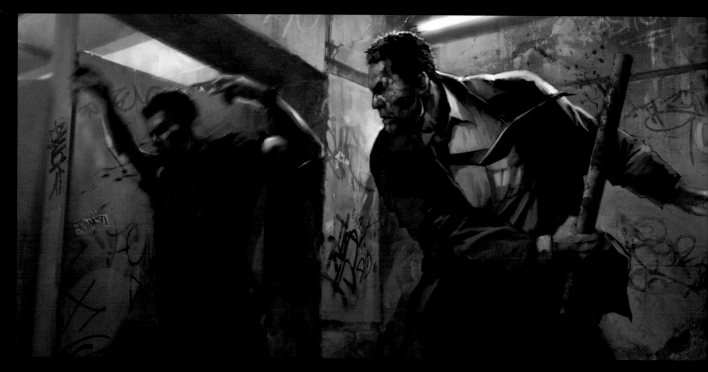

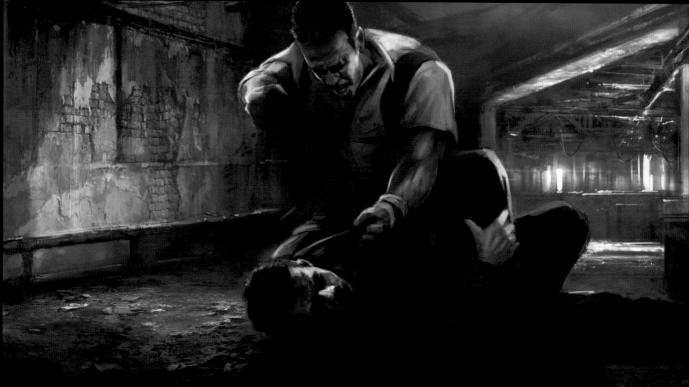

(Above and Top) **A concept showing the brawling element and a little bit of interrogation from *Necessary Force.***
Art: Pete Thompson | Art Director: Cumron Ashtiani

(Left) **Early mood paint from *Necessary Force.* We wanted to capture the "do whatever it takes" nature of the main player character (The Detective). At this stage we wondered if he would dislike being so brutal, but then decided that he would be more empowering for the player if he was emotionally as hard as nails.**
Art: Pete Thompson | Art Director: Cumron Ashtiani

(Right) **Box art mockup for *Necessary Force.***
Art: Pete Thompson | Art Director: Cumron Ashtiani

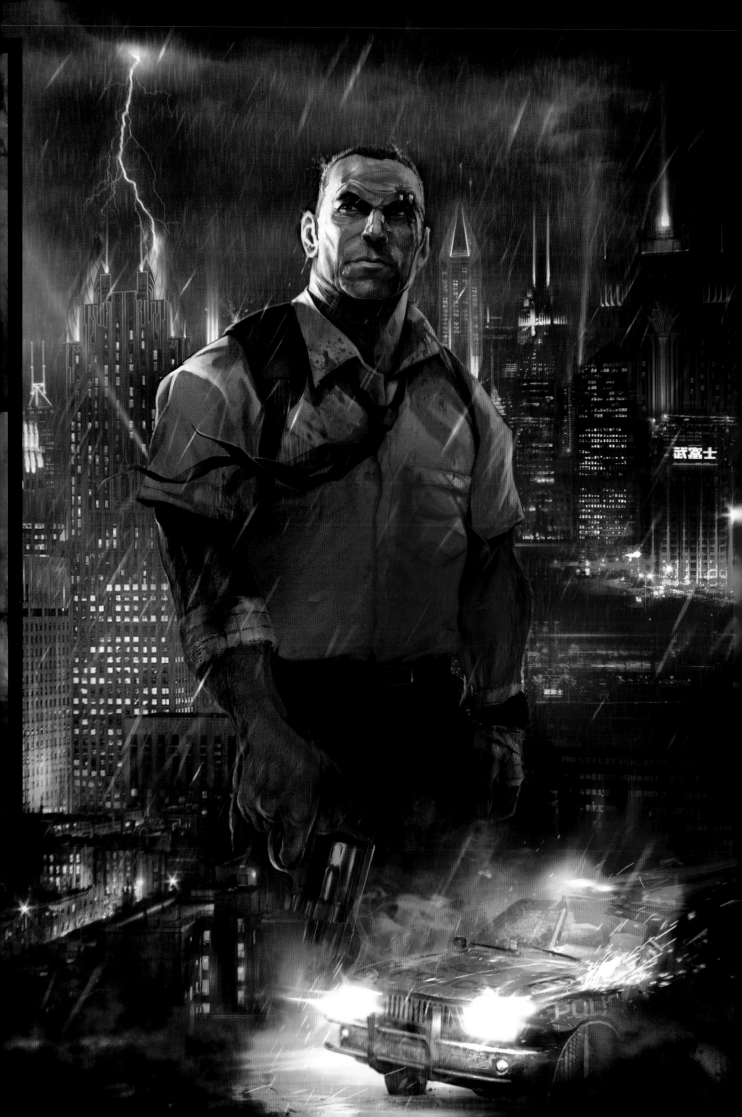

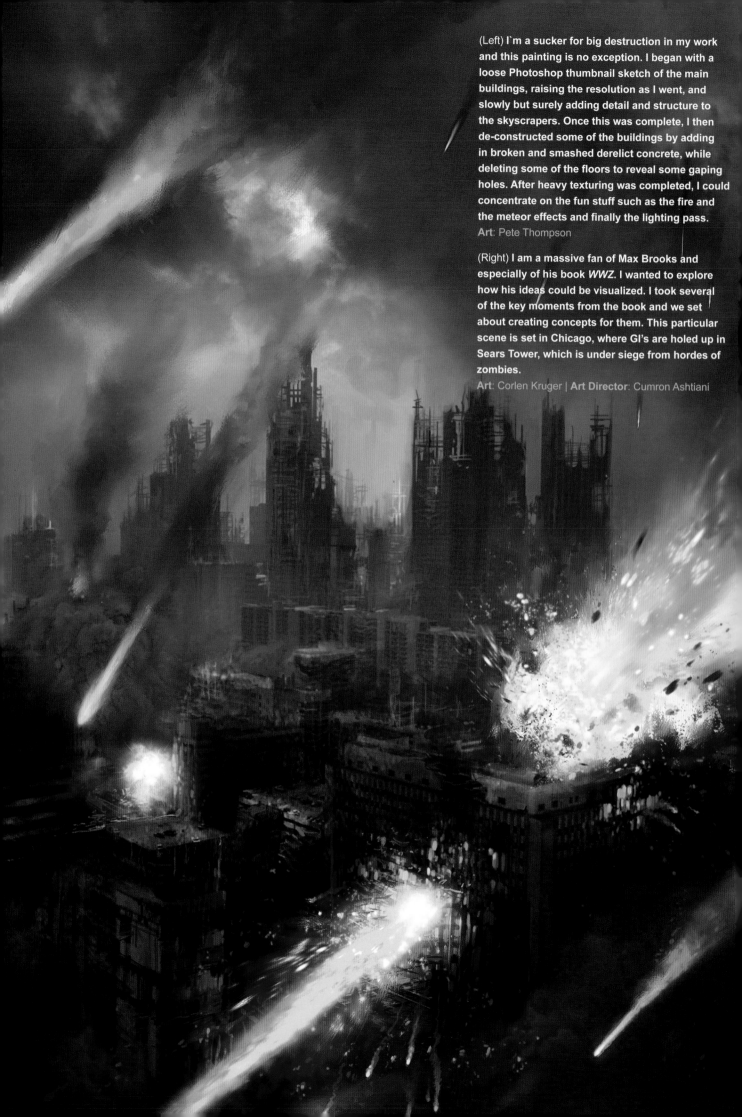

(Left) I`m a sucker for big destruction in my work and this painting is no exception. I began with a loose Photoshop thumbnail sketch of the main buildings, raising the resolution as I went, and slowly but surely adding detail and structure to the skyscrapers. Once this was complete, I then de-constructed some of the buildings by adding in broken and smashed derelict concrete, while deleting some of the floors to reveal some gaping holes. After heavy texturing was completed, I could concentrate on the fun stuff such as the fire and the meteor effects and finally the lighting pass.
Art: Pete Thompson

(Right) I am a massive fan of Max Brooks and especially of his book *WWZ*. I wanted to explore how his ideas could be visualized. I took several of the key moments from the book and we set about creating concepts for them. This particular scene is set in Chicago, where GI's are holed up in Sears Tower, which is under siege from hordes of zombies.
Art: Corlen Kruger | Art Director: Cumron Ashtiani

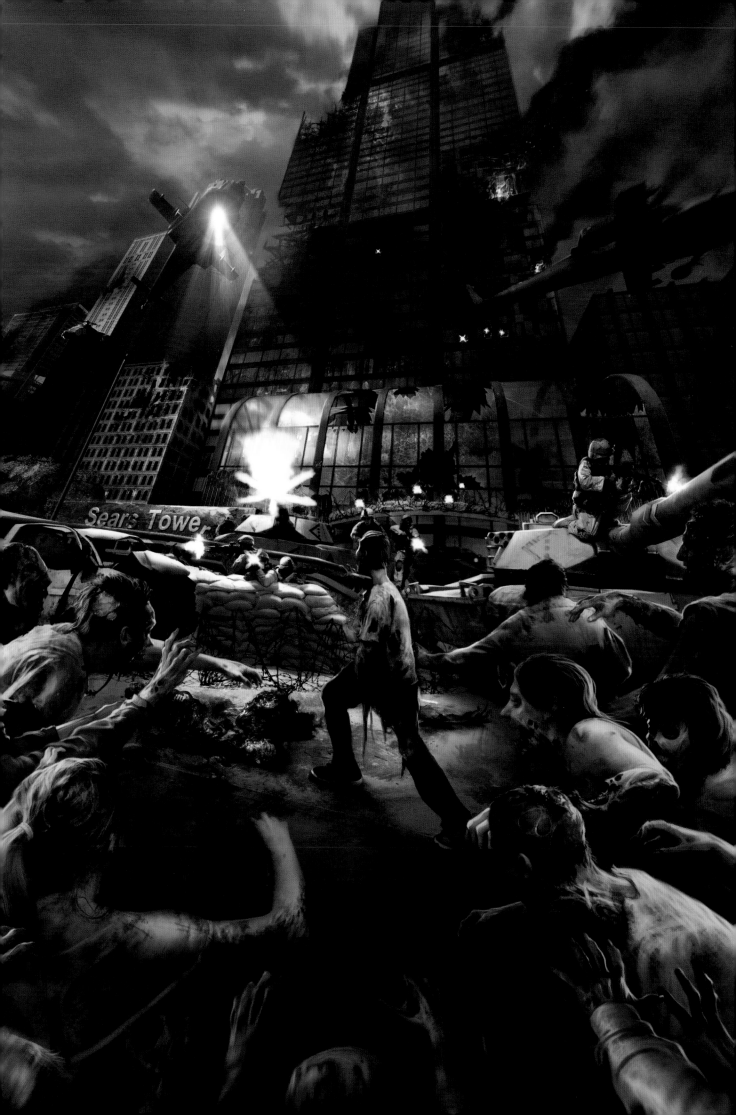

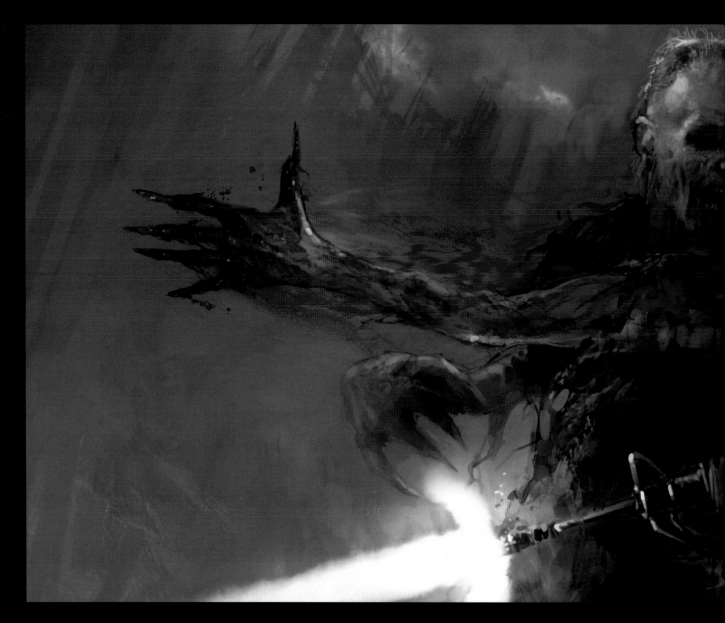

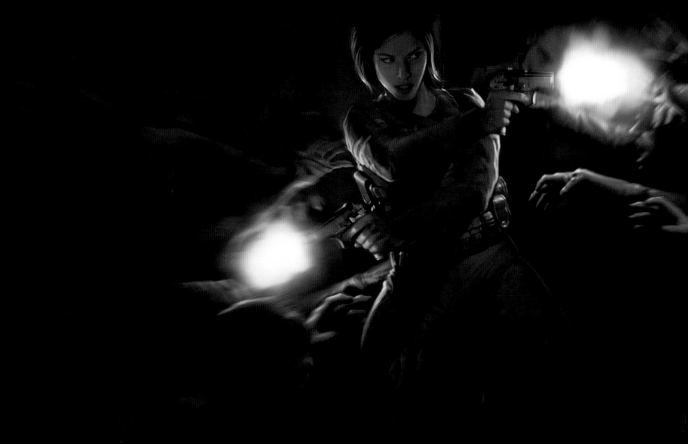

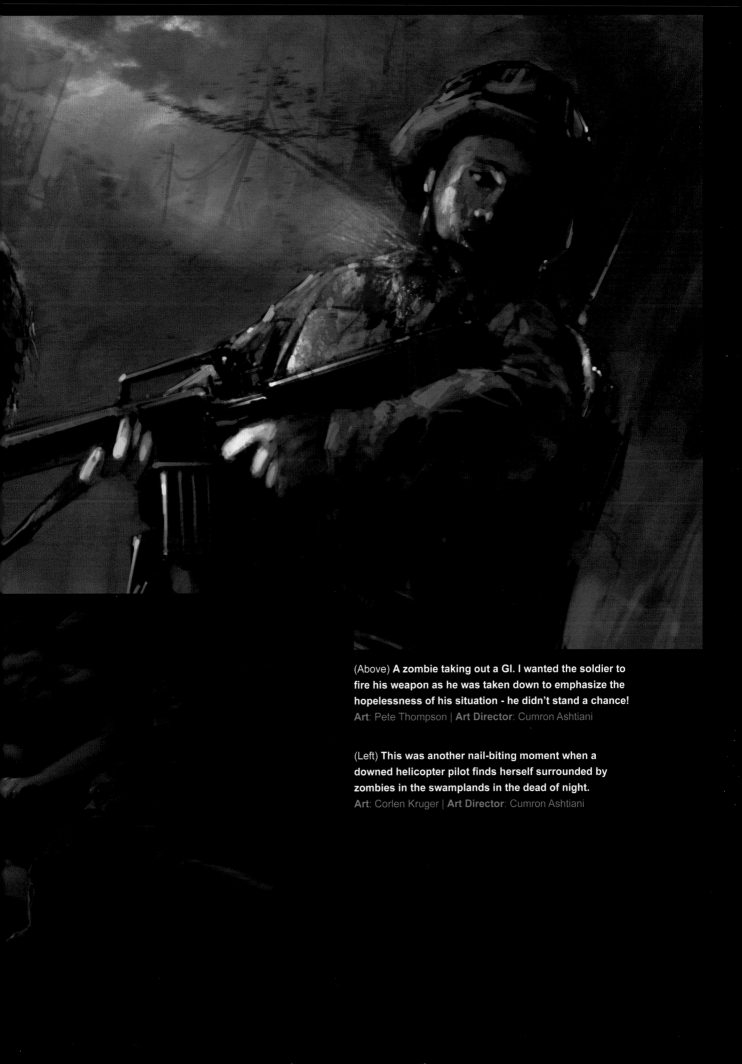

(Above) **A zombie taking out a GI. I wanted the soldier to fire his weapon as he was taken down to emphasize the hopelessness of his situation - he didn't stand a chance!**
Art: Pete Thompson | **Art Director**: Cumron Ashtiani

(Left) **This was another nail-biting moment when a downed helicopter pilot finds herself surrounded by zombies in the swamplands in the dead of night.**
Art: Corlen Kruger | **Art Director**: Cumron Ashtiani

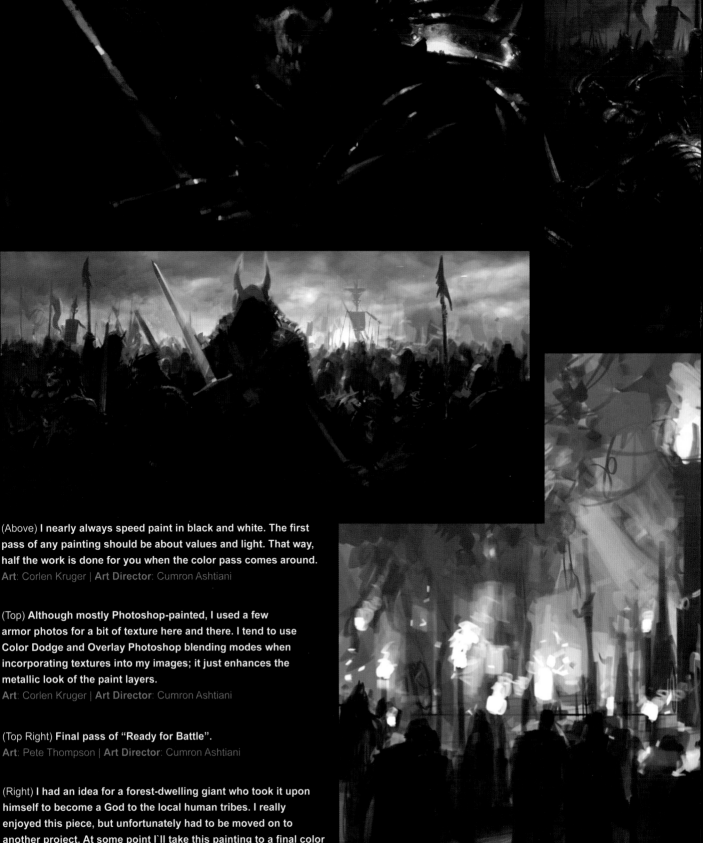

(Above) **I nearly always speed paint in black and white. The first pass of any painting should be about values and light. That way, half the work is done for you when the color pass comes around.**
Art: Corlen Kruger | Art Director: Cumron Ashtiani

(Top) **Although mostly Photoshop-painted, I used a few armor photos for a bit of texture here and there. I tend to use Color Dodge and Overlay Photoshop blending modes when incorporating textures into my images; it just enhances the metallic look of the paint layers.**
Art: Corlen Kruger | Art Director: Cumron Ashtiani

(Top Right) **Final pass of "Ready for Battle".**
Art: Pete Thompson | Art Director: Cumron Ashtiani

(Right) **I had an idea for a forest-dwelling giant who took it upon himself to become a God to the local human tribes. I really enjoyed this piece, but unfortunately had to be moved on to another project. At some point I`ll take this painting to a final color**

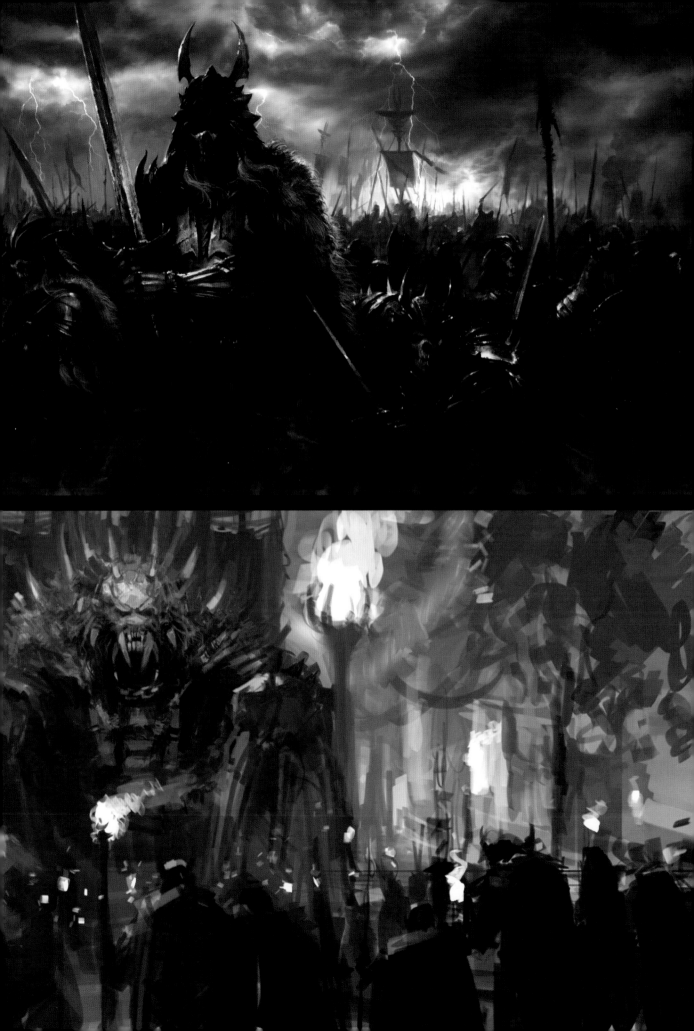

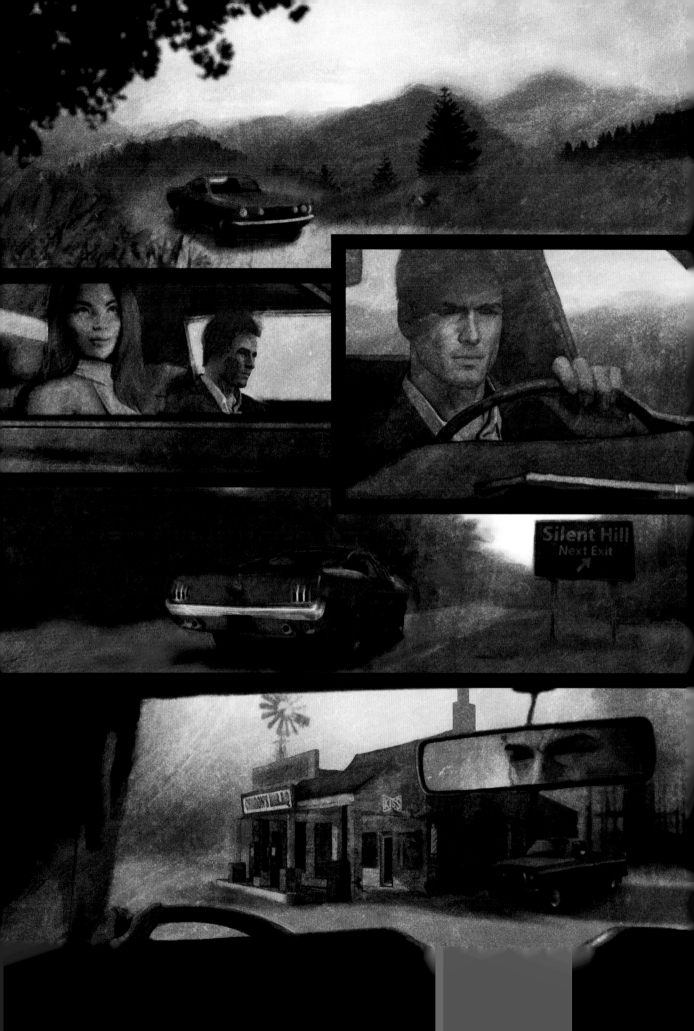

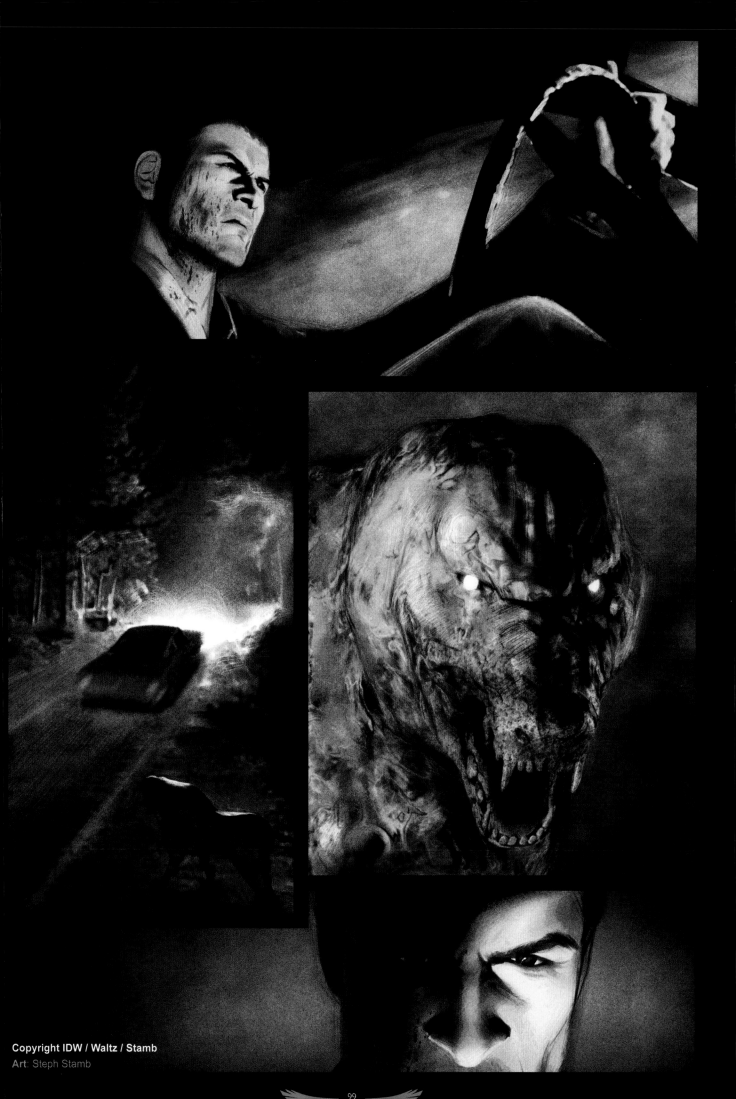

Art: Steph Stamb

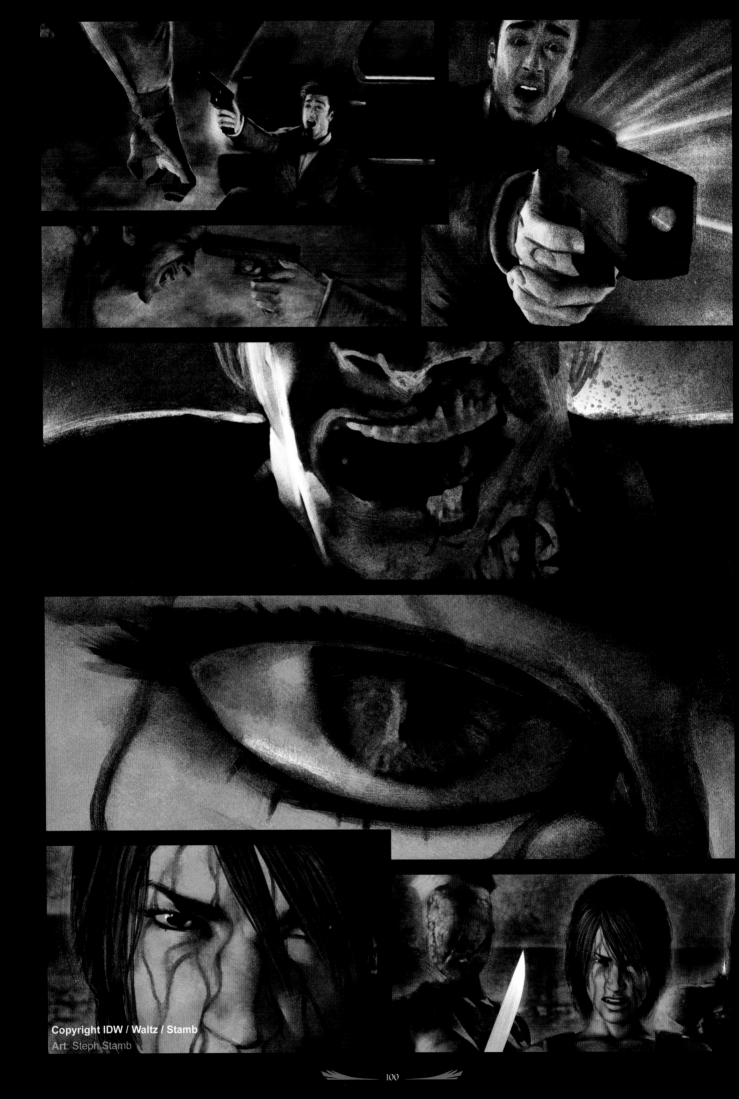

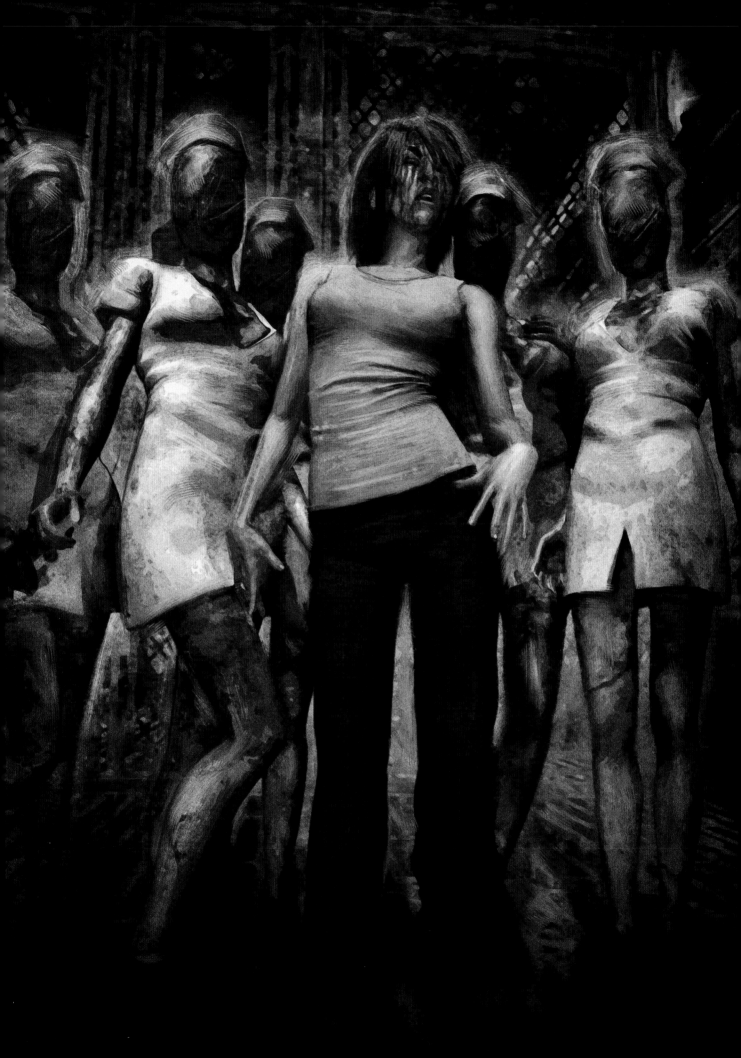

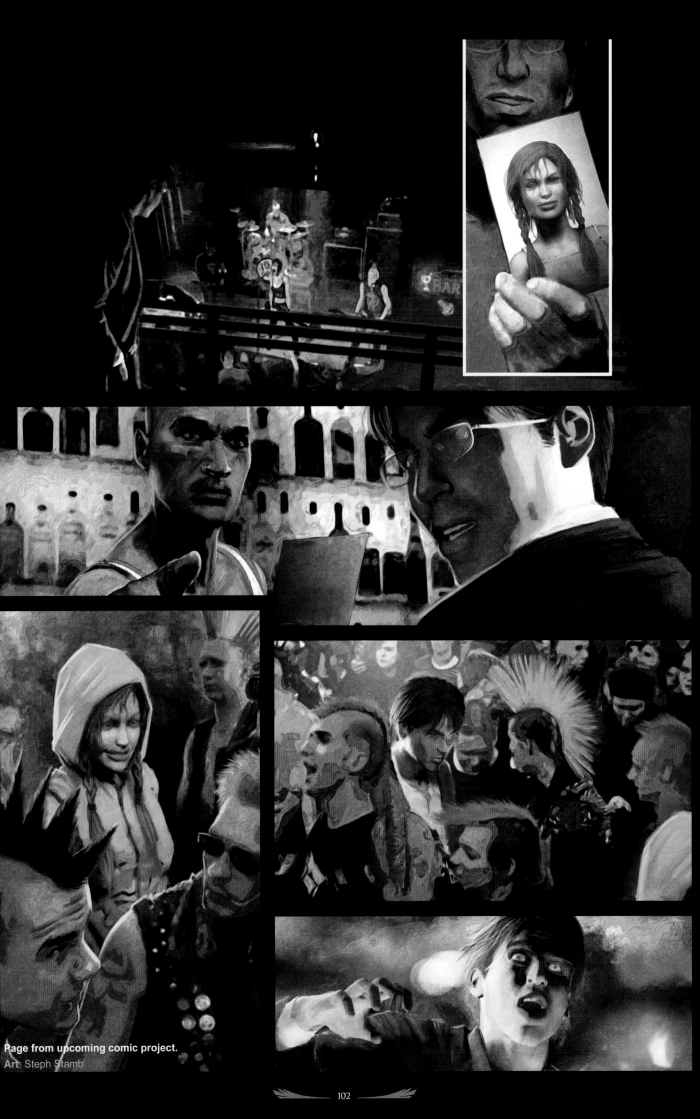

Page from upcoming comic project.
Art: Steph Stamb

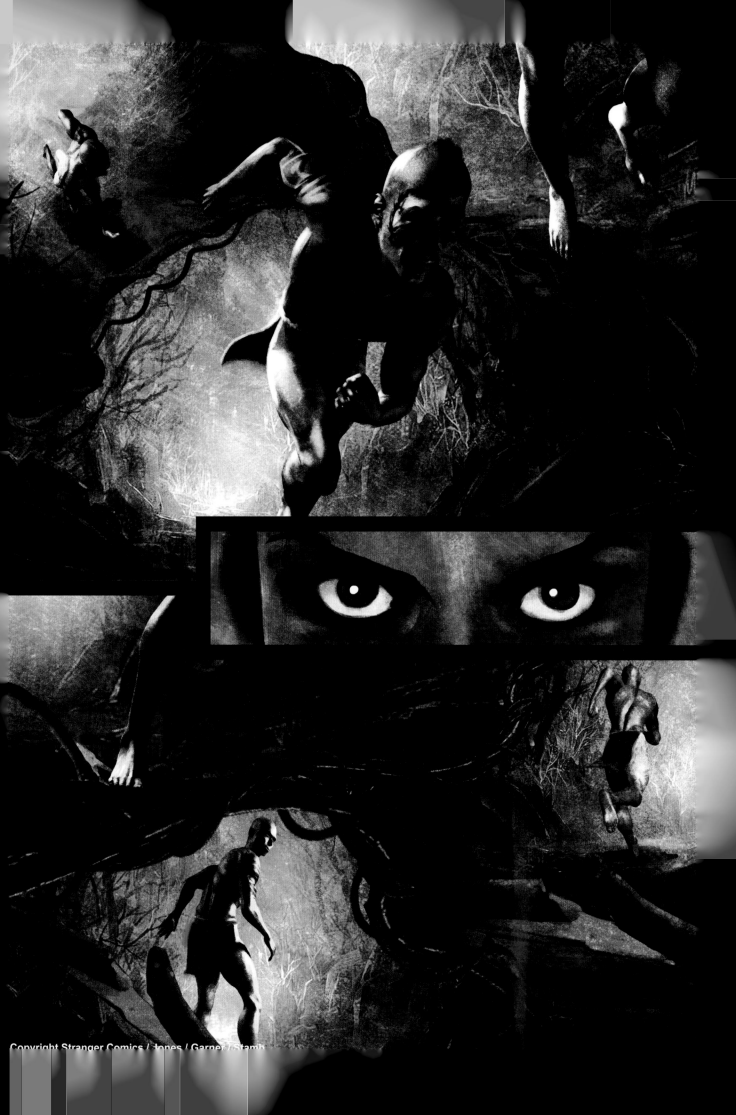

ENVIRONMENT
CONCEPTS

The environment sets the tone, mood and the background story, and also gives an indication of what is to come - it is often the thread that ties all the various design components together. Creatively, environments need to be rich and detailed, telling the viewer about the world's history and inhabitants as well as conveying the intended atmosphere.

Technically, we often work with 3D modelers and set builders, and so understand what they require in order to build the worlds we create. We classify images in several ways: a mood shot, matte painting, architectural study or a design schematic, depending on the purpose.

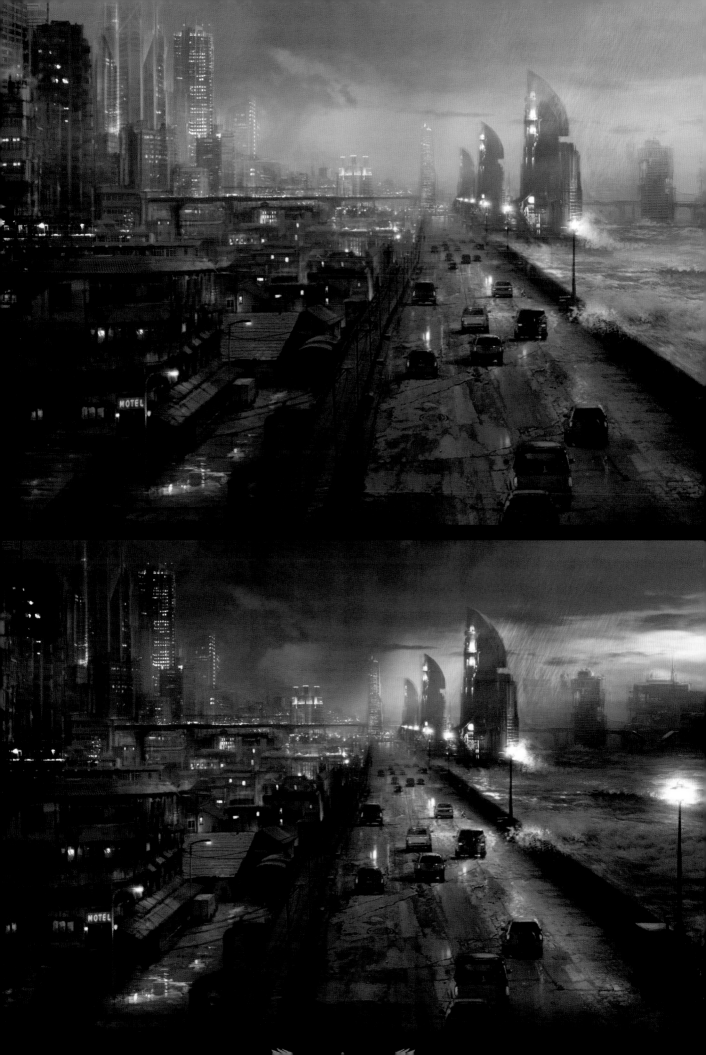

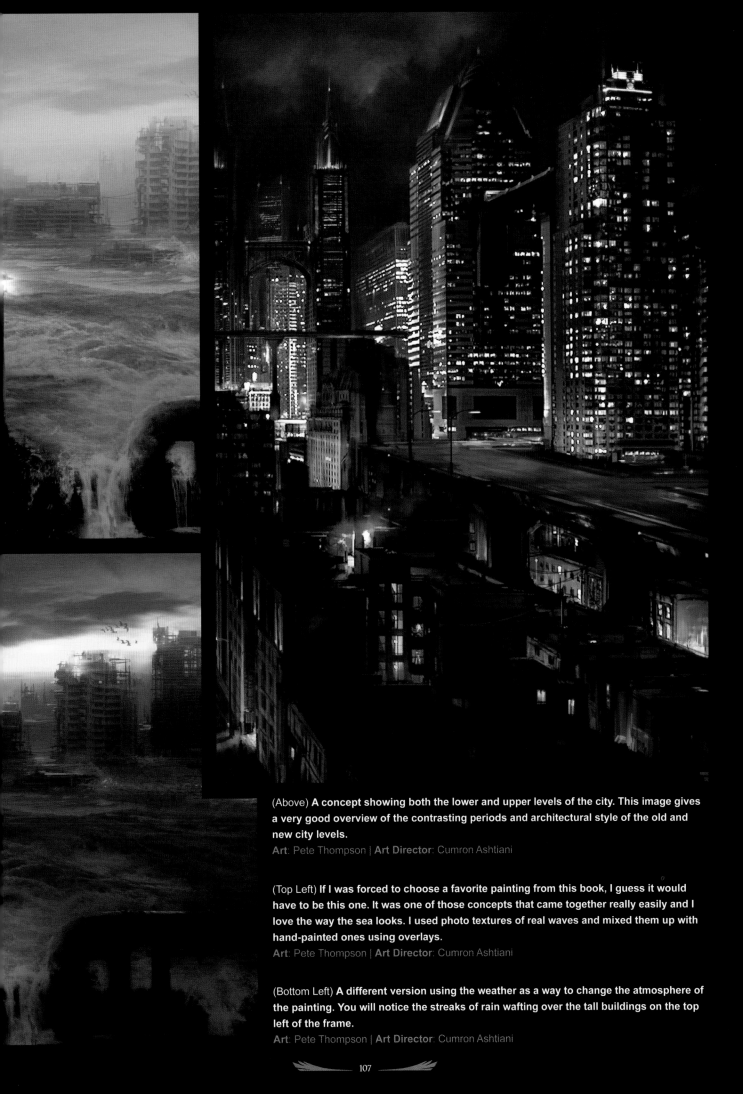

(Above) **A concept showing both the lower and upper levels of the city. This image gives a very good overview of the contrasting periods and architectural style of the old and new city levels.**
Art: Pete Thompson | Art Director: Cumron Ashtiani

(Top Left) **If I was forced to choose a favorite painting from this book, I guess it would have to be this one. It was one of those concepts that came together really easily and I love the way the sea looks. I used photo textures of real waves and mixed them up with hand-painted ones using overlays.**
Art: Pete Thompson | Art Director: Cumron Ashtiani

(Bottom Left) **A different version using the weather as a way to change the atmosphere of the painting. You will notice the streaks of rain wafting over the tall buildings on the top left of the frame.**
Art: Pete Thompson | Art Director: Cumron Ashtiani

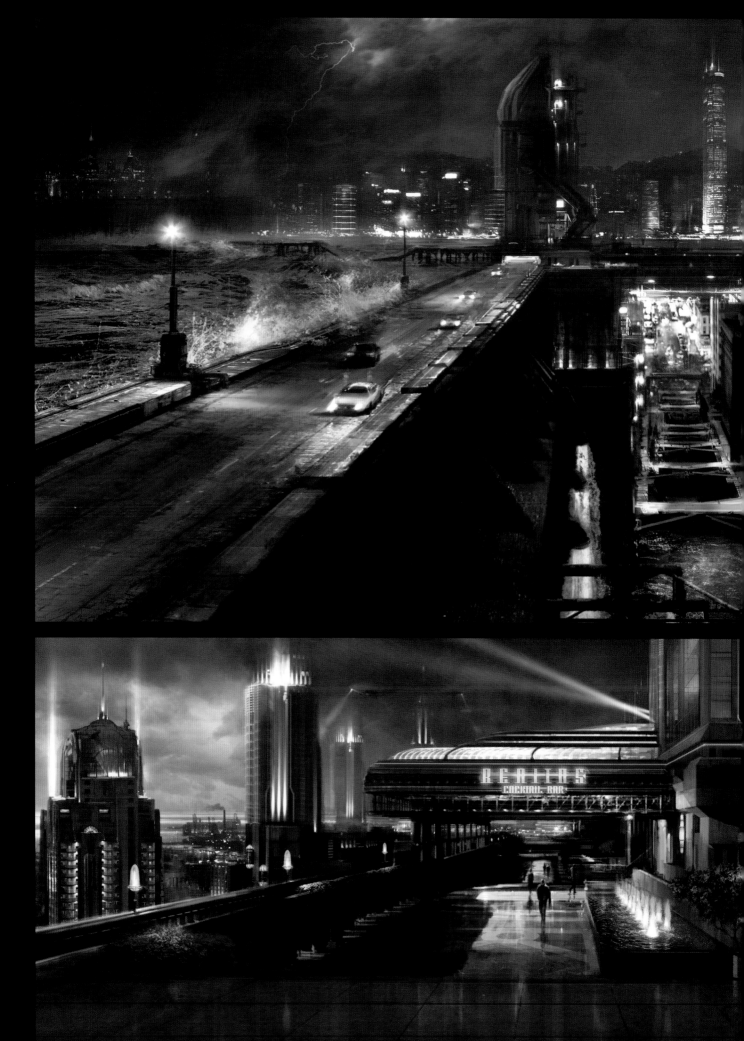

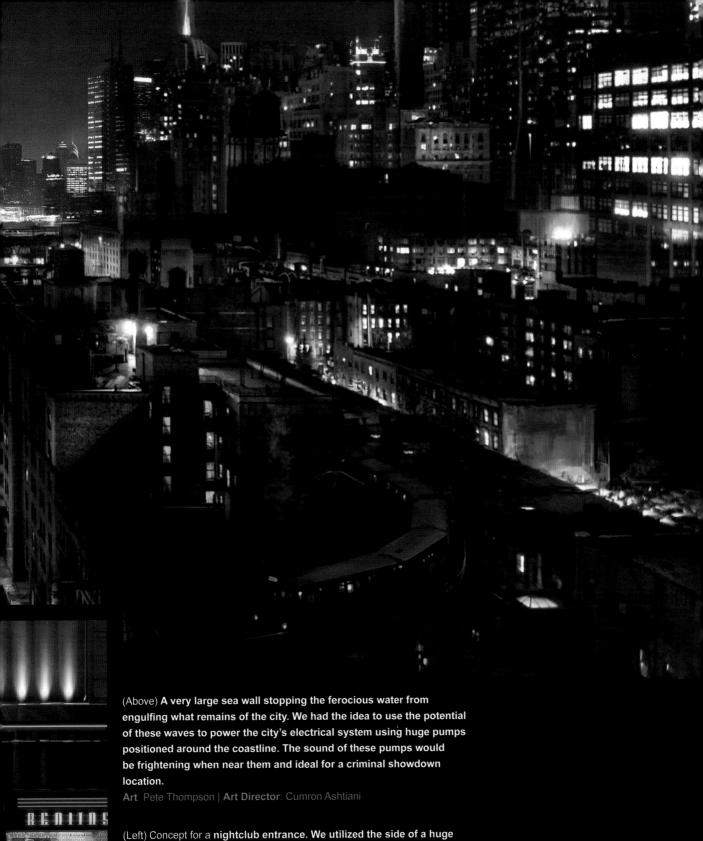

(Above) **A very large sea wall stopping the ferocious water from engulfing what remains of the city. We had the idea to use the potential of these waves to power the city's electrical system using huge pumps positioned around the coastline. The sound of these pumps would be frightening when near them and ideal for a criminal showdown location.**
Art: Pete Thompson | **Art Director**: Cumron Ashtiani

(Left) Concept for a **nightclub entrance. We utilized the side of a huge skyscraper so you can get a sense of the city beyond the Art Deco-themed entrance.**
Art: Pete Thompson | **Art Director**: Cumron Ashtiani

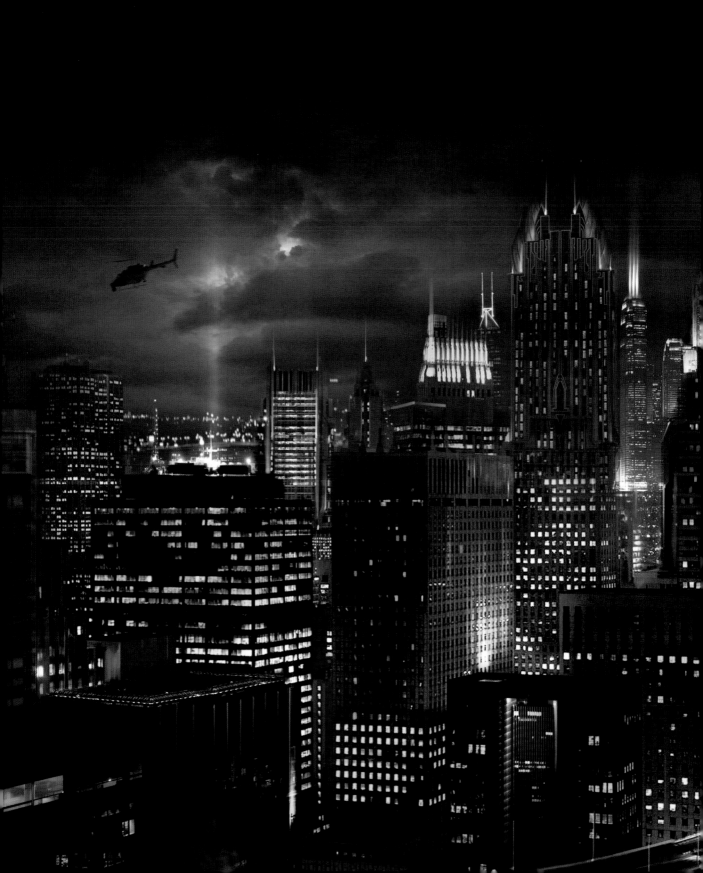

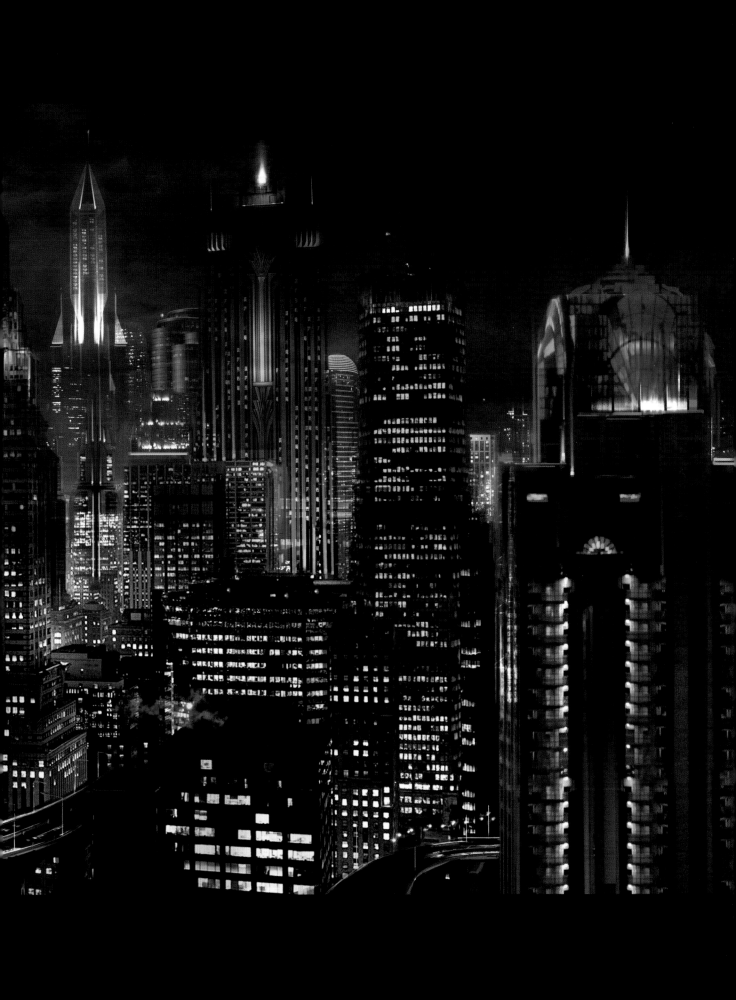

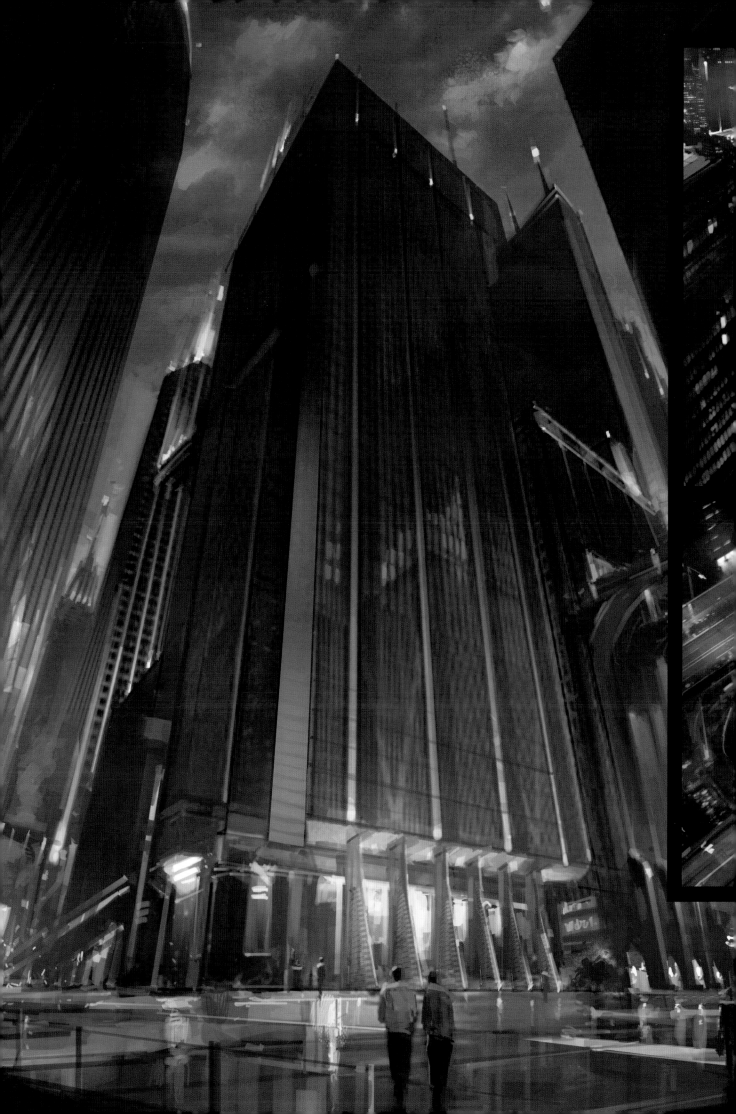

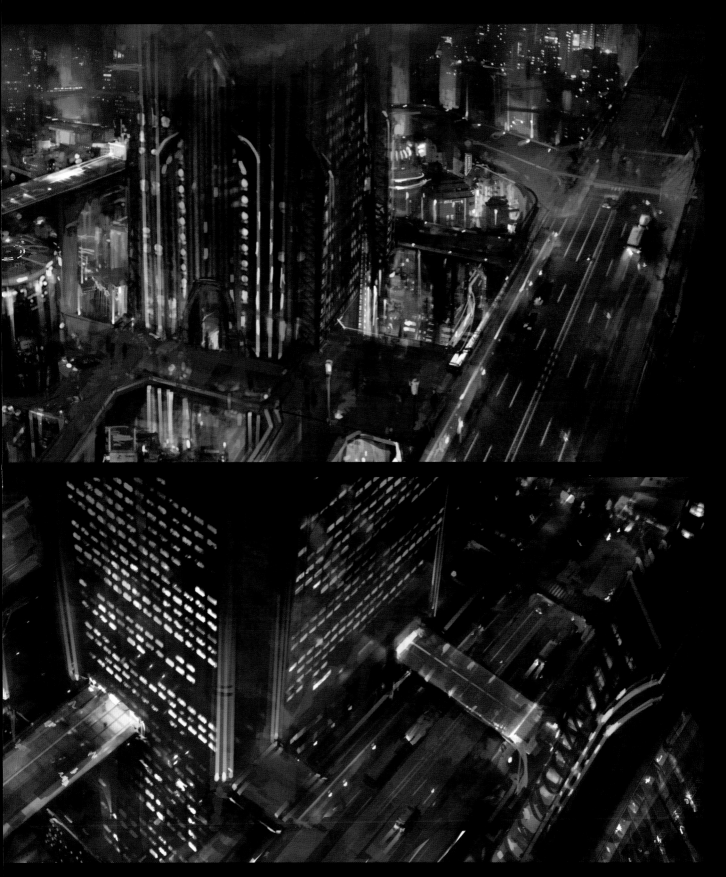

(Left, Top and Above) **Black and white Photoshop speed paints of the upper level skyscrapers.**

Art: Pete Thompson | **Art Director**: Cumron Ashtiani

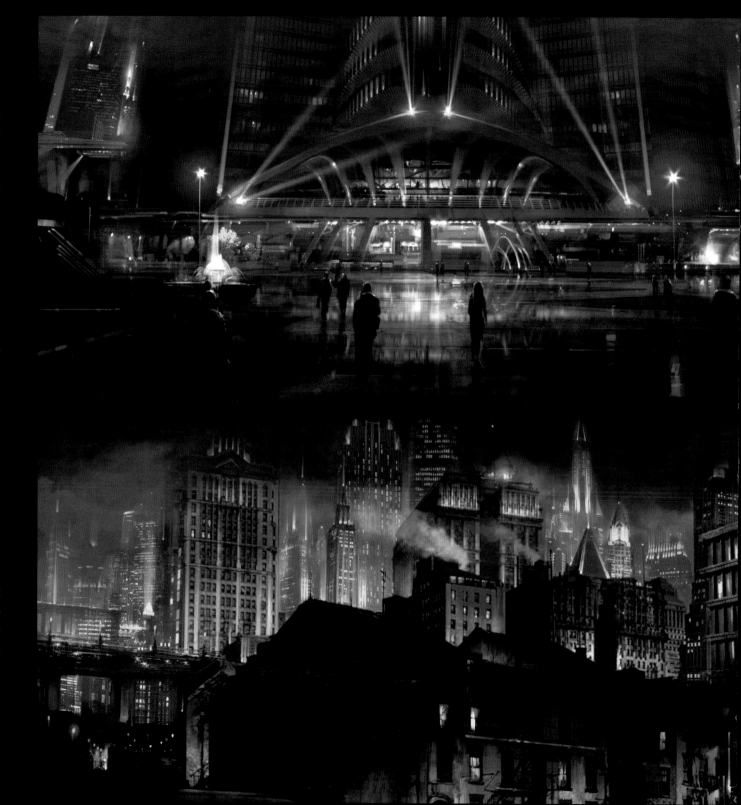

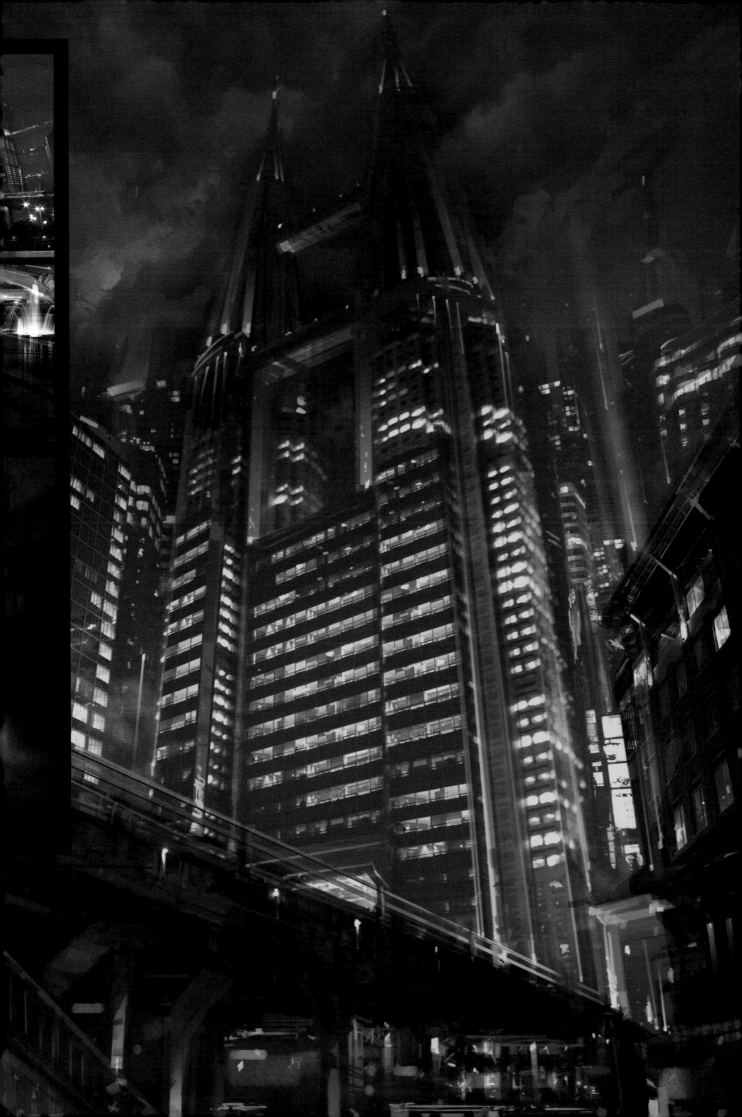

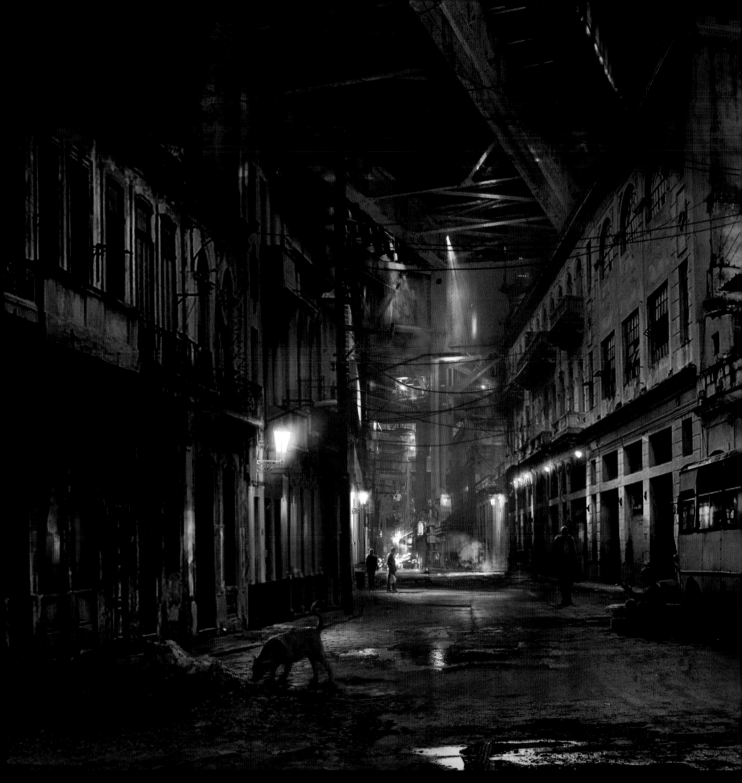

(Above) **Here`s a perfect example of mixing styles in order to come up with a fresh outlook on a concept. The lower buildings are based on the slum streets of Latin America and towering above we have the huge supporting cast iron bridges that hold up the elegant skyscrapers. A burned out bus is used as a rent-free dwelling for a local inhabitant.**

Art: Pete Thompson | **Art Director**: Cumron Ashtiani

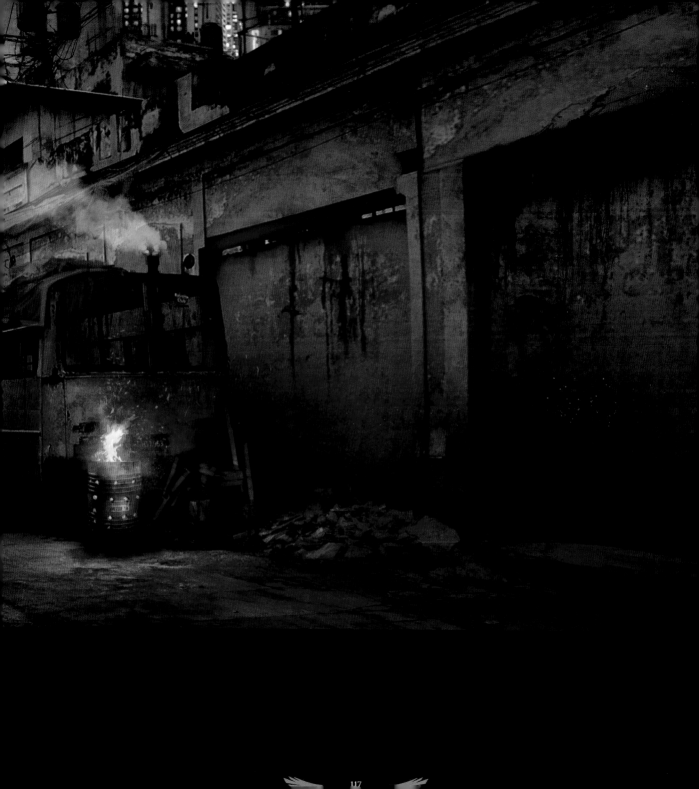

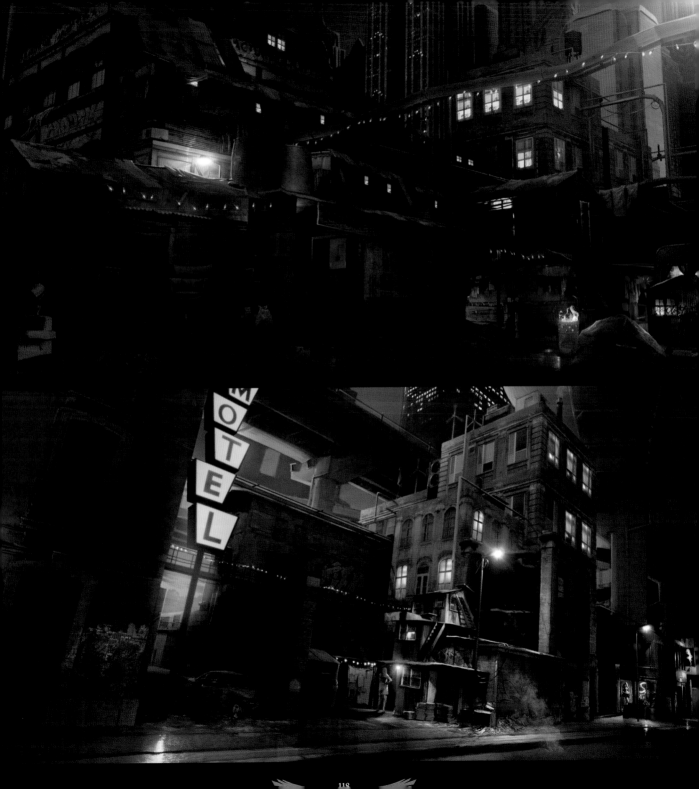

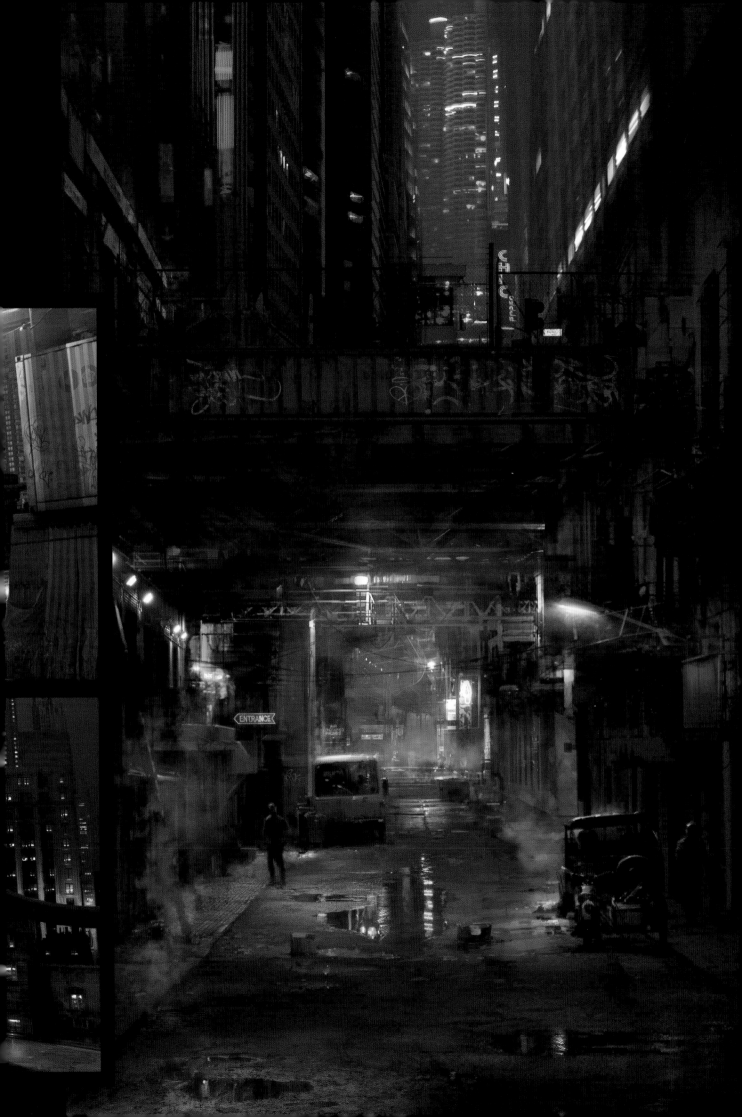

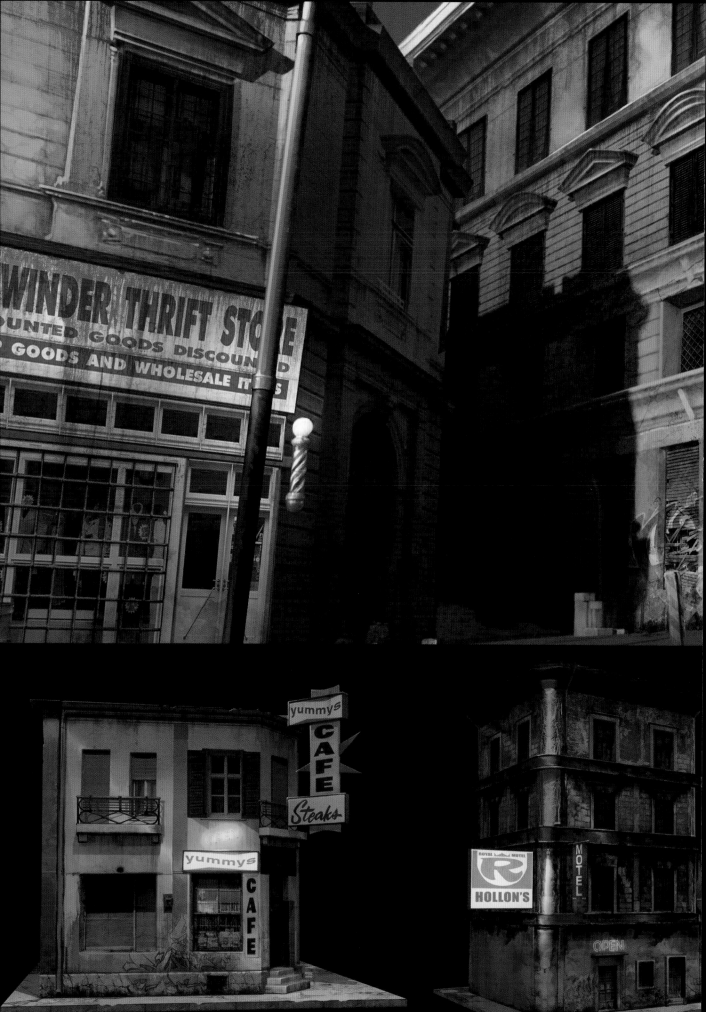

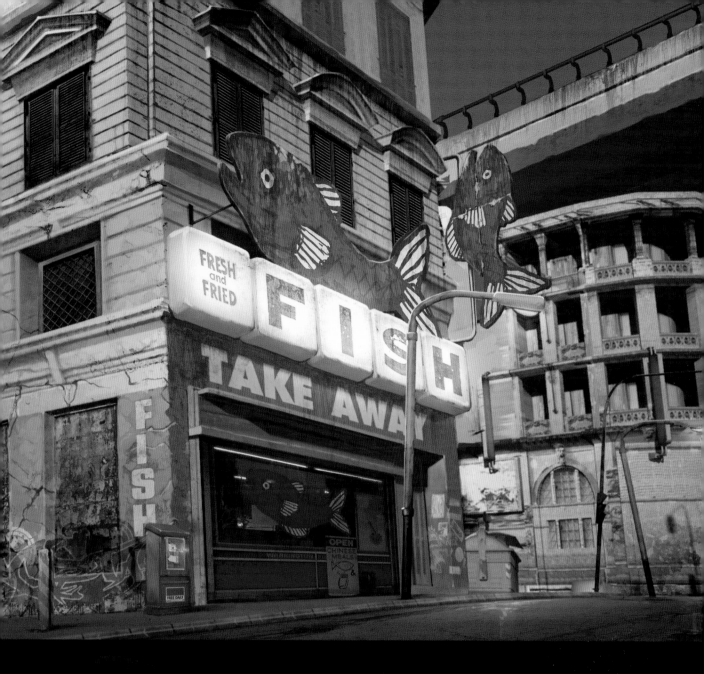

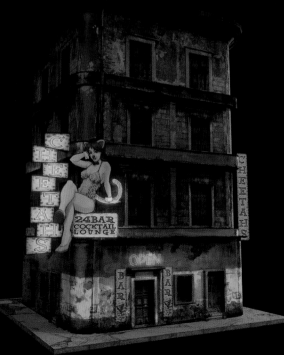

(Above) **Shop front concepts to help create the world of** *Necessary Force*; **exploring different types of texture treatment, shops and shop signs to help create a more immersive world.**
Art: Corlen Kruger | **Art Director**: Cumron Ashtiani

(Left) **Signage is a very important part of creating believable game worlds and is often overlooked. By creating virtual brands that reflect the mood of the game world, we get an insight into the fictional society that lives within it. This was very much evident in the** *Robocop* **films where ads were used to give the viewer an idea of the status of society.**
Art: Corlen Kruger | **Art Director**: Cumron Ashtiani

(Far Left) **Concept showing how signage can be placed on buildings. Sometimes the same building can be re-dressed in several ways by either changing its color and/or purpose; for example: from a shop to a small hotel.**
Art: Corlen Kruger | **Art Director**: Cumron Ashtiani

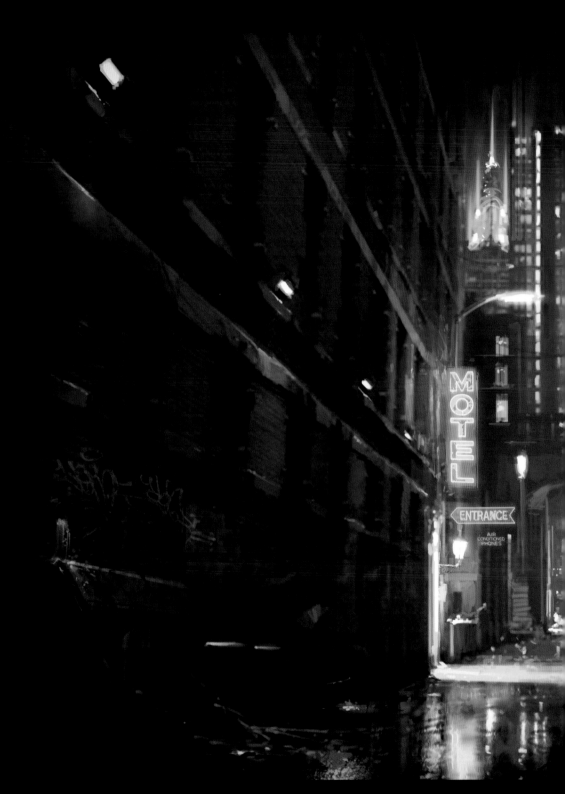

(Above) **An early concept showing how the streets of the old city below contrast with the towering new world built above them. We specifically wanted to capture the Noir film style with steam coming from the ground and strong contrasting light and shadow, but also bring in color as seen in Neo Noir films like *Blade Runner*.**

Art: Pete Thompson | **Art Director**: Cumron Ashtiani

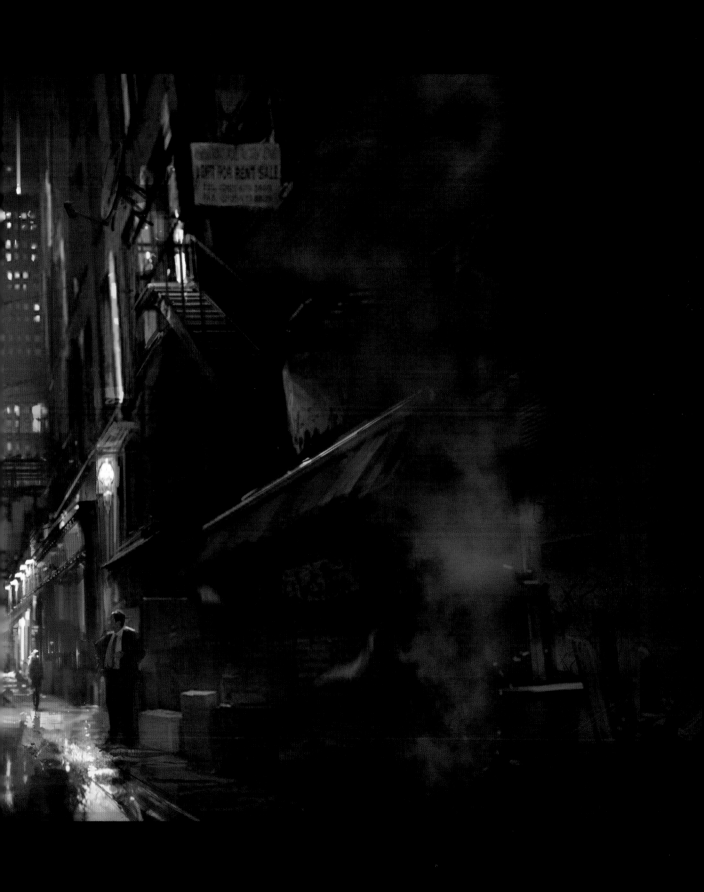

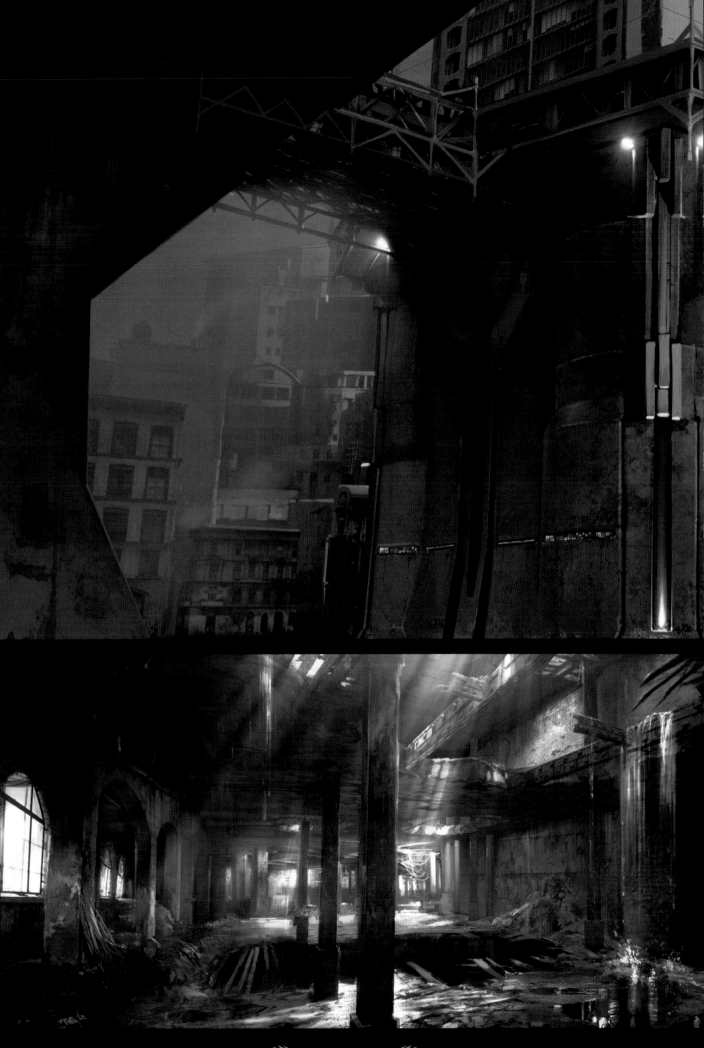

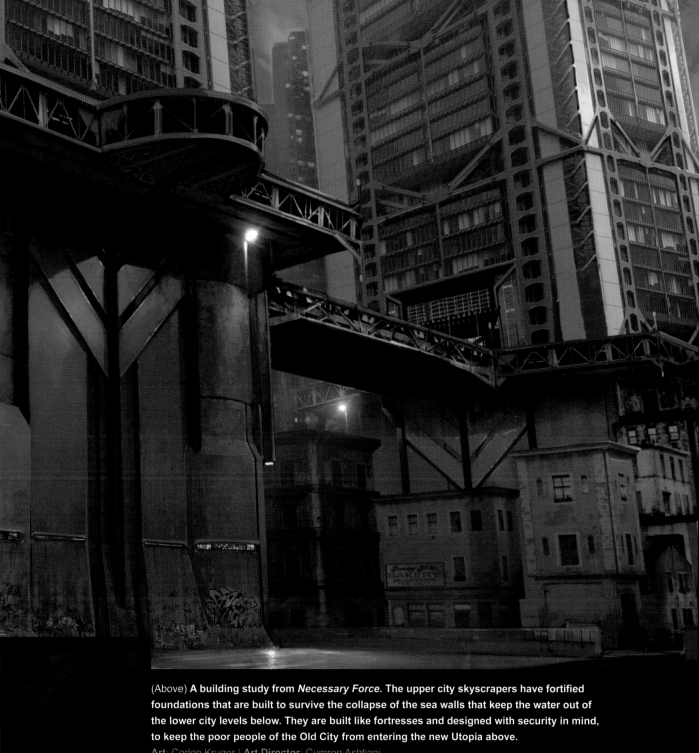

(Above) **A building study from** *Necessary Force*. **The upper city skyscrapers have fortified foundations that are built to survive the collapse of the sea walls that keep the water out of the lower city levels below. They are built like fortresses and designed with security in mind, to keep the poor people of the Old City from entering the new Utopia above.**
Art: Corlen Kruger | **Art Director**: Cumron Ashtiani

(Left) **A large portion of the lower city levels (the Old City) in** *Necessary Force* **are under the water line due to rising sea levels, and despite the construction of giant sea walls to keep the water out, the lower levels suffer from extreme damp and water damage. I wanted to create an environment that has contrasting worlds; a decaying old city that was once full of old world grandeur (based on 19th century stylizing), and a new city above it inspired by the boom of American construction in the 1920's and 40's (modern Art Deco) with a Noir period theme.**

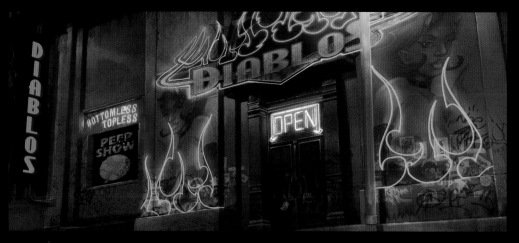

(Above) **Diablos Club concept showing off its elaborate entrance.**
Art: Pete Thompson | **Art Director**: Cumron Ashtiani

(Right) **Lower tier flea market. This concept was to explore different ways to create visual interest in the city and also give designers ideas for on-foot chase scenes.**
Art: Corlen Kruger | **Art Director**: Cumron Ashtiani

(Below) **Another concept of the lower levels complete with lowlifes, drug dealers, and a cop sent to clean the streets of scum.**
Art: Pete Thompson | **Art Director**: Cumron Ashtiani

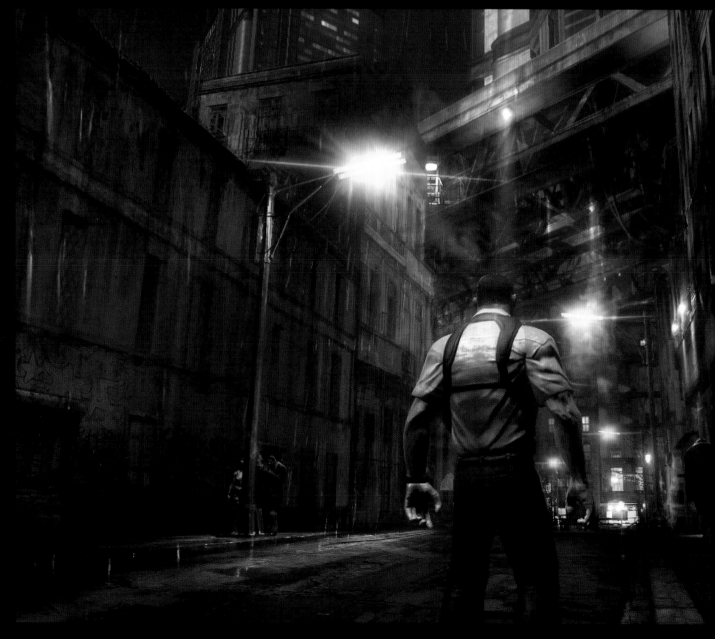

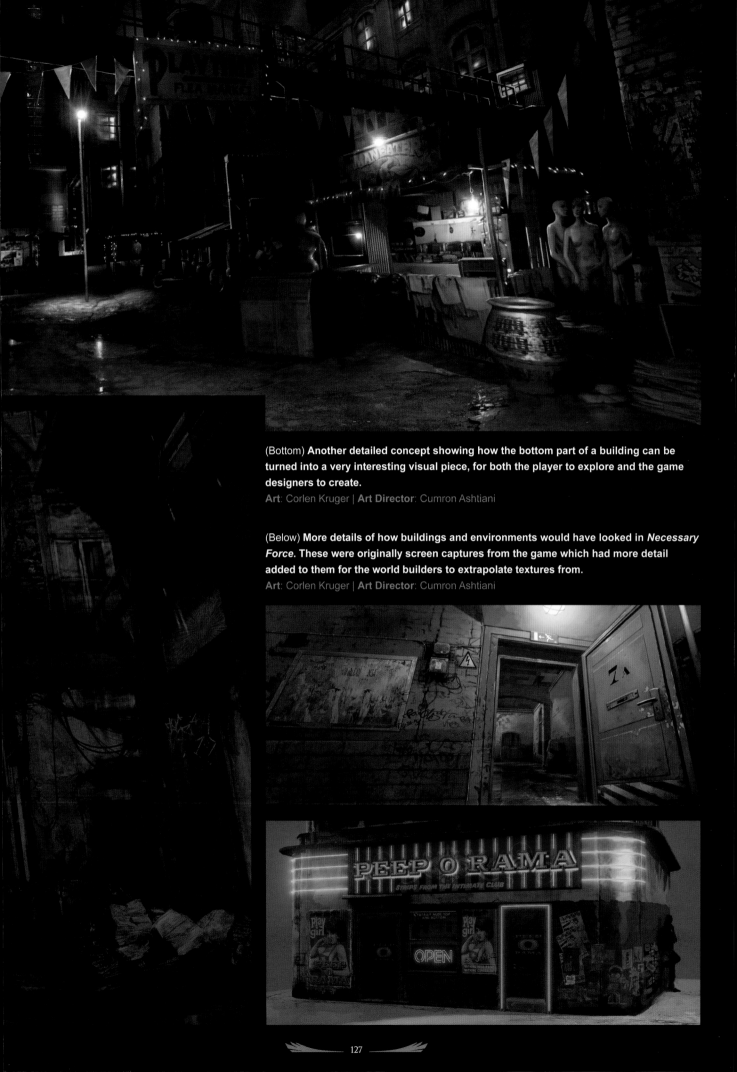

(Bottom) **Another detailed concept showing how the bottom part of a building can be turned into a very interesting visual piece, for both the player to explore and the game designers to create.**
Art: Corlen Kruger | Art Director: Cumron Ashtiani

(Below) **More details of how buildings and environments would have looked in *Necessary Force*. These were originally screen captures from the game which had more detail added to them for the world builders to extrapolate textures from.**
Art: Corlen Kruger | Art Director: Cumron Ashtiani

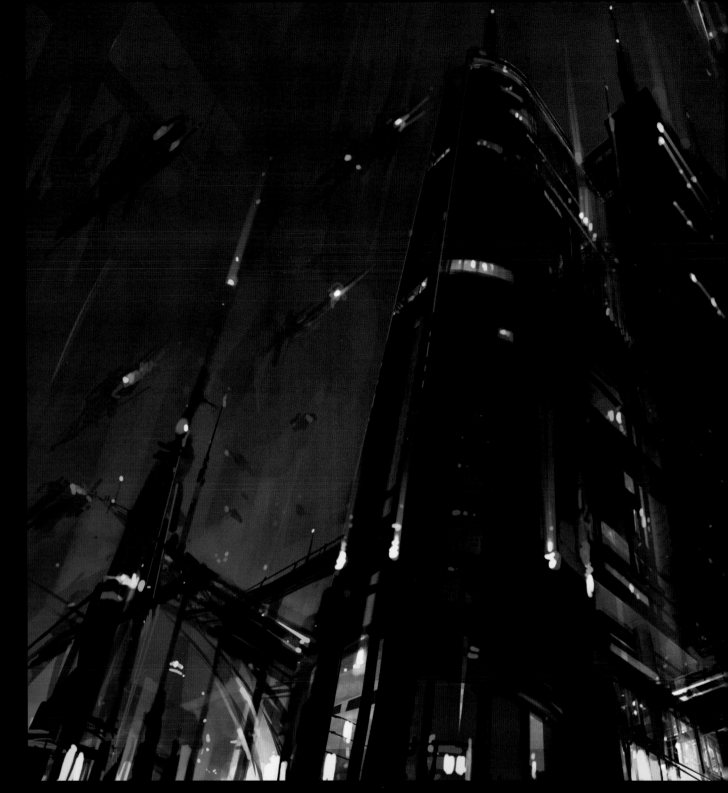

(Above) **Futuristic buildings executed in Painter.**
Art: Pete Thompson | **Art Director**: Cumron Ashtiani

(Right) **A desert track environment bolted onto huge rock towers. The gas mine was added at a later date so it emphasized the industrial-versus-organic look.**
Art: Pete Thompson | **Art Director**: Cumron Ashtiani

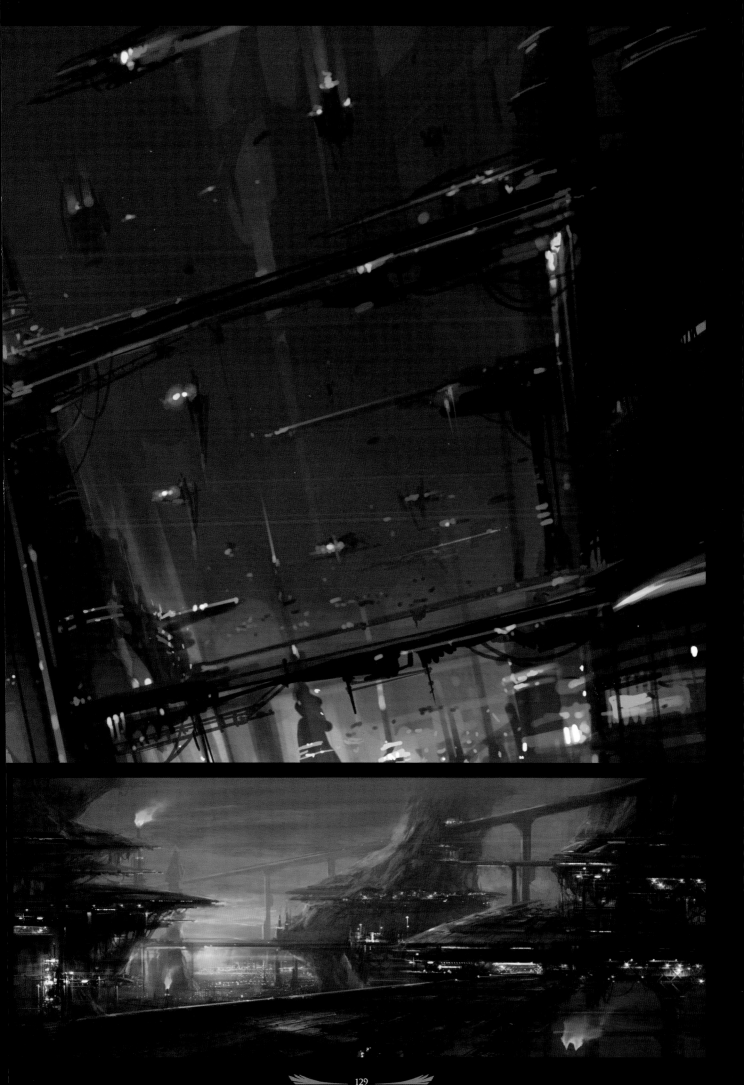

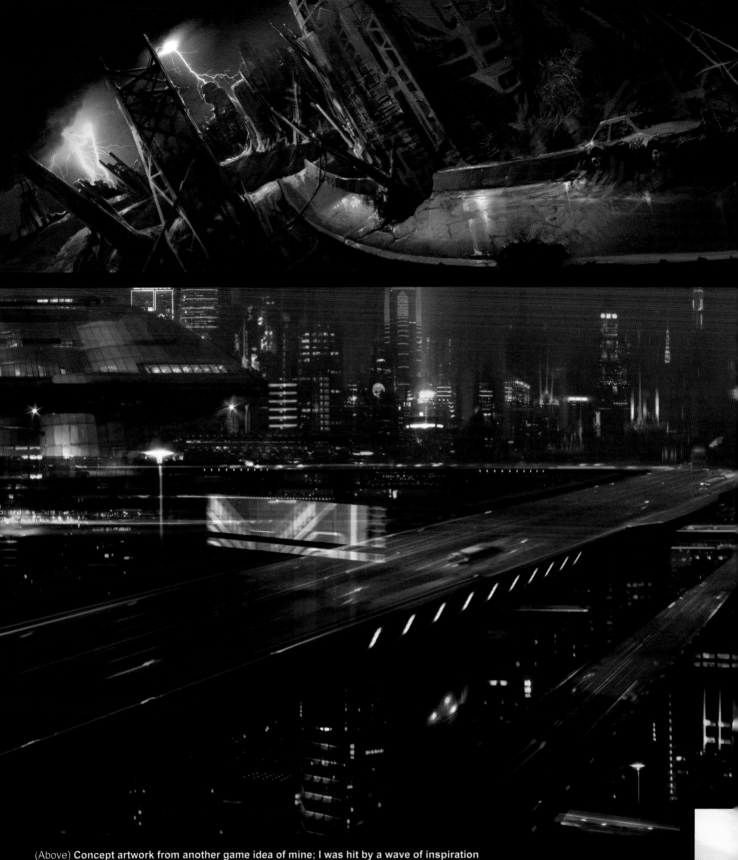

(Above) Concept artwork from another game idea of mine; I was hit by a wave of inspiration while seeing Muse at the V festival in 2008. I had always wanted to make an Akira-influenced racing game, as I loved the shots of the futuristic bikes racing through the city. The concert had an incredible light show and the two influences just clicked in my head - a racing game set in future "mega-cities" where the main style influence was light in motion.
Art: Pete Thompson | Art Director: Cumron Ashtiani

(Top and Right) Two race track concepts for Neo Racer. The idea behind this game was to concept otherworldly locations for each level of the game, making the environment just as perilous as the tracks themselves.
Art: Corlen Kruger | Art Director: Cumron Ashtiani

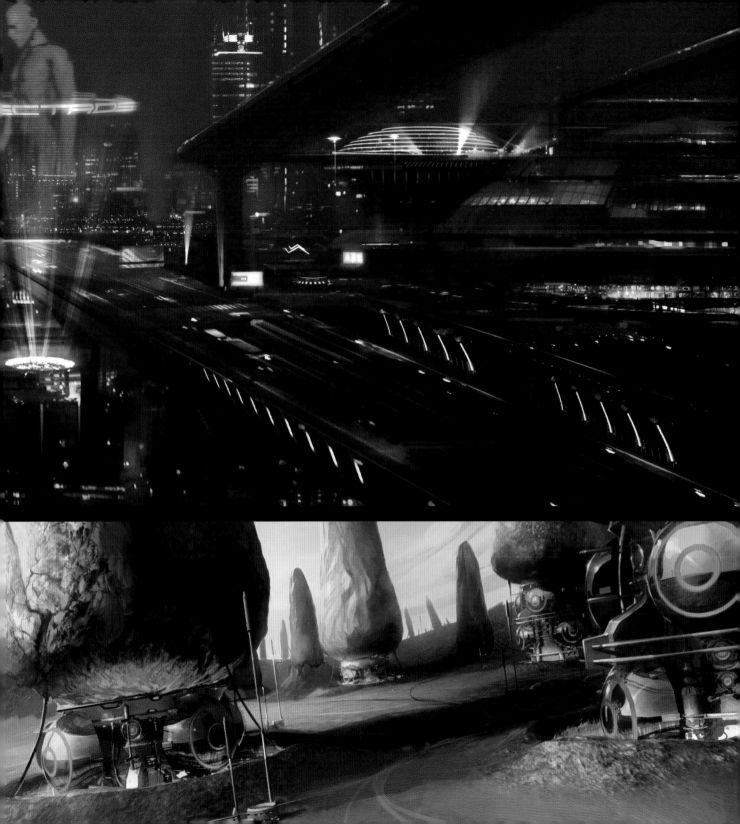

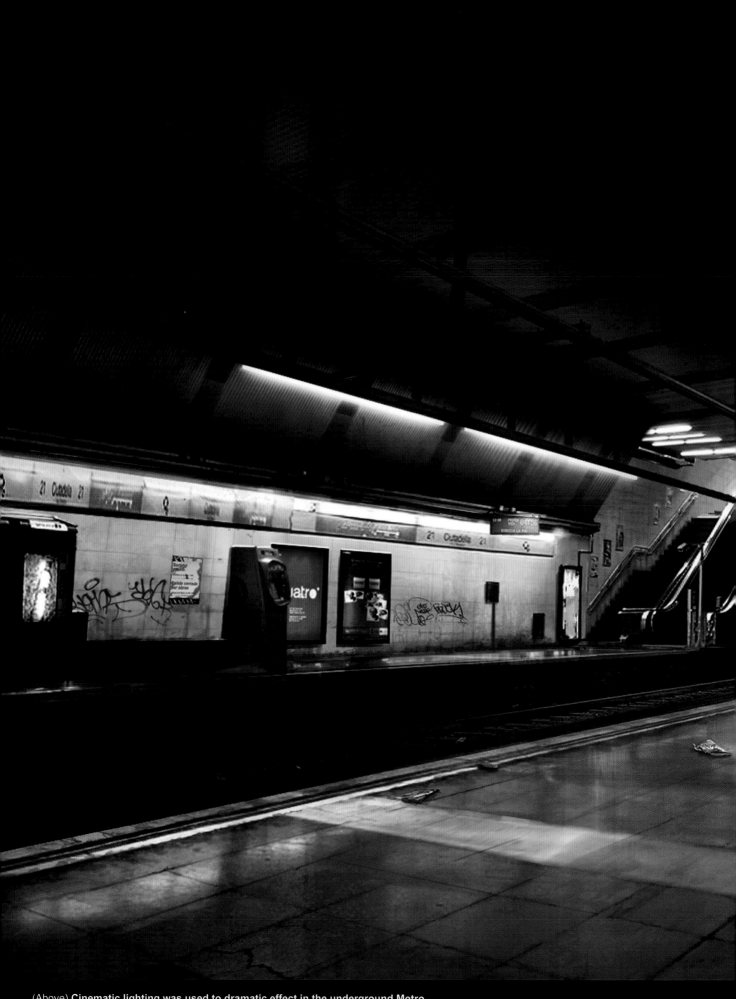

(Above) **Cinematic lighting was used to dramatic effect in the underground Metro station in Barcelona.**

Art: Pete Thompson | **Art Director**: Steve Dietz

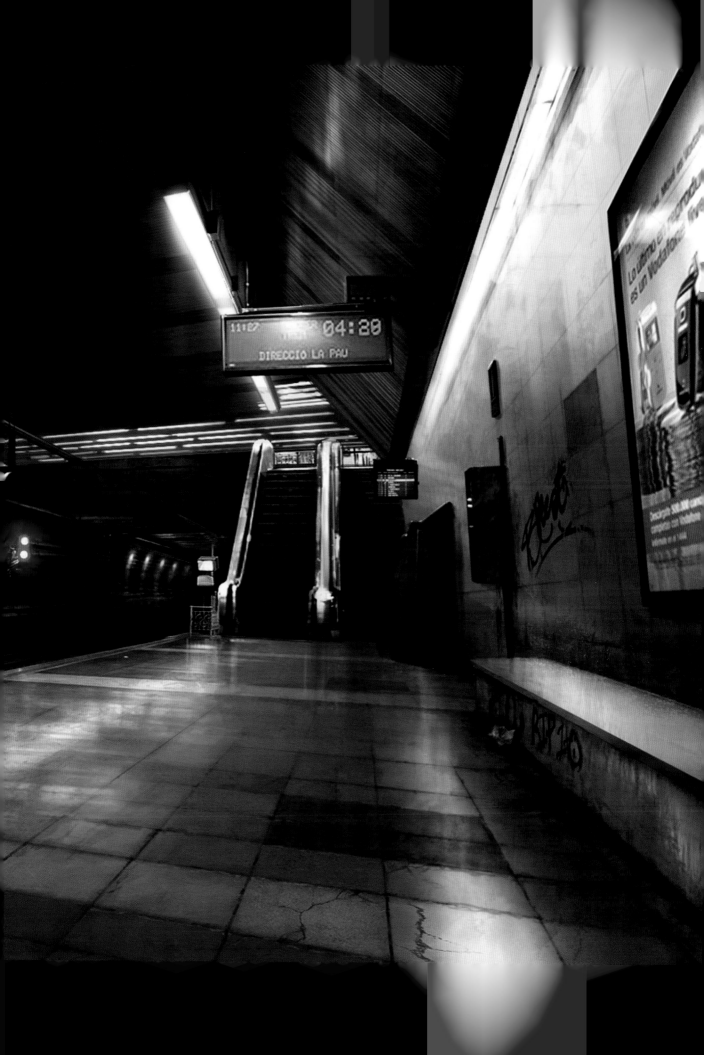

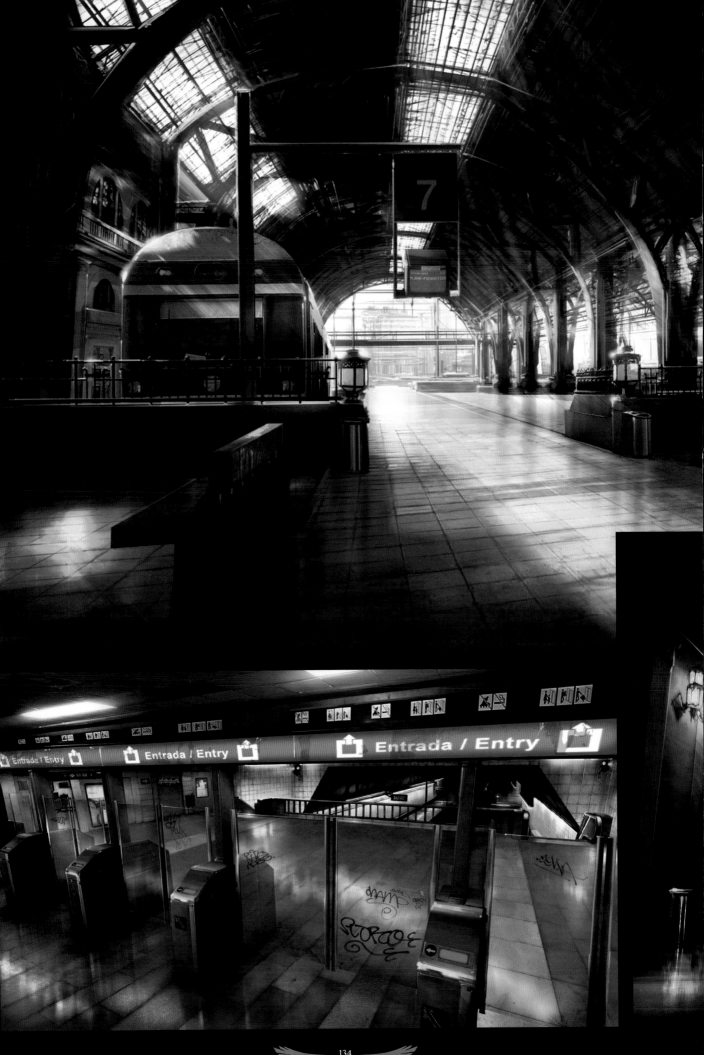

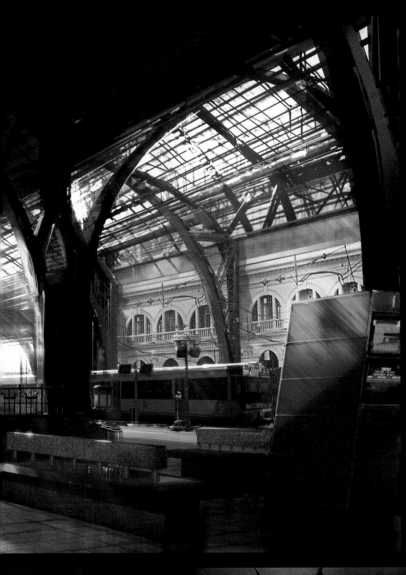

(Left) **Barcelona Station interior concept.**
Art: Pete Thompson | Art Director: Steve Dietz

(Bottom Left) **Metro turnstile with extended glass doors for motorbikes to smash though.**
Art: Pete Thompson | Art Director: Steve Dietz

(Below) **Barcelona Station lobby interior concept.**
Art: Pete Thompson | Art Director: Steve Dietz

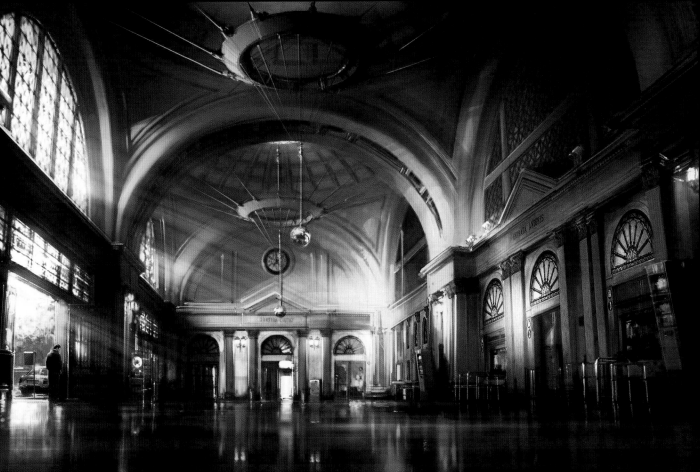

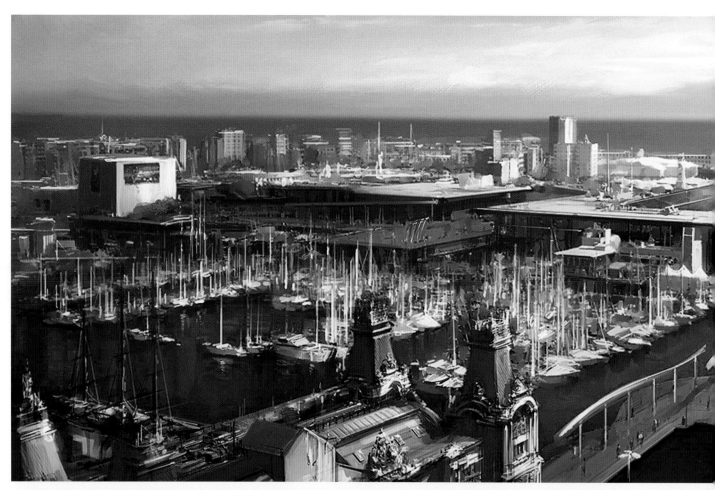

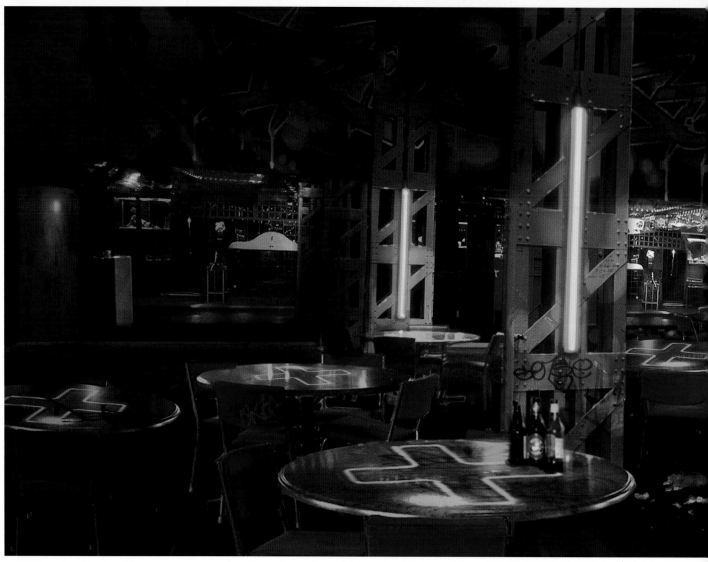

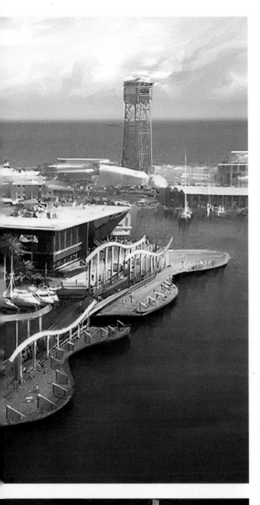

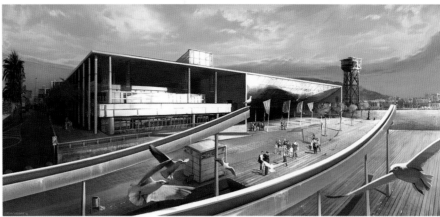

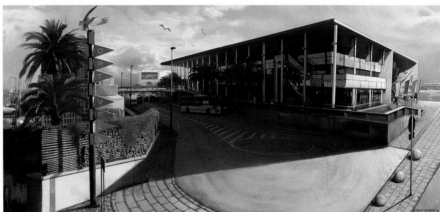

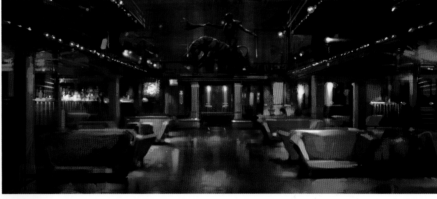

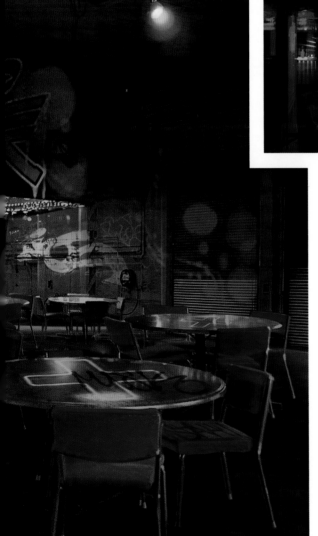

(Above) **First round of speed paintings for the nightclub scene.**
Art: Pete Thompson | Art Director: Steve Dietz

(Top) **Concept of the Maremagnum Center in Spain.**
Art: Corlen Kruger | Art Director: Steve Dietz

(Top Left) **Often people ask me why would you ever need to concept a real existing location when you have photo reference for the modelers to work from? For the final lighting pass of any game though, you need that extra magic - we needed to emphasize the way the sunlight bleaches the sea and rooftops.**
Art: Pete Thompson | Art Director: Steve Dietz

(Left) **An early concept for the Drug Store, a gang-operated night club that also served as the hideout for the Chulos gang. This was the first early phase concept, but it changed later as the designers also changed the gang's location.**
Art: Corlen Kruger | Art Director: Steve Dietz

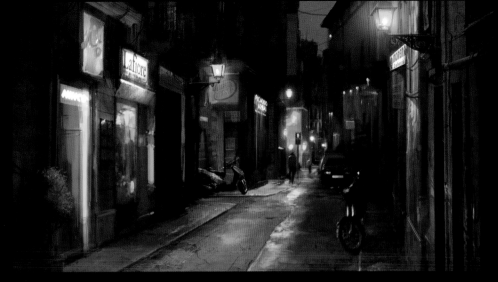

(Above) **Based on a few photos I took on Holiday in Greece. I love how the evening scene is flooded with light - far more interesting than a sunny day, I think.**
Art: Pete Thompson | Art Director: Steve Dietz

(Right) **Final concept of the Zaptaedo Club's garden patio area.**
Art: Pete Thompson | Art Director: Steve Dietz

(Bottom Right) **Final concept of the Zaptaedo Club's front entrance area.**
Art: Pete Thompson | Art Director: Steve Dietz

(Below) **Final concept of the Zaptaedo Club restaurant.**
Art: Pete Thompson | Art Director: Steve Dietz

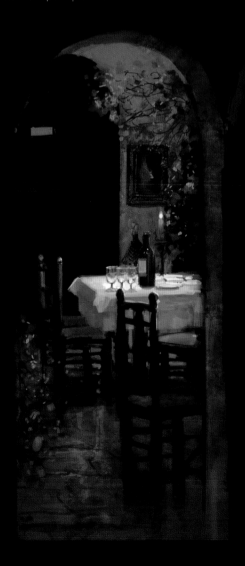

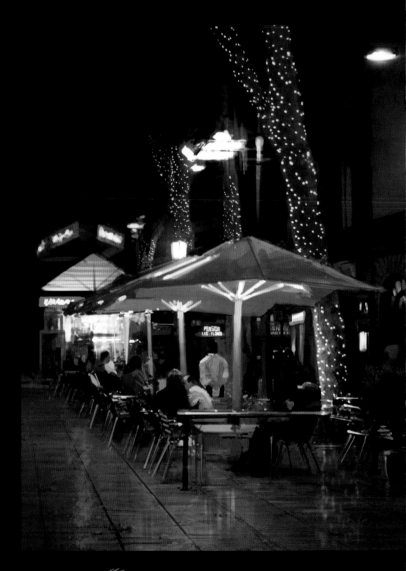

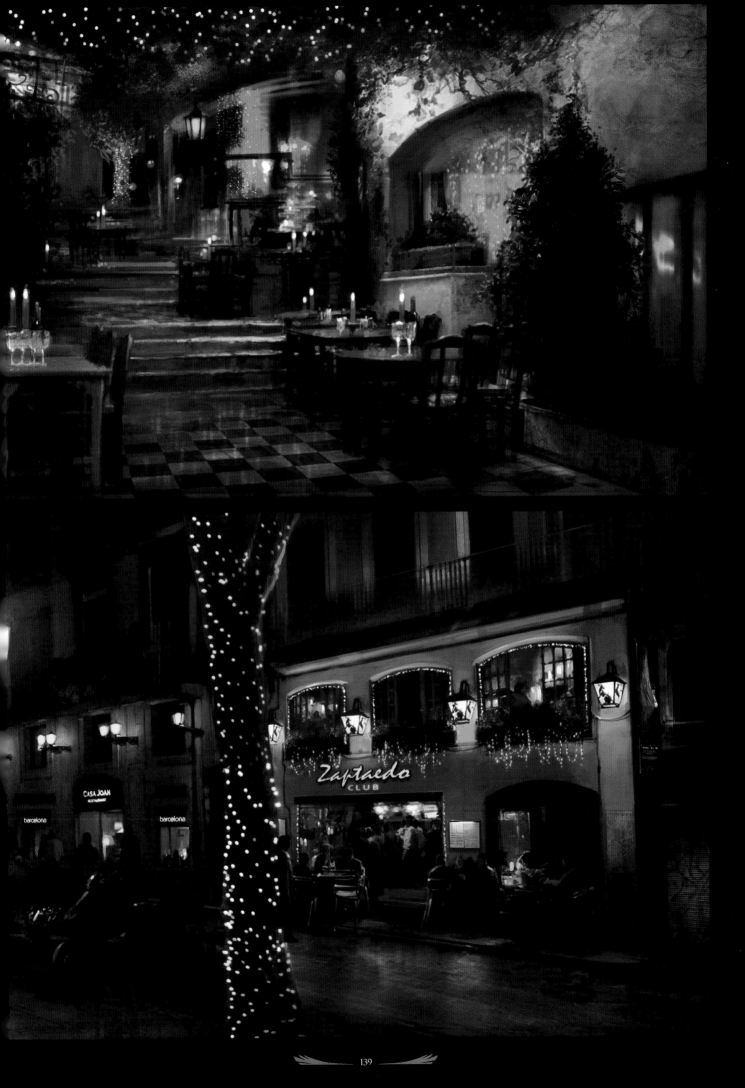

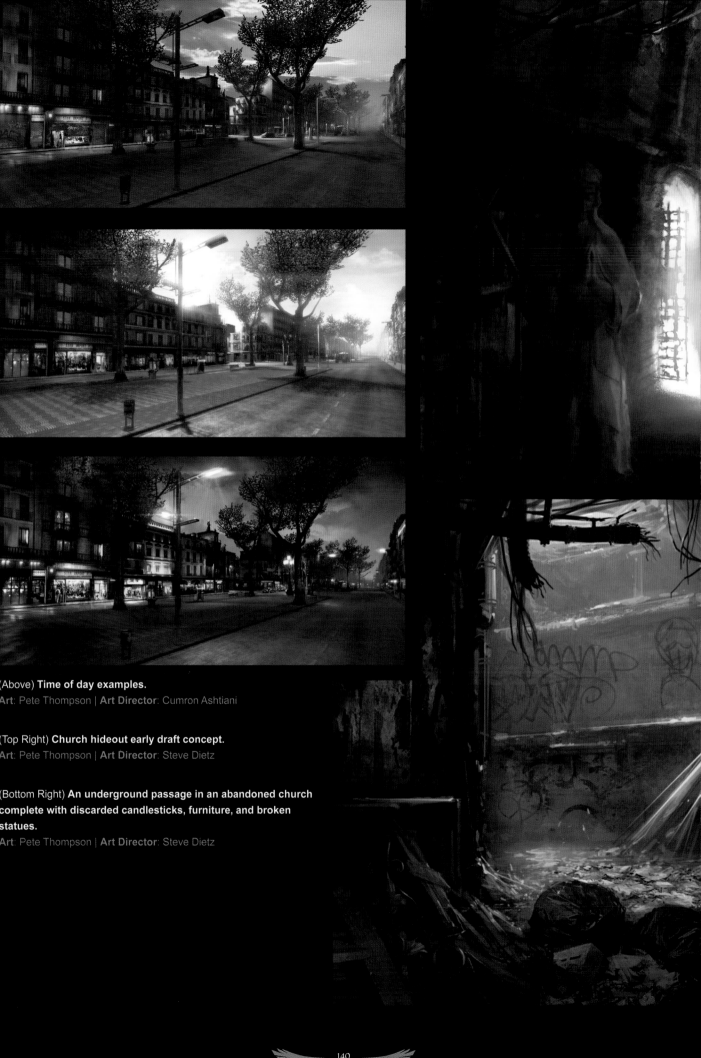

(Above) **Time of day examples.**
Art: Pete Thompson | Art Director: Cumron Ashtiani

(Top Right) **Church hideout early draft concept.**
Art: Pete Thompson | Art Director: Steve Dietz

(Bottom Right) **An underground passage in an abandoned church complete with discarded candlesticks, furniture, and broken statues.**
Art: Pete Thompson | Art Director: Steve Dietz

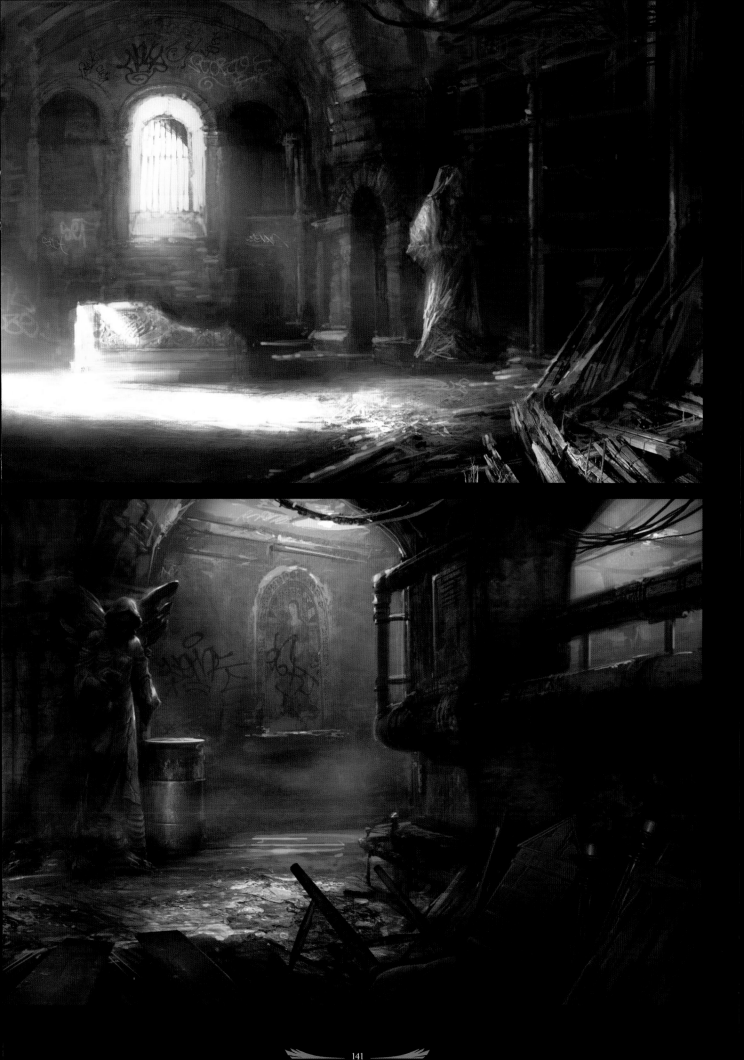

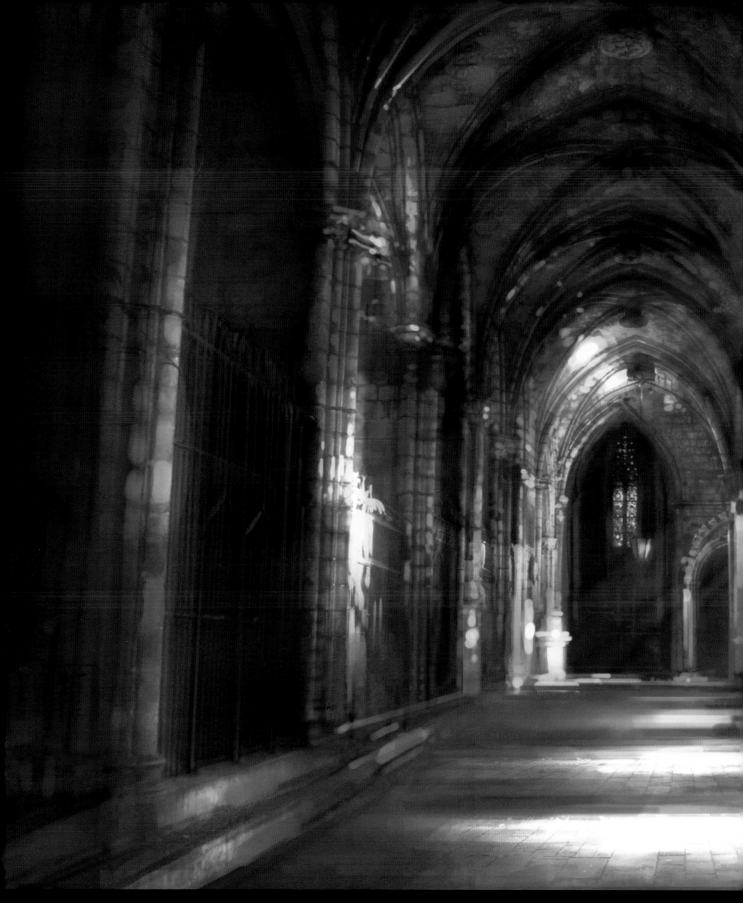

(Above) **Church cloisters painting to emphasize how light floods in from the central garden area.**

Art: Pete Thompson | Art Director: Steve Dietz

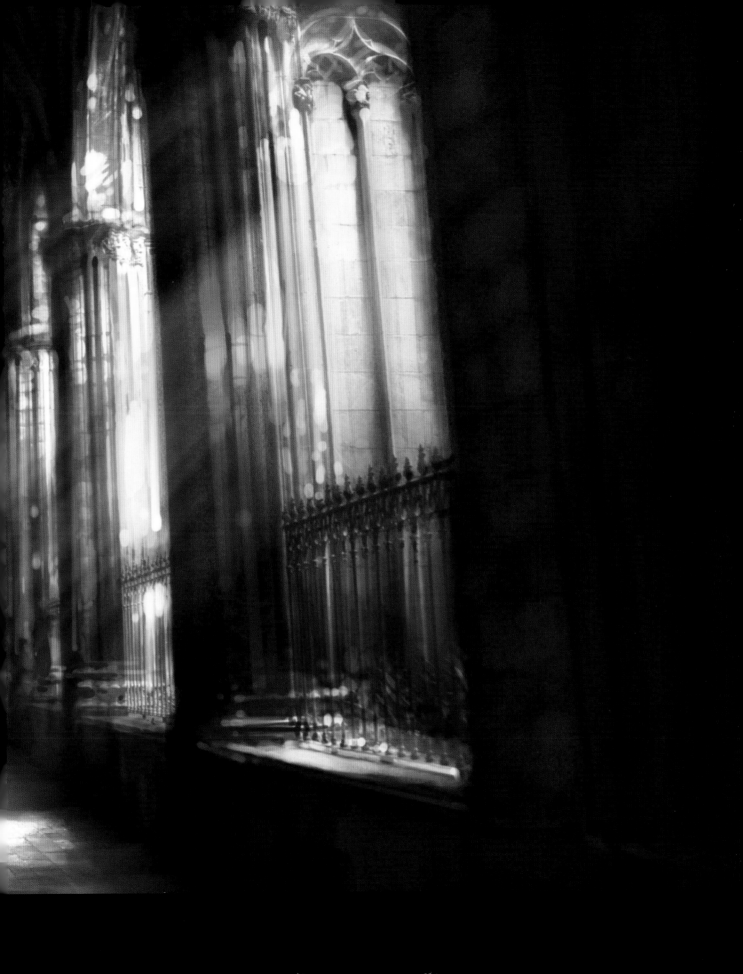

(Right) **First version of the church hideout, complete with scaffolding and wooden walkways for gameplay purposes.**
Art: Pete Thompson | Art Director: Steve Dietz

(Middle Right) **The cloister fountain area within the cathedral. I really played about with the way sunlight dances across the stonework until the right effect was achieved.**
Art: Pete Thompson | Art Director: Steve Dietz

(Bottom Right) **Church hideout early draft concept.**
Art: Pete Thompson | Art Director: Steve Dietz

(Bottom) **Final version of the abandoned church. The high camera angle was requested for a cut scene.**
Art: Pete Thompson | Art Director: Steve Dietz

(Below) **Before and after shot showing the original block out render and completed concept.**
Art: Pete Thompson | Art Director: Steve Dietz

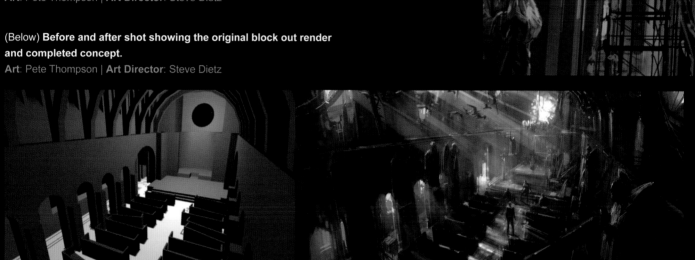

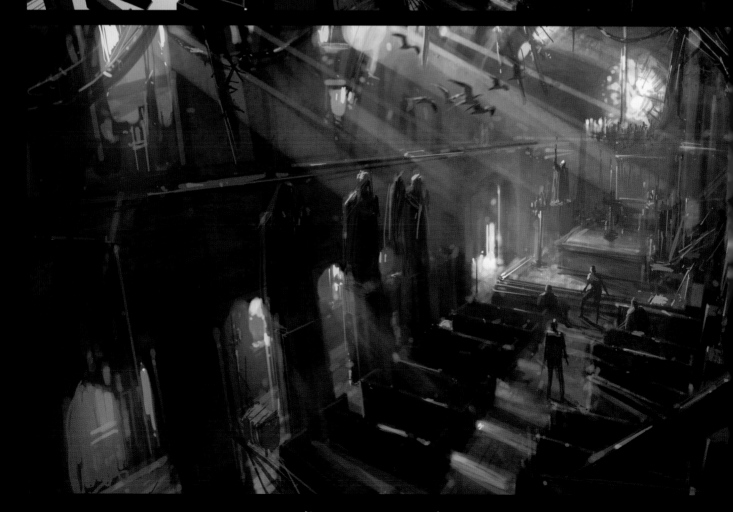

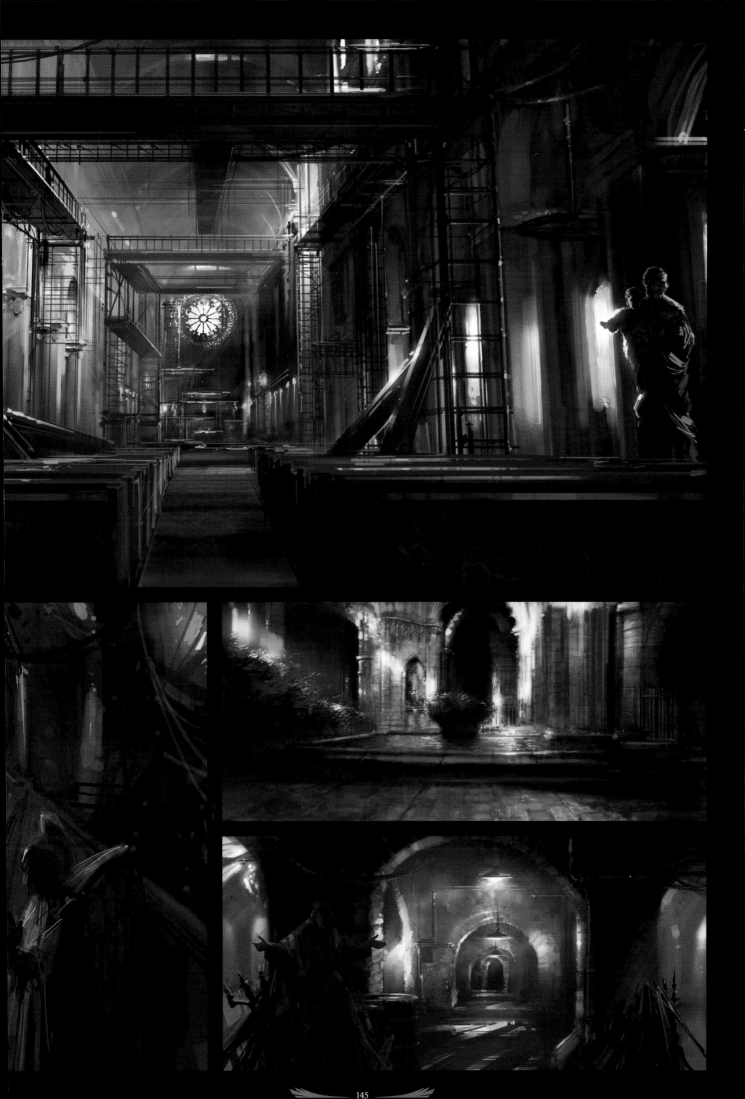

(Right) **The very first conceptual piece for** *Wheelman* **submitted for the game pitch.**
Art: Pete Thompson | **Art Director**: Steve Dietz

(Bottom Left) **A derelict empty slum district complete with low walls, alleyways and open areas for shootouts.**
Art: Pete Thompson | **Art Director**: Steve Dietz

(Bottom Right) **Slum District close-up concept.**
Art: Pete Thompson | **Art Director**: Steve Dietz

(Below) **I tried to go for a realistic approach with this concept. I started with a loose composition then blocked out the whole area with tonal light and shade. Once I was happy with the overall look, I overlaid the whole painting with muted warm tones mixed with cool purples for the shadows. It was then overlaid again with photo textures for a cinematic feel.**
Art: Pete Thompson | **Art Director**: Cumron Ashtiani

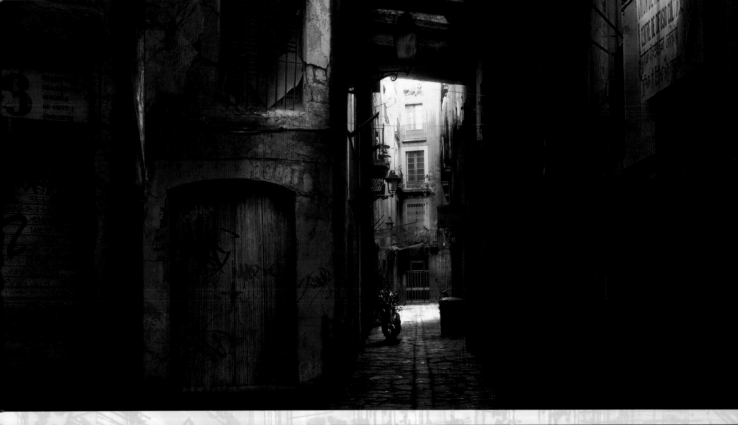

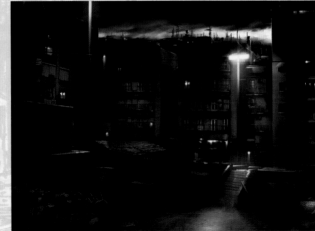

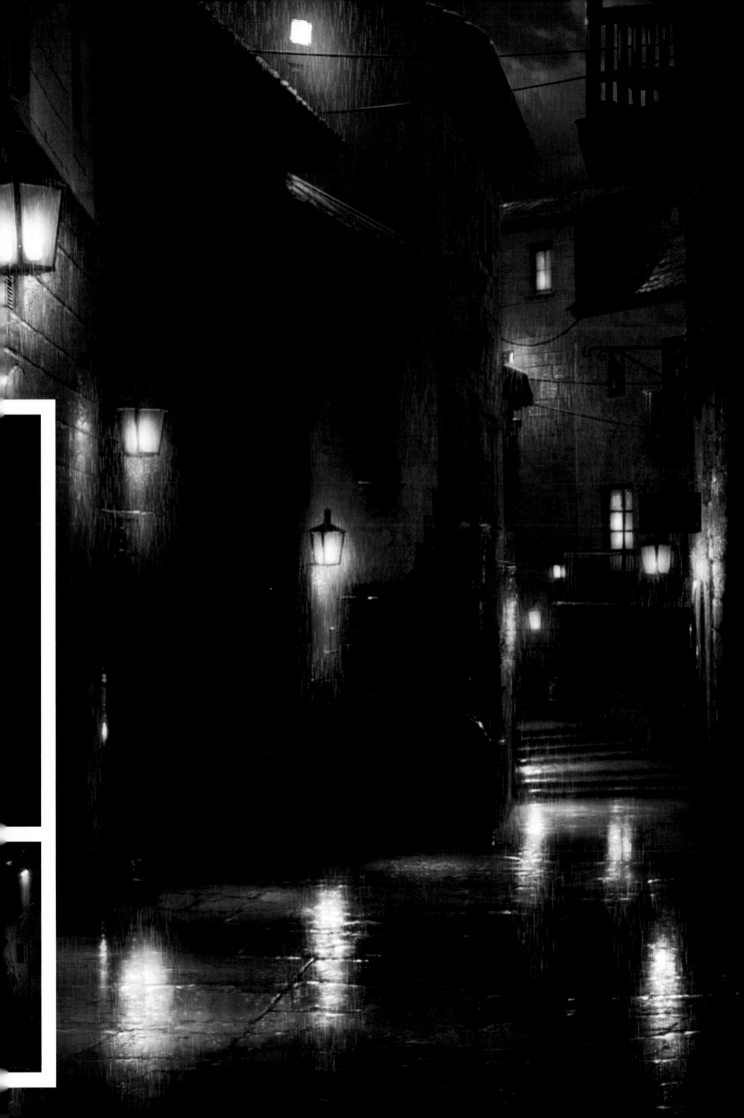

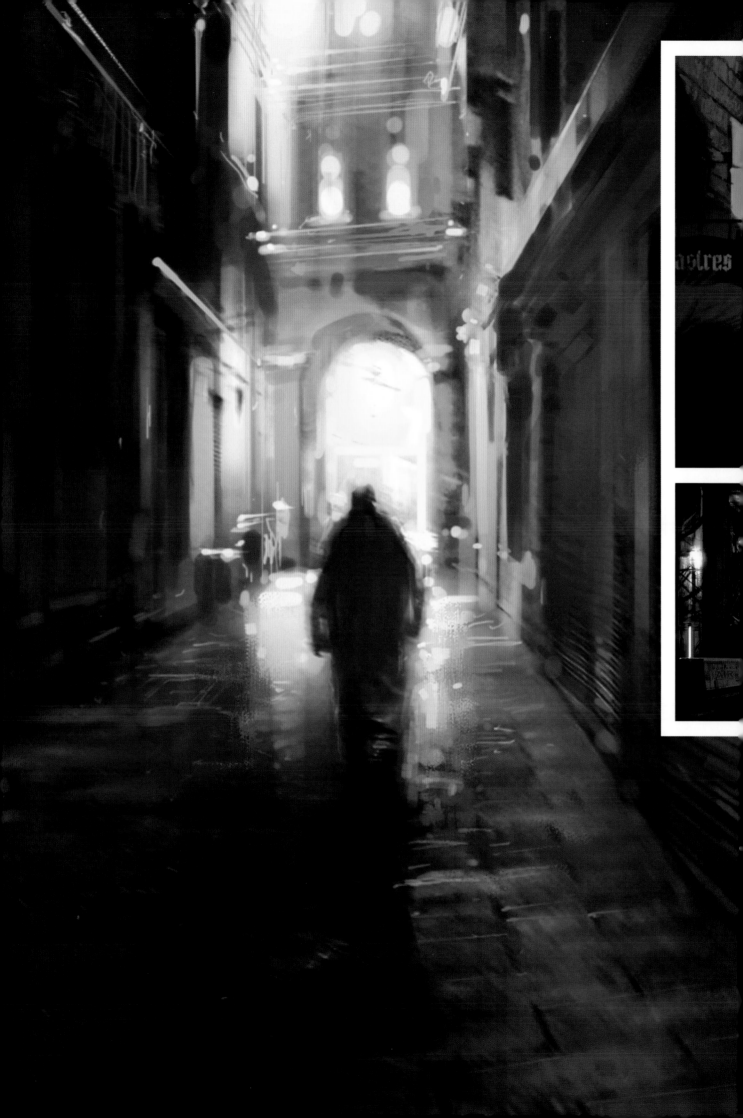

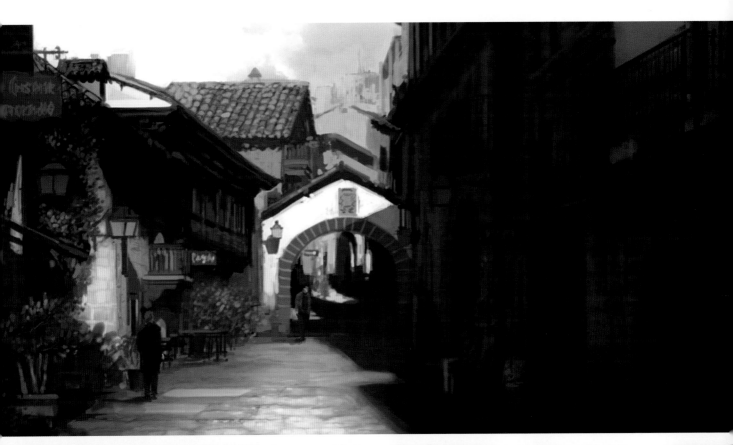

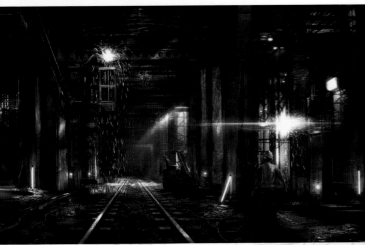
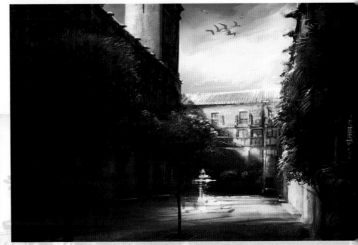

(Above) **I had my doubts about working on this piece as an underground construction site could be quite a boring subject. But the more I painted, the more the potential really hit me and I started playing with lights and shadows. Sometimes the most mundane locations can be brought to another level.**
Art: Pete Thompson | Art Director: Cumron Ashtiani

(Top) **This speed painting was composed from a mixture of old-world Mediterranean street photo references. At the start of the project I had to come up with a bunch of quick images that captured the feel and atmosphere of an authentic village street. Extra street furniture was requested at a later date, such as postcard stands and shop signs.**
Art: Pete Thompson | Art Director: Steve Dietz

(Left) **A mysterious lonely character meanders through the plaza corridors of Barcelona in this first mood draft shot for *Wheelman*.**
Art: Pete Thompson | Art Director: Steve Dietz

(Above Right) **A very pretty town square is a perfect location for a shootout. It was dropped in the early stages for another location, but was later resurrected and tweaked for a cut scene.**
Art: Pete Thompson | Art Director: Steve Dietz

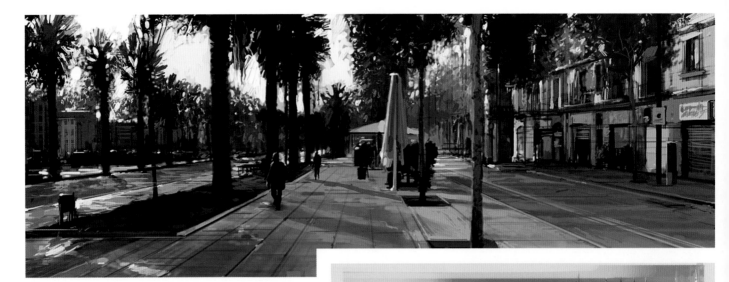

(Above) **Street study painting in Barcelona. We actually widened the footpaths and roads for extra gameplay and better car handling.**
Art: Pete Thompson | **Art Director**: Steve Dietz

(Top Right) **Street study sketch in the Barcelona shopping district.**
Art: Pete Thompson | **Art Director**: Steve Dietz

(Bottom Right) **Matte paintings can be very daunting at first, but the main thing to remember is to up the resolution of your art in stages - that way you won't start concentrating on one tiny window at the start of the painting.**
Art: Pete Thompson | **Art Director**: Steve Dietz

(Far Right) **Plaça Reial paint study.**
Art: Pete Thompson | **Art Director**: Steve Dietz

(Below) **Another example of taking a real location and changing the street width for gameplay purposes.**
Art: Pete Thompson | **Art Director**: Steve Dietz

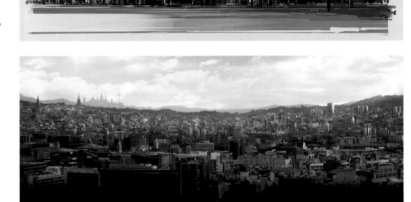

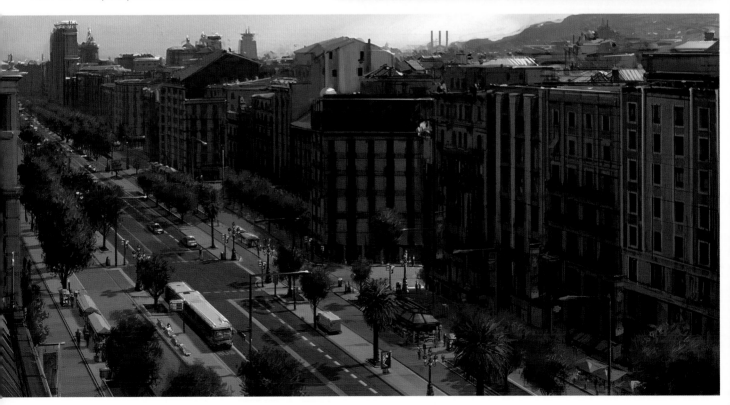

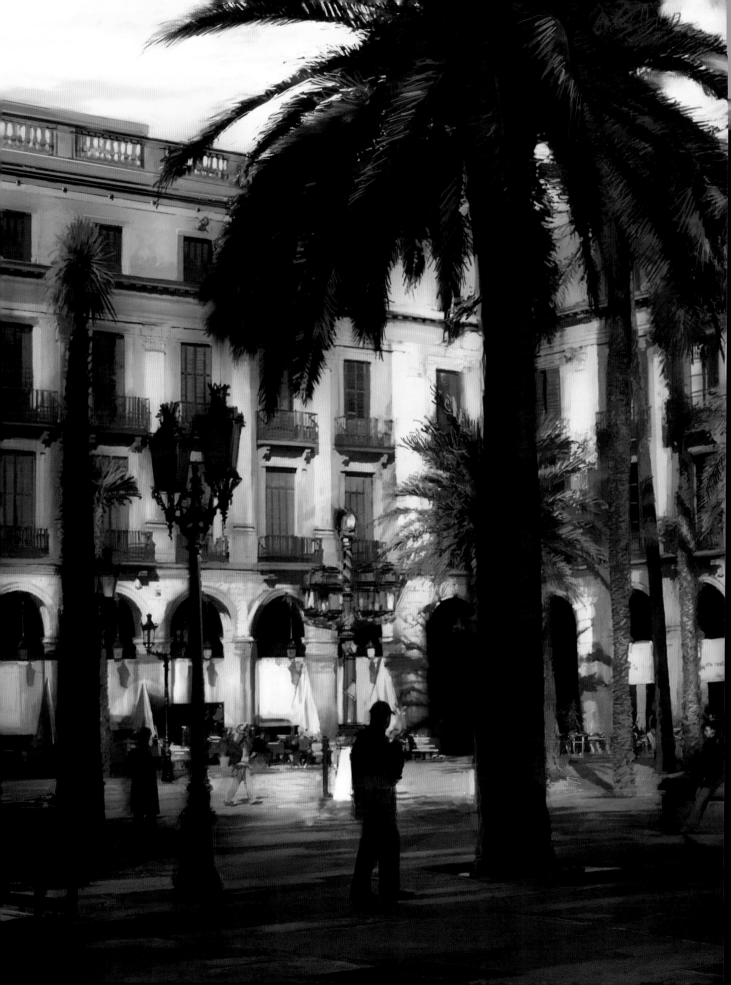

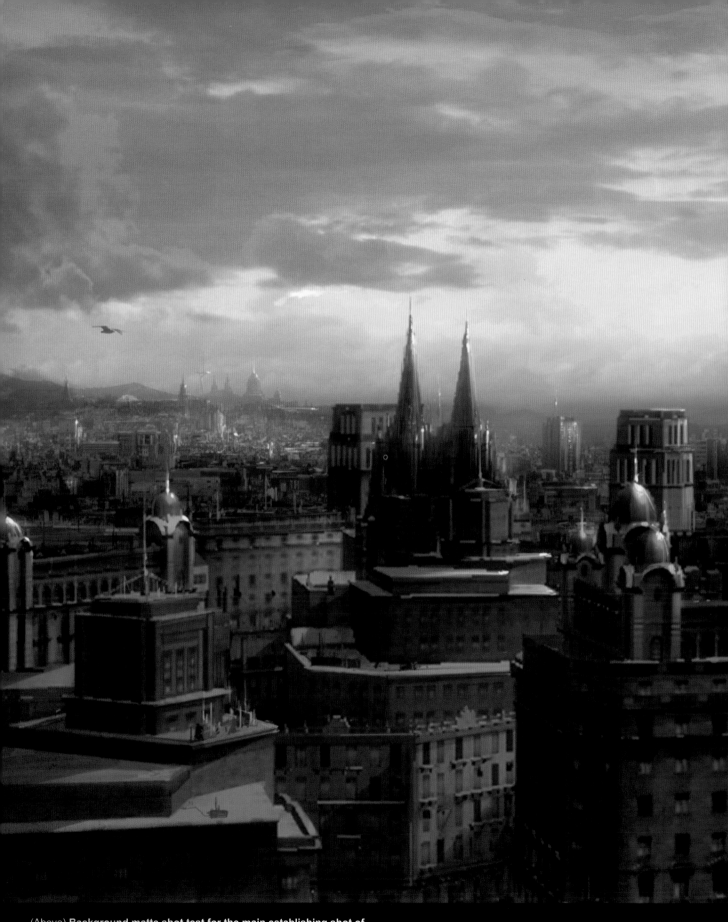

(Above) **Background matte shot test for the main establishing shot of Barcelona. This was a dry run before the final matte was painted and inserted.**

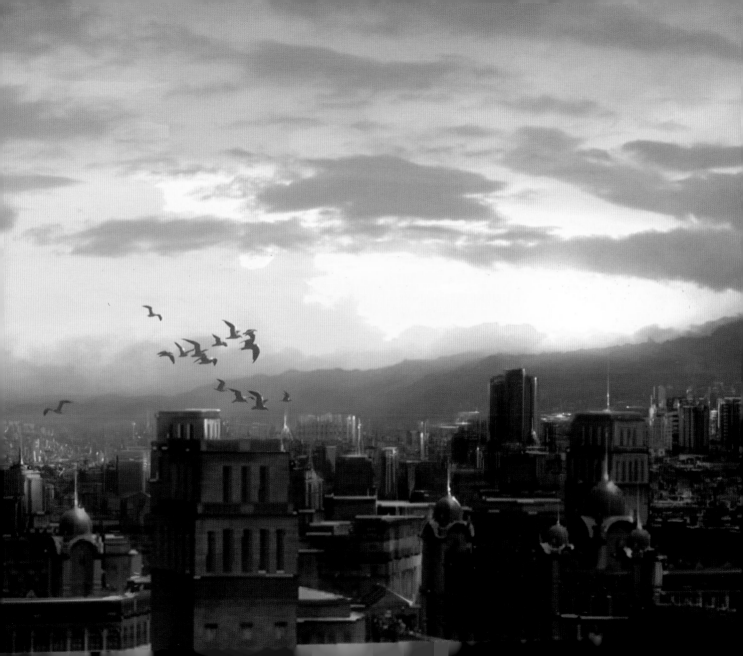

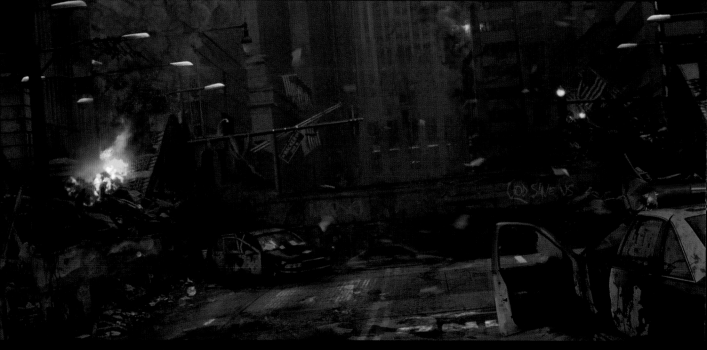

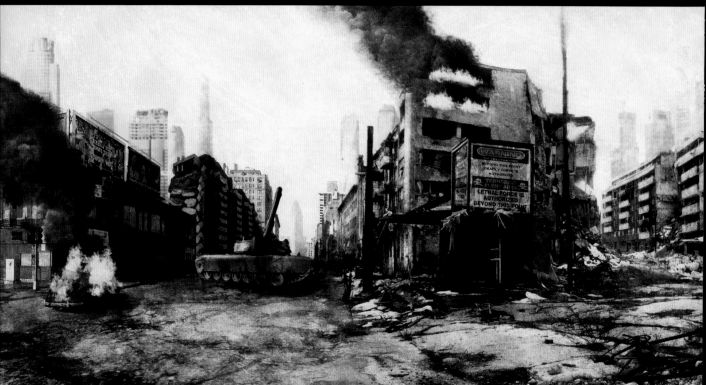

(Above) **Urban war concept.**
Art: Steph Stamb

(Top) **Lower level concept of Chicago just after the carnage of a zombie invasion.**
Art: Pete Thompson | Art Director: Cumron Ashtiani

(Right) **When doing any ruined city scene, it`s best to keep your color palette very muted so the sense of mood and foreboding is in the painting.**
Art: Pete Thompson | Art Director: Cumron Ashtiani

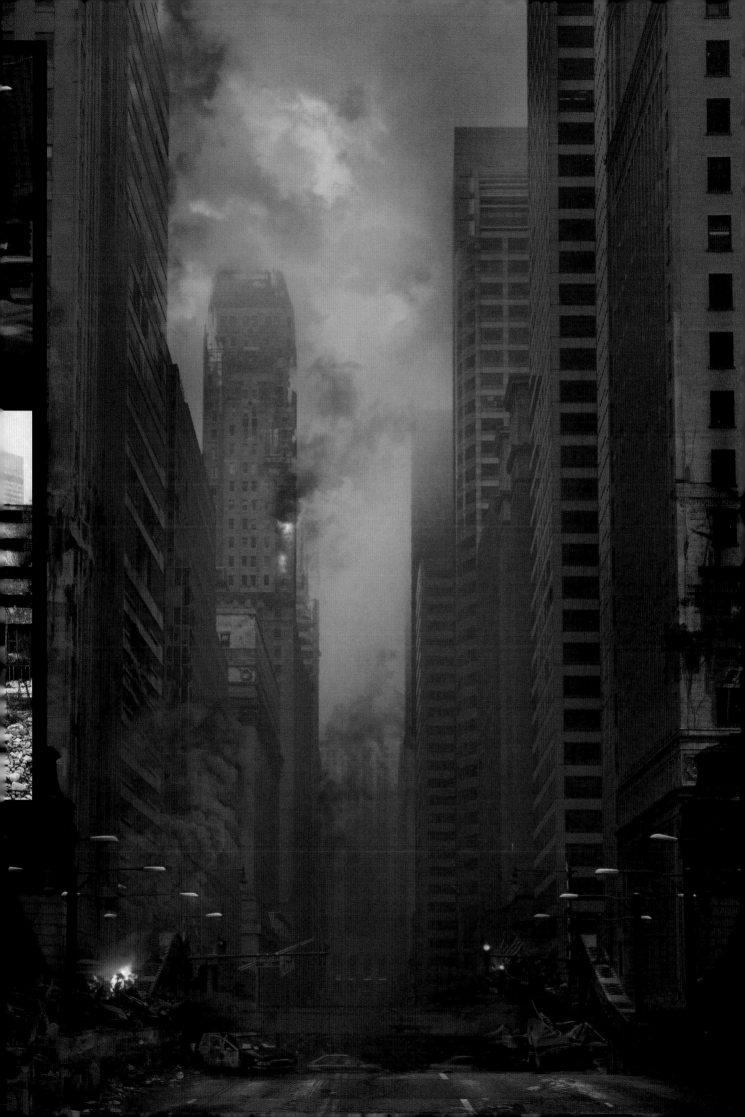

(Right) When doing environments, **I normally start a speed painting in landscape format, but as this painting evolved over time I suddenly flipped it 45 degrees and it completely changed my outlook on the composition. Now, instead of towers set in some mountains, it evolved into an airbase suspended on cliffs.**
Art: Pete Thompson

(Bottom) **In order to convey a sense of realism in sci-fi art, the environments need to have some sense of grounding in the real world. I used reference photos of the Lake District in England as a good starting point. The idea was to have a huge starship embedded in the hills which has, through time, been converted into some sort of base for ground troops.**
Art: Pete Thompson

(Below) **The last remnants of society blasting off from a cluster of launch pads.**
Art: Pete Thompson

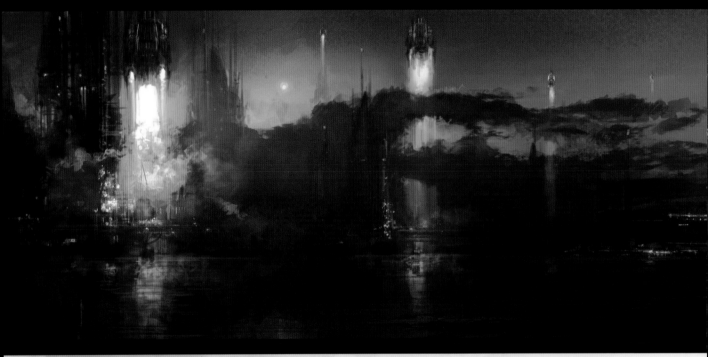

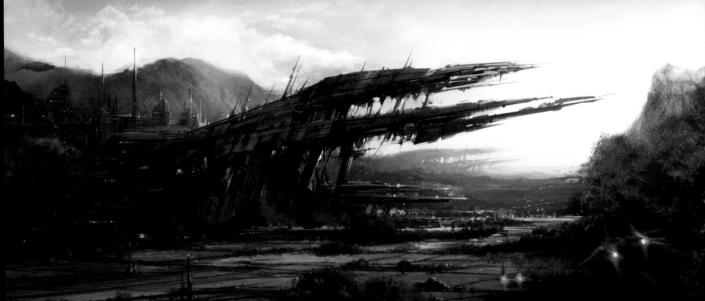

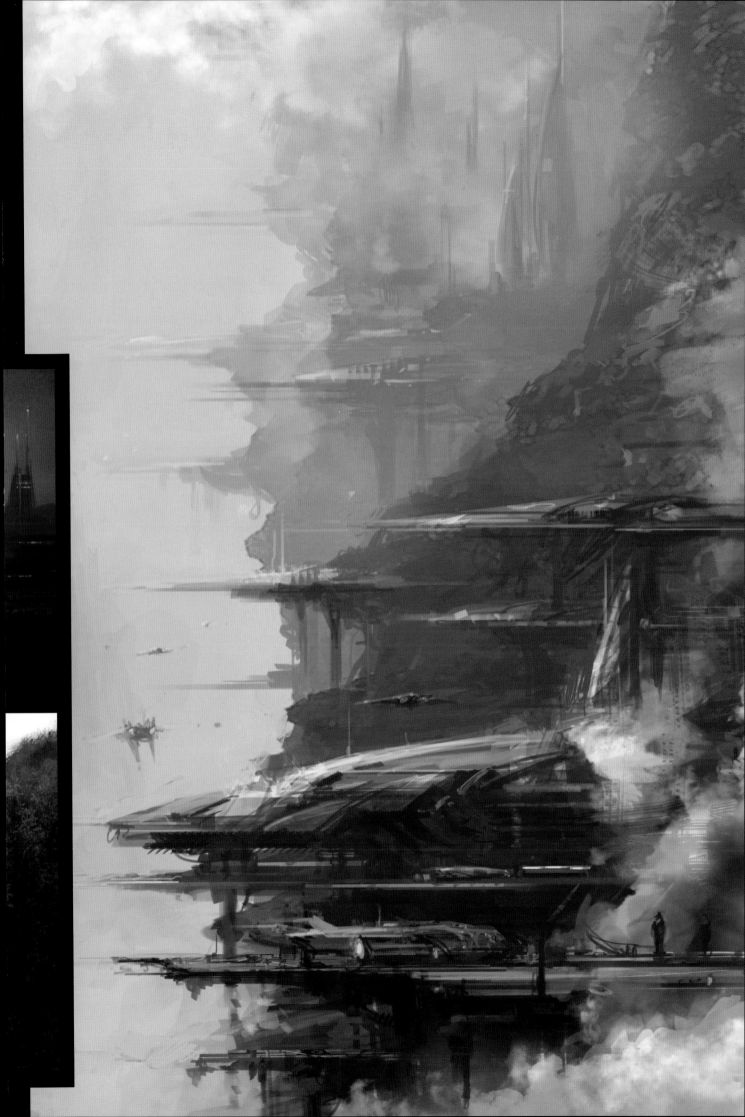

(Middle Left) **A quick landscape speed paint based on a photo I took in the dark winter months. I was very happy with the warm sunset making the scene seem very inviting rather than cold and harsh.**
Art: Pete Thompson

(Below) **I get inspired by everyday normal scenes just as much as painting otherworldly environments. I love winter scenes and this little un-assuming church underneath a blanket of snow is just as fascinating as a spaceport on a distant planet.**
Art: Pete Thompson

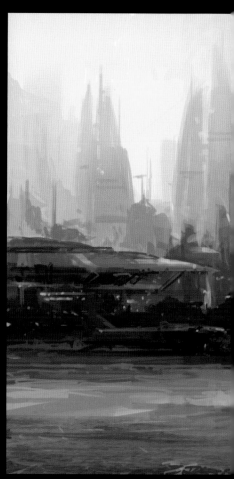

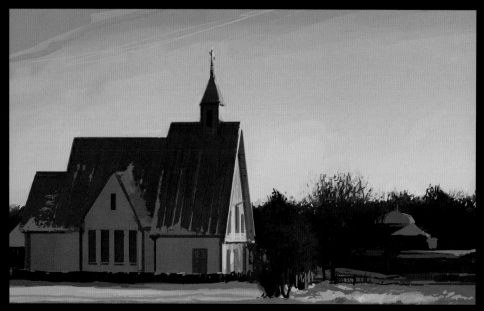

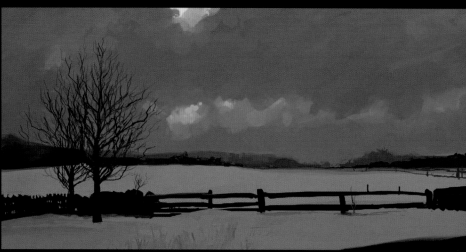

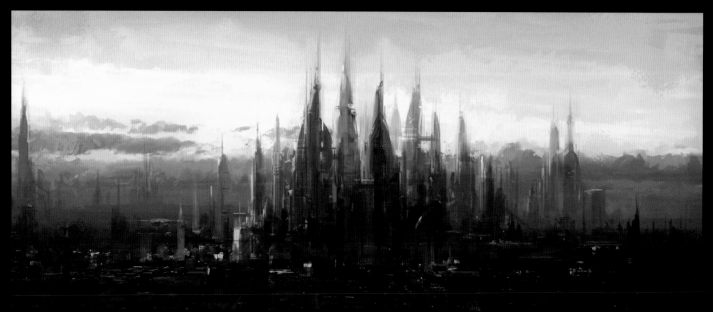

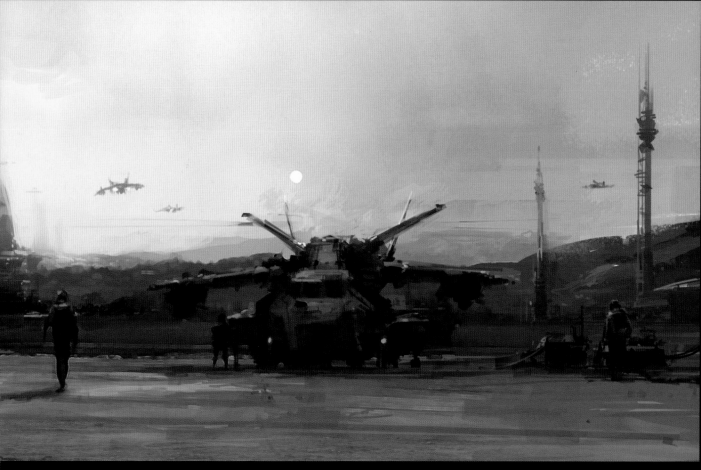

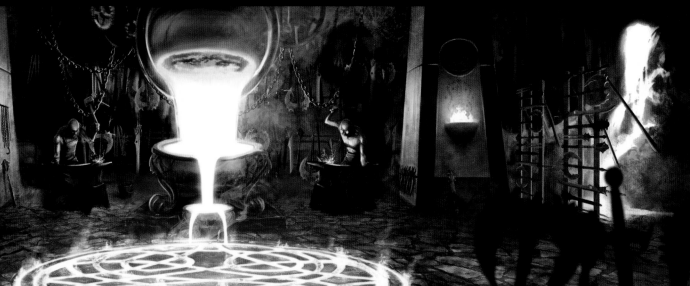

(Above) (CA) **The first piece of work Steph did at Atomhawk. I wanted him to get into the process of concept art as he had come from the comic book industry. I set him a brief to create a fantasy armory where blacksmith's work tirelessly to create weapons for a mighty army. He did very well indeed!**
Art: Steph Stamb | Art Director: Cumron Ashtiani

(Top) **Airbase speed painting completed in one hour.**
Art: Pete Thompson

(Left) **A very loose study of a cityscape set in the not-too-distant future.**
Art: Pete Thompson

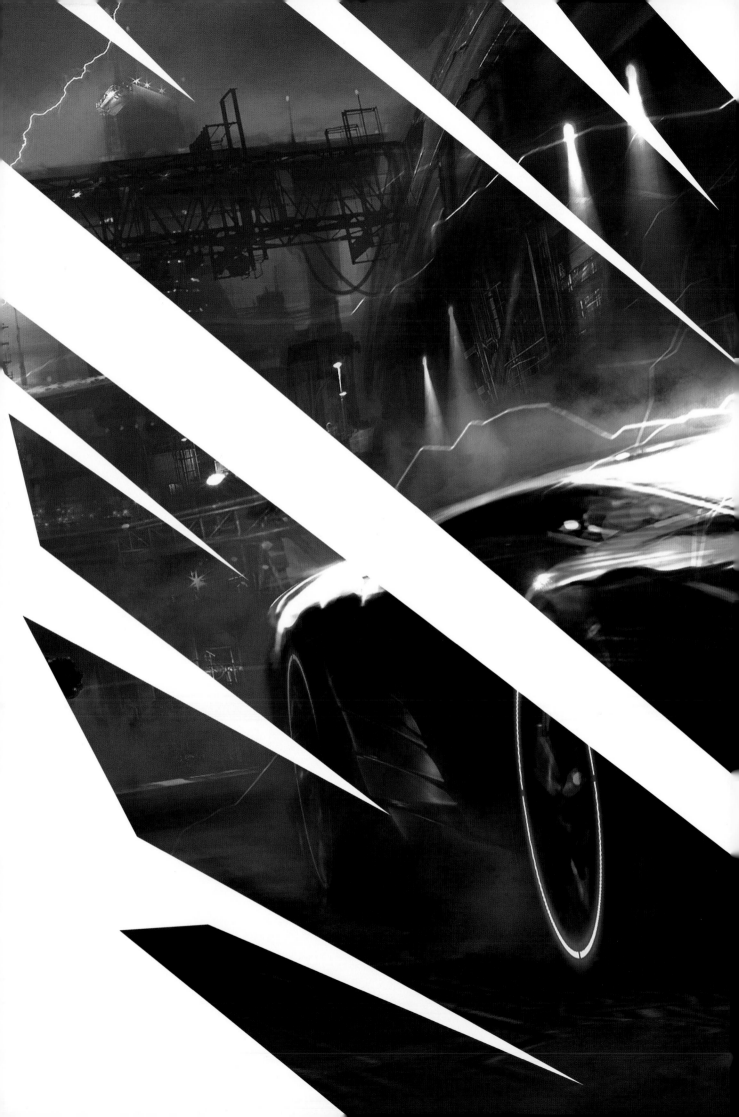

VEHICLE
CONCEPTS

Much like characters, vehicles need to be unique and convey their own personality traits. People can't help but relate vehicle design to a personality or emotion. Often for games and film, the hero will transfer his (and thus the viewer/player persona) onto a vehicle, either through direct control in a game or through driving a cool vehicle in a movie chase scene. A vehicle's design must tell you about its purpose and also the type of person that uses it.

In the real world, vehicles are often a work of art and are carefully crafted for their purpose by teams of designers. When creating concepts, it is important to think like a designer so that every detail has a purpose.

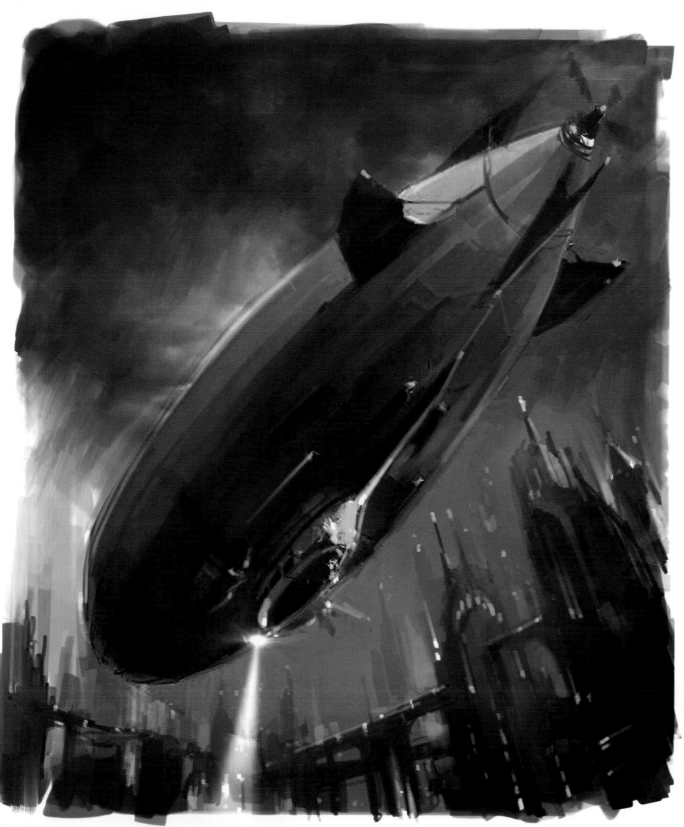

(Top Left and Right) **Airship concepts in flight. We were after a real Metropolis vibe with these images.**
Art: Pete Thompson | **Art Director**: Cumron Ashtiani

(Bottom Left and Right) **Airship concept thumbs.**
Art: Pete Thompson | **Art Director**: Cumron Ashtiani

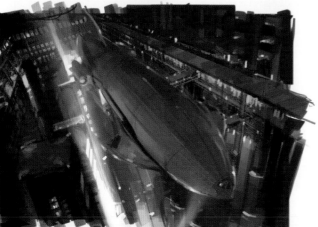

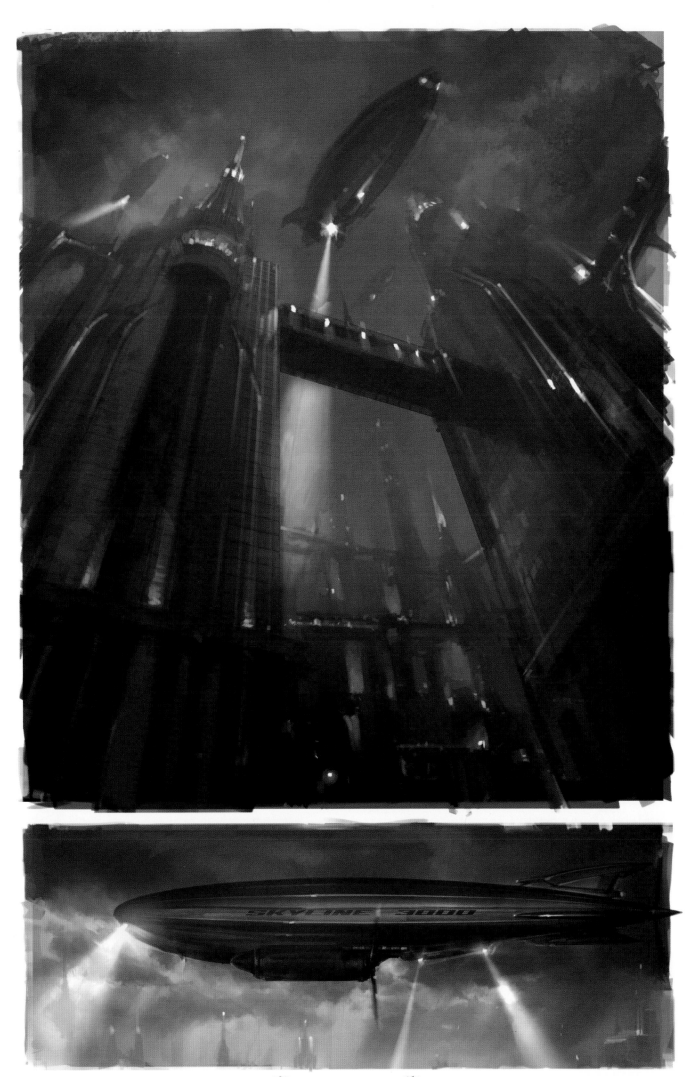

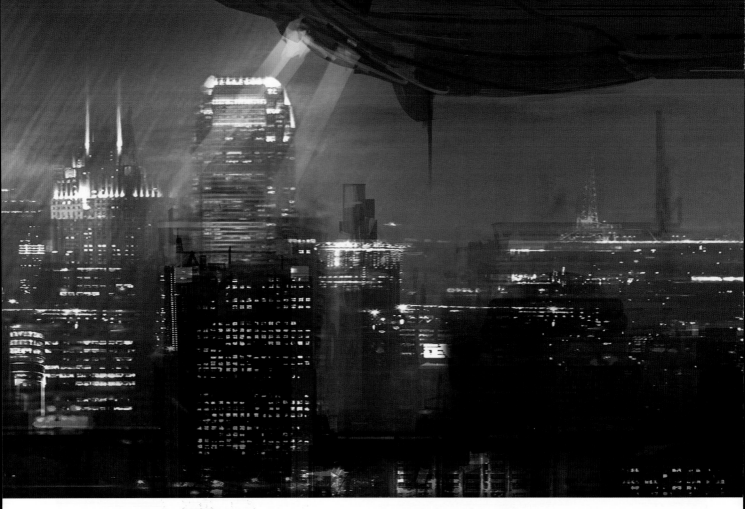

(Above) **I wanted the skyline of the city in *Necessary Force* to be full of movement and light, but to also stick to the retro theme, so the idea of having airships with holographic projection advertising was born (I was also heavily influenced by the film *Artificial Intelligence: AI*).**
Art: Pete Thompson | **Art Director**: Cumron Ashtiani

(Below and Right) **Airship concepts.**
Art: Corlen Kruger | **Art Director**: Cumron Ashtiani

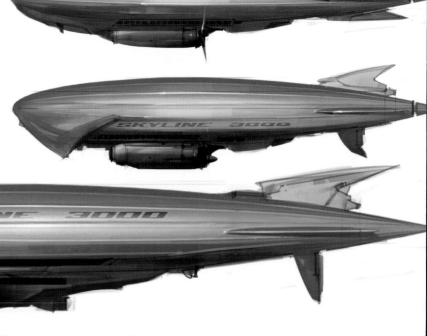

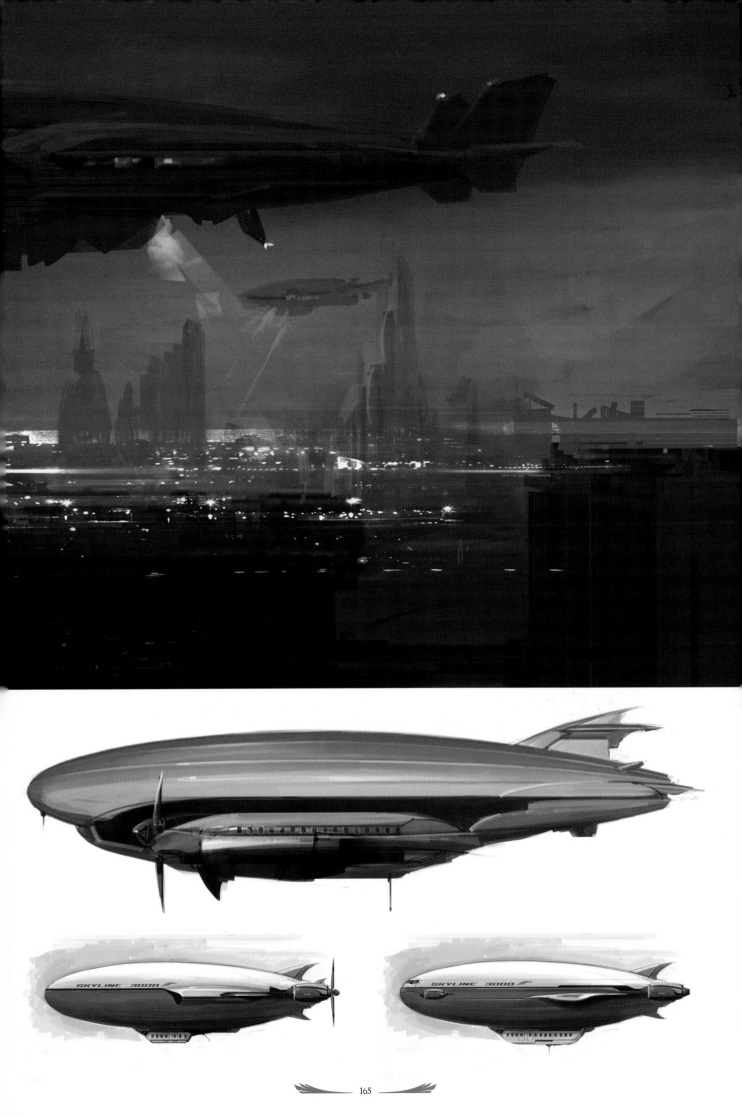

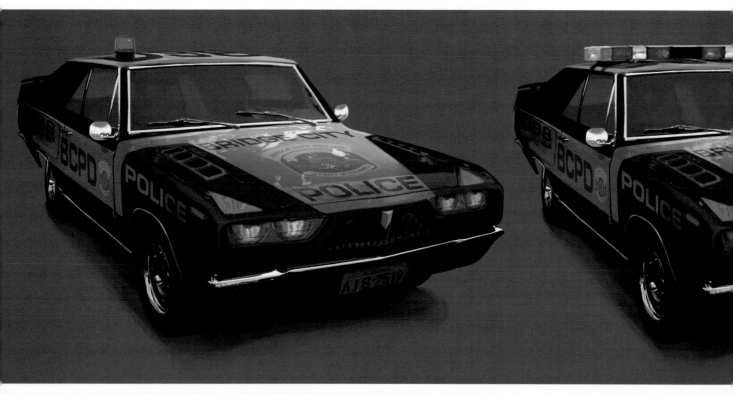

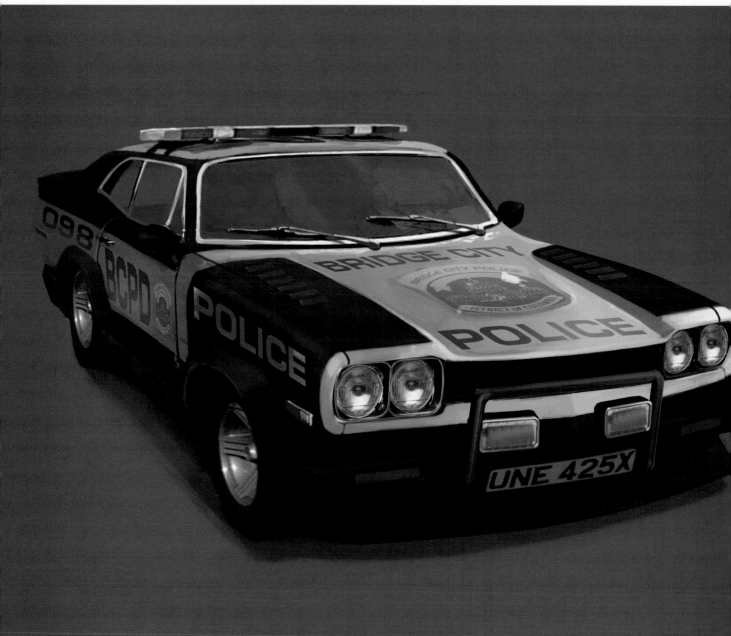

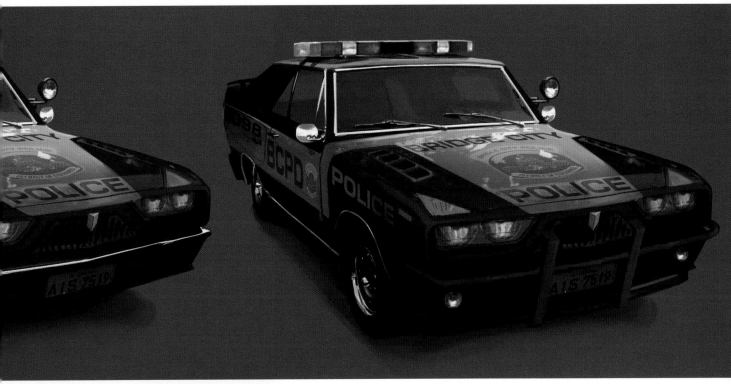

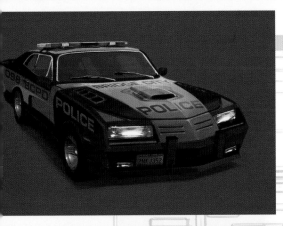

(Above and Left) **Various stages of development that the Police Interceptor went through before the final concept was approved. The concept for the car is a mixture of 80's muscle car and modern day police car.**
Art: Corlen Kruger | **Art Director**: Cumron Ashtiani

(Bottom Left) **Rear view of the final concept for the Police Interceptor.**
Art: Corlen Kruger | **Art Director**: Cumron Ashtiani

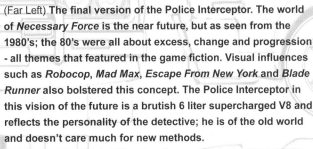

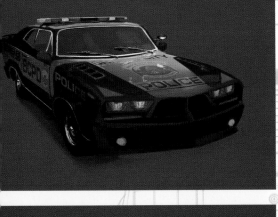

(Far Left) **The final version of the Police Interceptor. The world of** *Necessary Force* **is the near future, but as seen from the 1980's; the 80's were all about excess, change and progression - all themes that featured in the game fiction. Visual influences such as** *Robocop*, *Mad Max*, *Escape From New York* **and** *Blade Runner* **also bolstered this concept. The Police Interceptor in this vision of the future is a brutish 6 liter supercharged V8 and reflects the personality of the detective; he is of the old world and doesn't care much for new methods.**
Art: Corlen Kruger | **Art Director**: Cumron Ashtiani

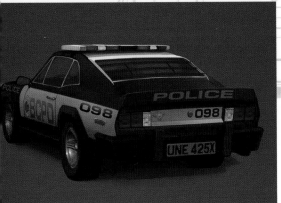

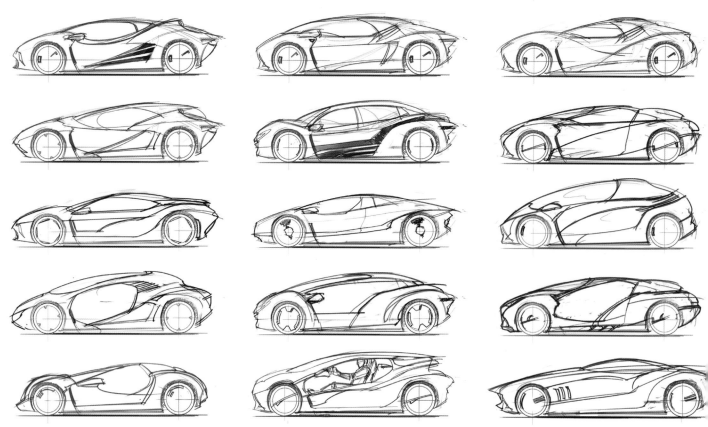

(Above) *Neo Racer* car design thumbnail sketches.
Art: Pete Thompson | **Art Director**: Cumron Ashtiani

(Below) *Neo Racer* racing buggy design.
Art: Pete Thompson | **Art Director**: Cumron Ashtiani

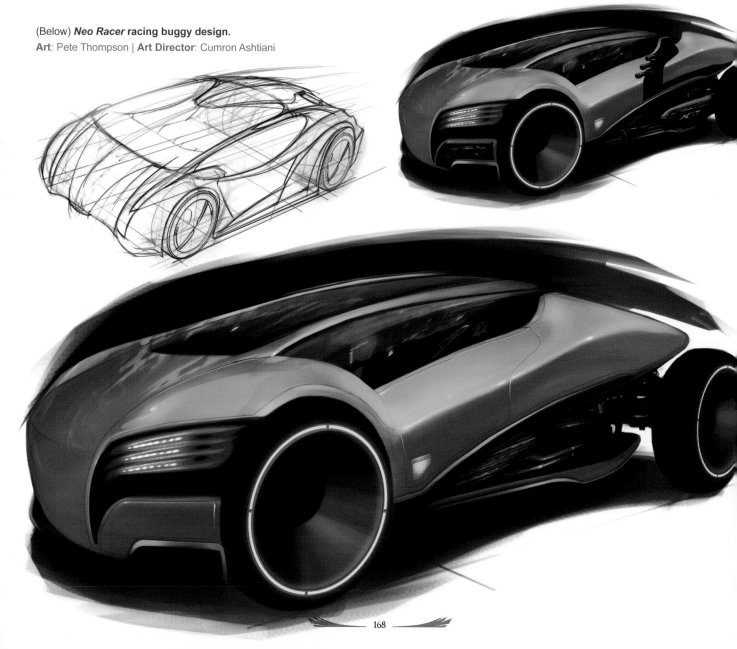

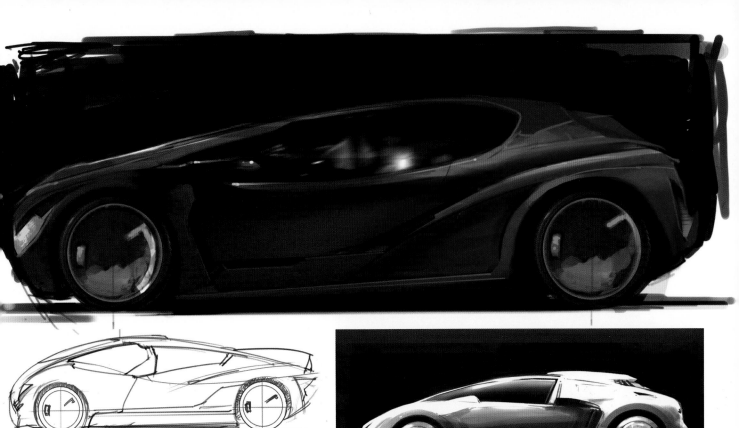

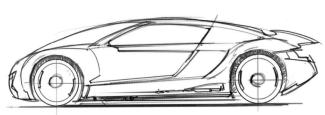

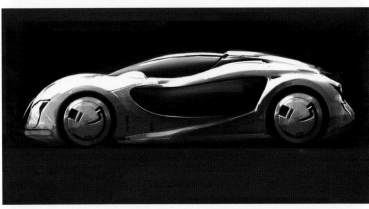

(Above and Top) *Neo Racer* car design sketch with custom color.
Art: Pete Thompson | Art Director: Cumron Ashtiani

(Below and Right) *Neo Racer* car designs.
Art: Pete Thompson | Art Director: Cumron Ashtiani

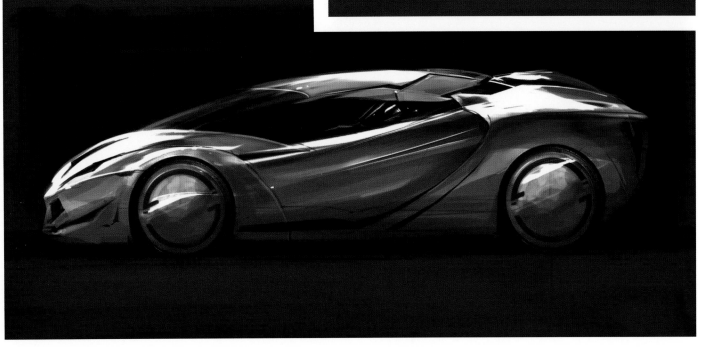

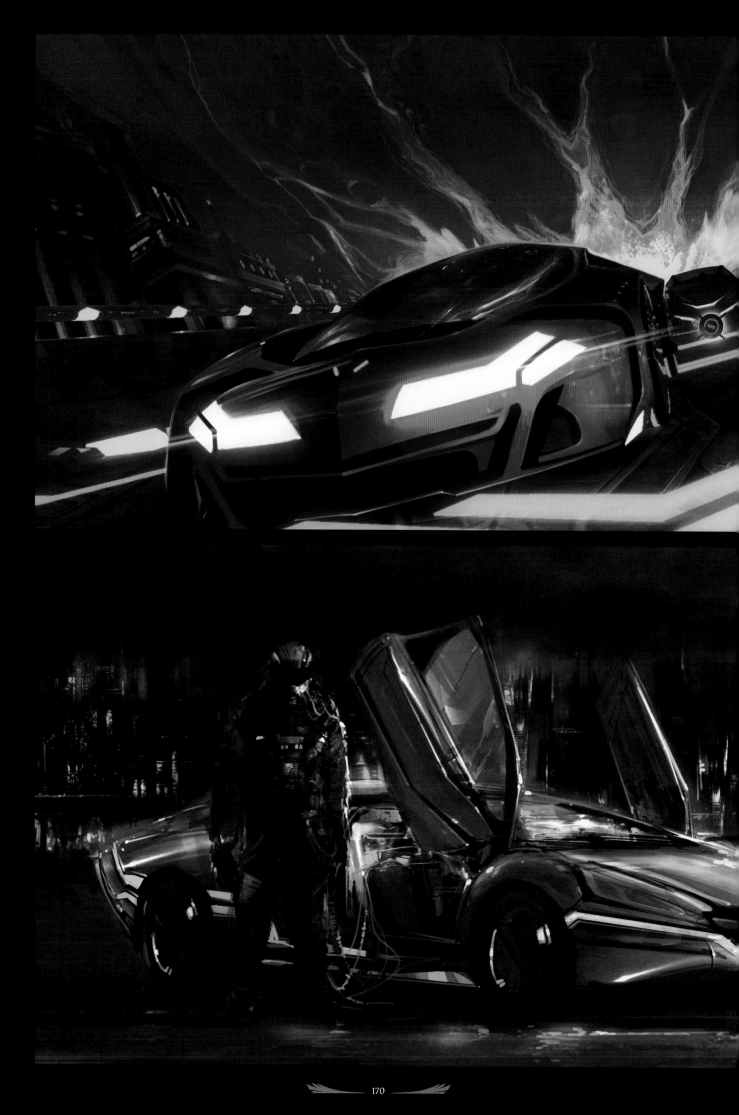

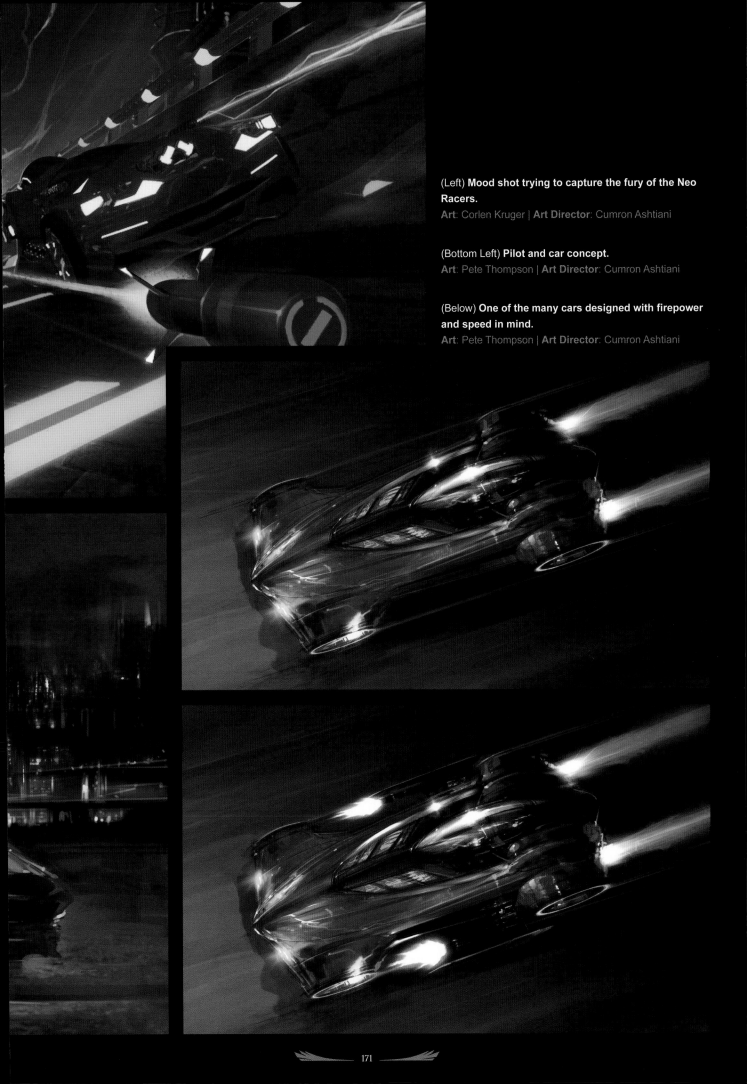

(Left) **Mood shot trying to capture the fury of the Neo Racers.**
Art: Corlen Kruger | Art Director: Cumron Ashtiani

(Bottom Left) **Pilot and car concept.**
Art: Pete Thompson | Art Director: Cumron Ashtiani

(Below) **One of the many cars designed with firepower and speed in mind.**
Art: Pete Thompson | Art Director: Cumron Ashtiani

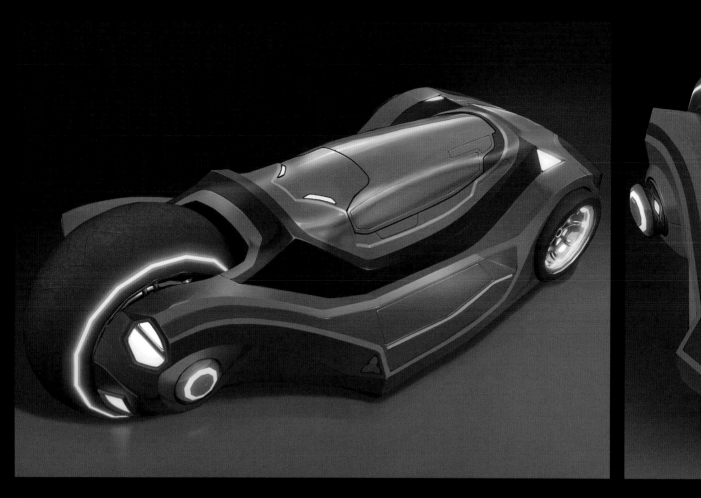

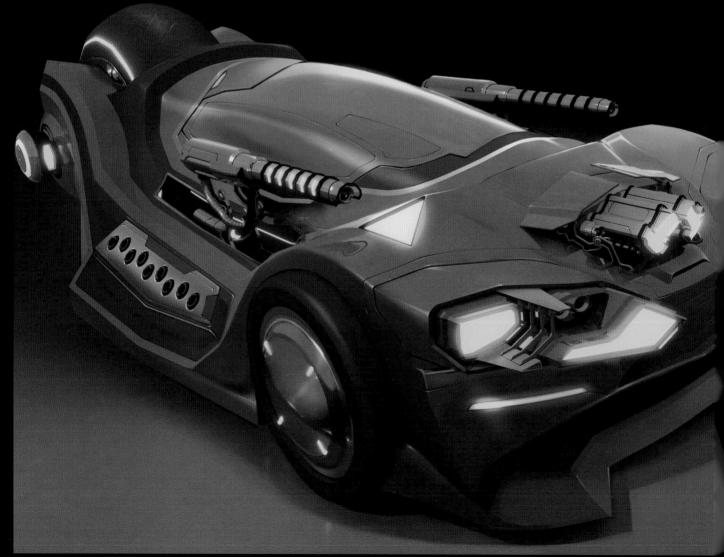

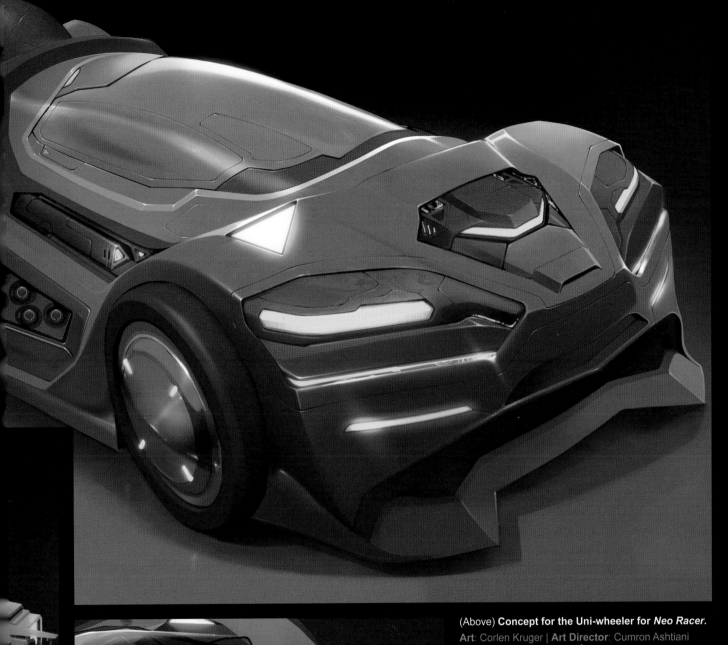

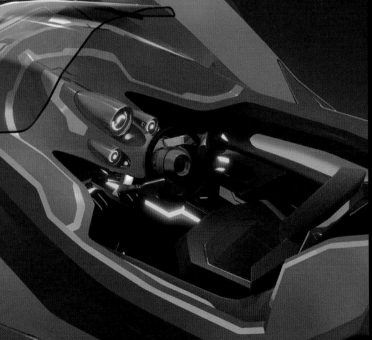

(Above) **Concept for the Uni-wheeler for *Neo Racer*.**
Art: Corlen Kruger | Art Director: Cumron Ashtiani

(Left) **Interior view concept for the Uni-wheeler car.**
Art: Corlen Kruger | Art Director: Cumron Ashtiani

(Top Left) **Rear view concept for the Uni-wheeler car.**
Art: Corlen Kruger | Art Director: Cumron Ashtiani

(Far Left) **All the vehicles for *Neo Racer* feature hidden weapons much like the cars in *Wacky Racers*, but far more deadly. They also feature *Tron*-like neon lighting so that they emit light trails at speed.**
Art: Corlen Kruger | Art Director: Cumron Ashtiani

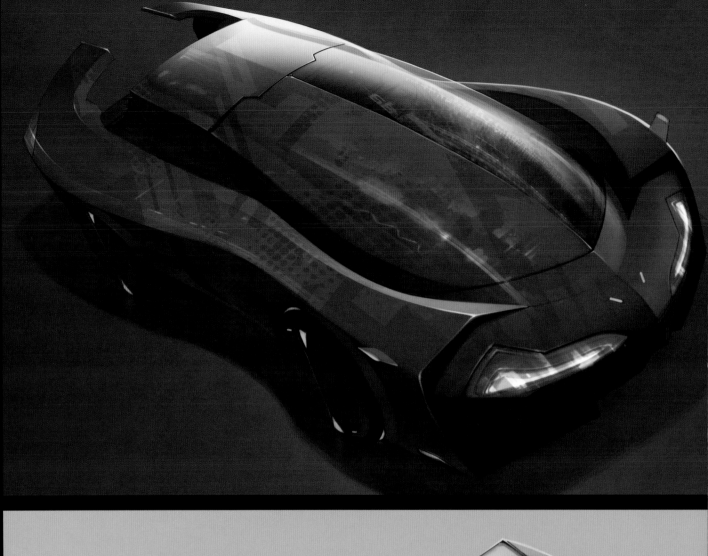
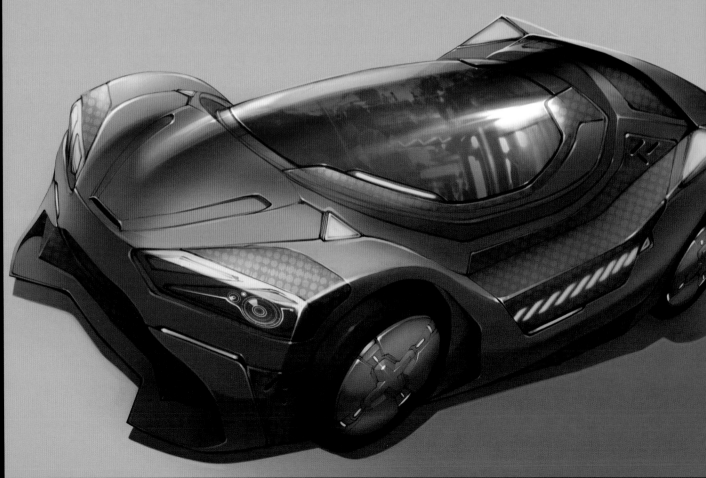

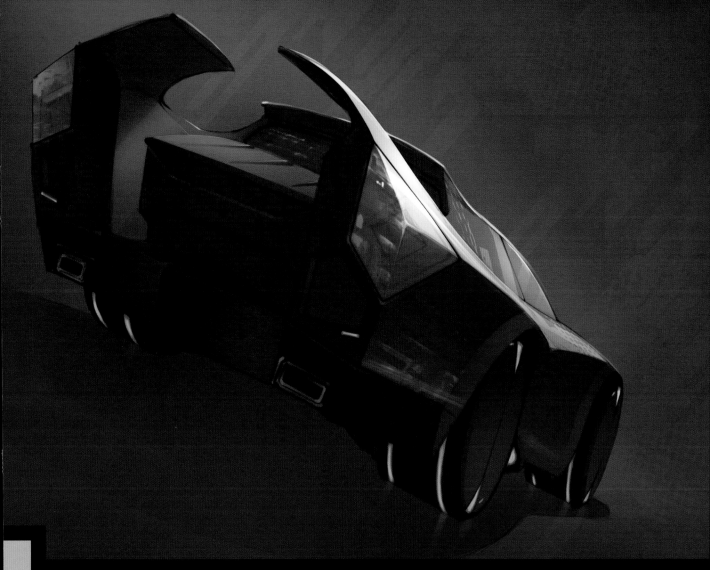

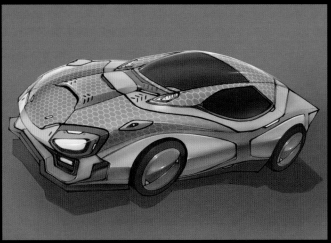 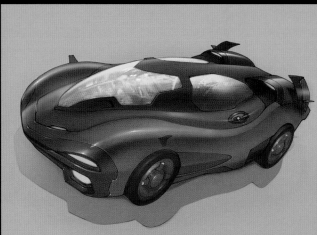

(Above and Right) **Early preliminary concepts for the** *Neo Racer* **cars.**
Art: Corlen Kruger | **Art Director**: Cumron Ashtiani

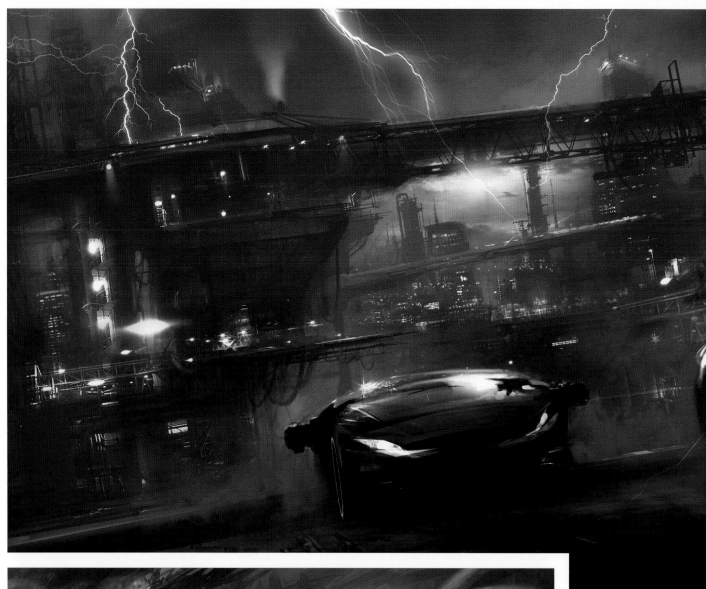

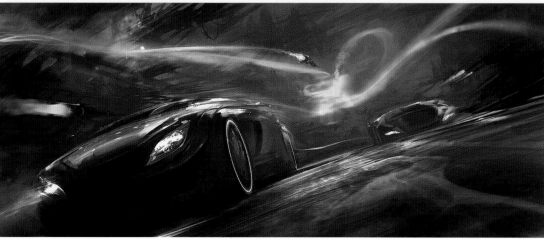

(Above & Right) **Neo Racer speed paint track designs.**
Art: Pete Thompson | **Art Director**: Cumron Ashtiani

(Top) **The final pass of the pitch concept for *Neo Racer*. The main idea for this one was to deliberately drive through dangerous areas such as an electrical power plant in order to feed of the energy of the towering electrically-charged structures.**
Art: Pete Thompson | **Art Director**: Cumron Ashtiani

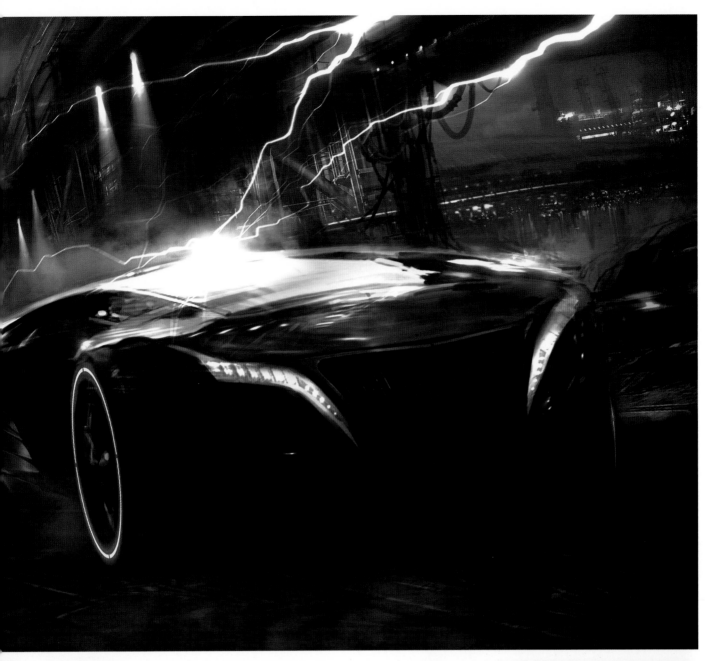

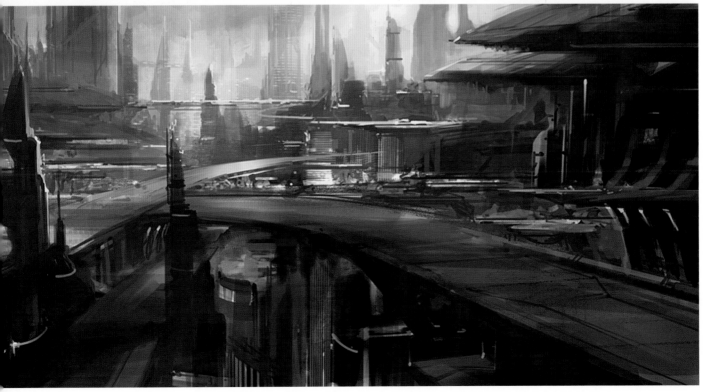

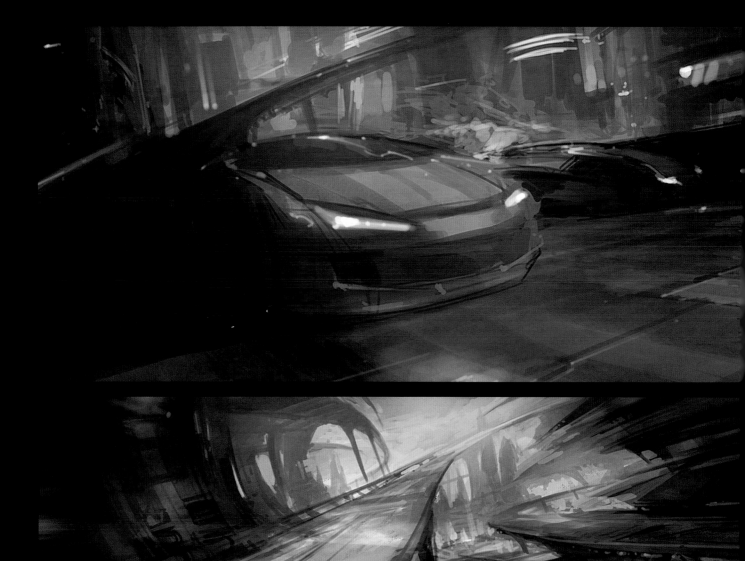

(Above) *Neo Racer* speed paint track designs.
Art: Pete Thompson | Art Director: Cumron Ashtiani

(Right) **A different take on the industrial setting in *Neo Racer*. We looked at a number of reference shots from chemical plants and foundries.**
Art: Pete Thompson | Art Director: Cumron Ashtiani

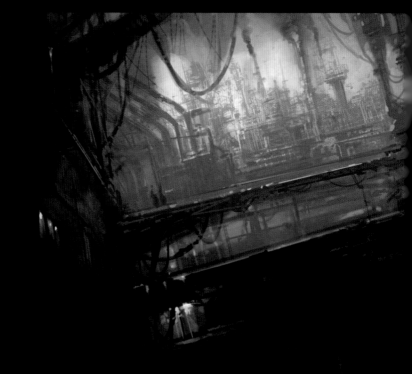

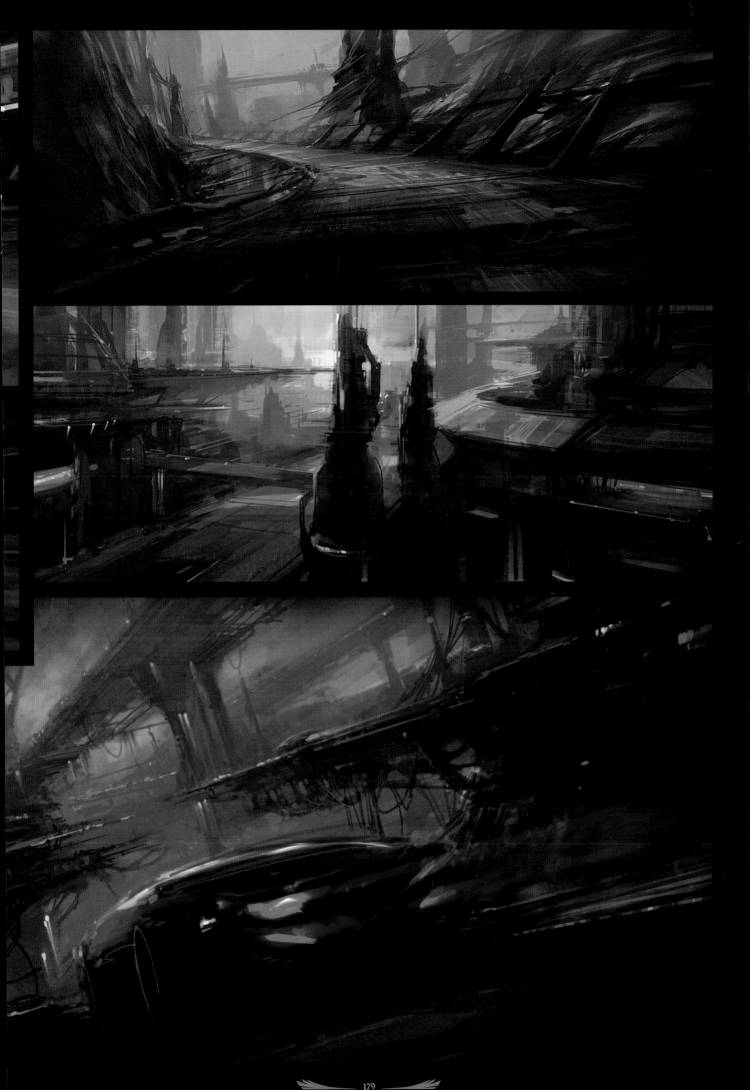

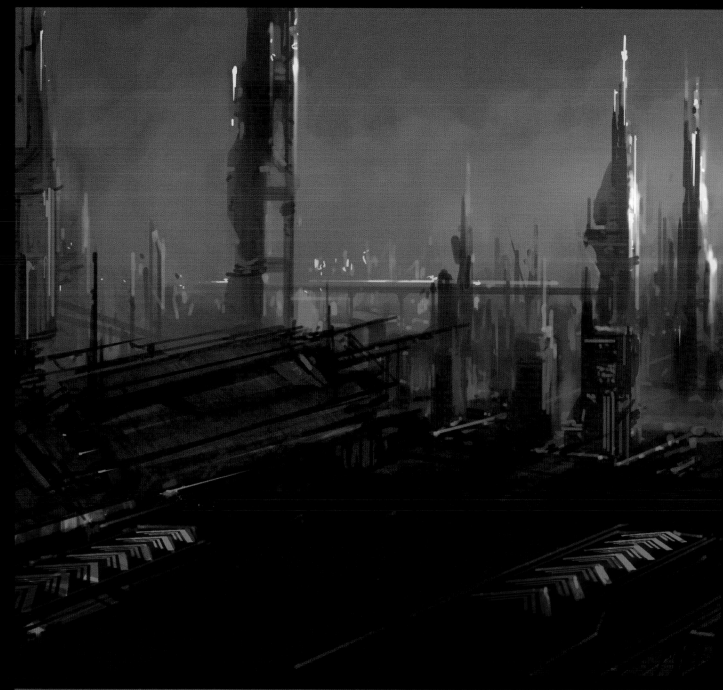

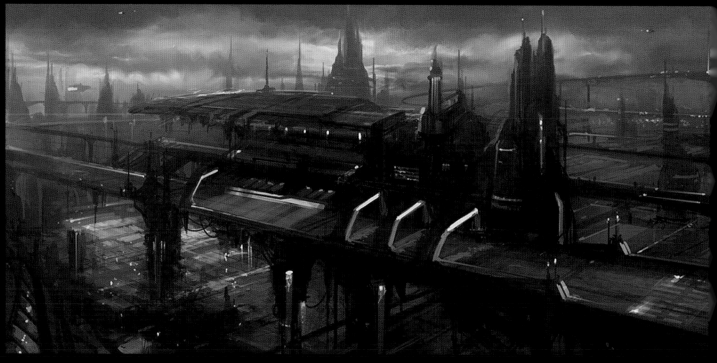

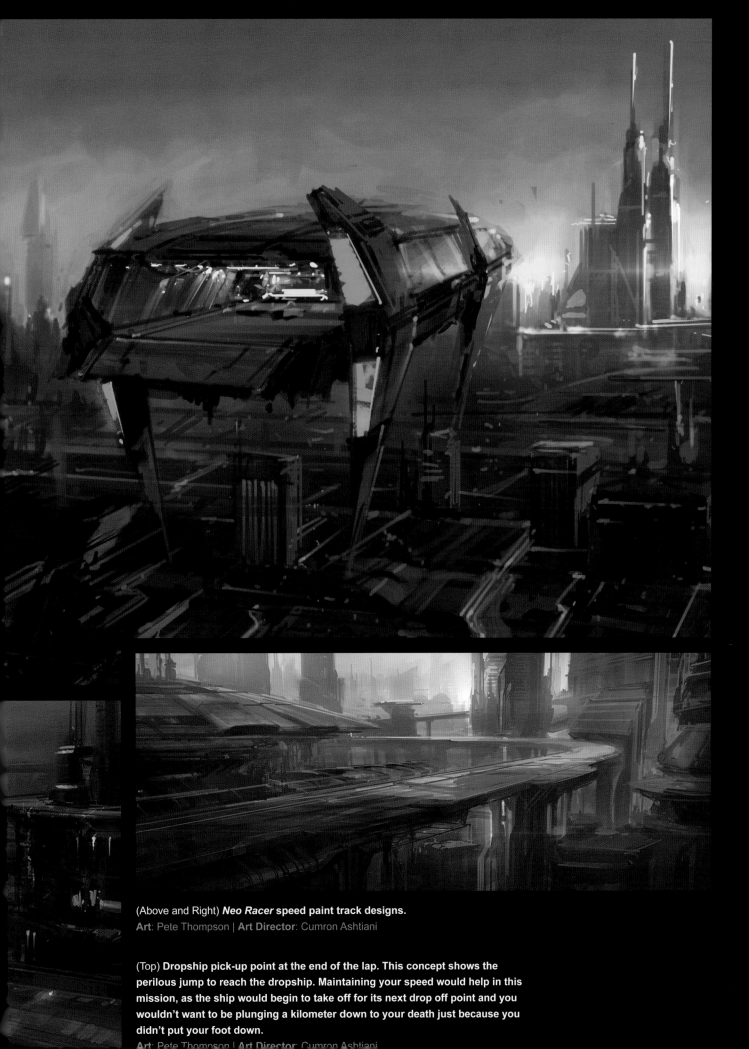

(Above and Right) *Neo Racer* speed paint track designs.
Art: Pete Thompson | **Art Director**: Cumron Ashtiani

(Top) **Dropship pick-up point at the end of the lap. This concept shows the
perilous jump to reach the dropship. Maintaining your speed would help in this
mission, as the ship would begin to take off for its next drop off point and you
wouldn't want to be plunging a kilometer down to your death just because you
didn't put your foot down.**
Art: Pete Thompson | **Art Director**: Cumron Ashtiani

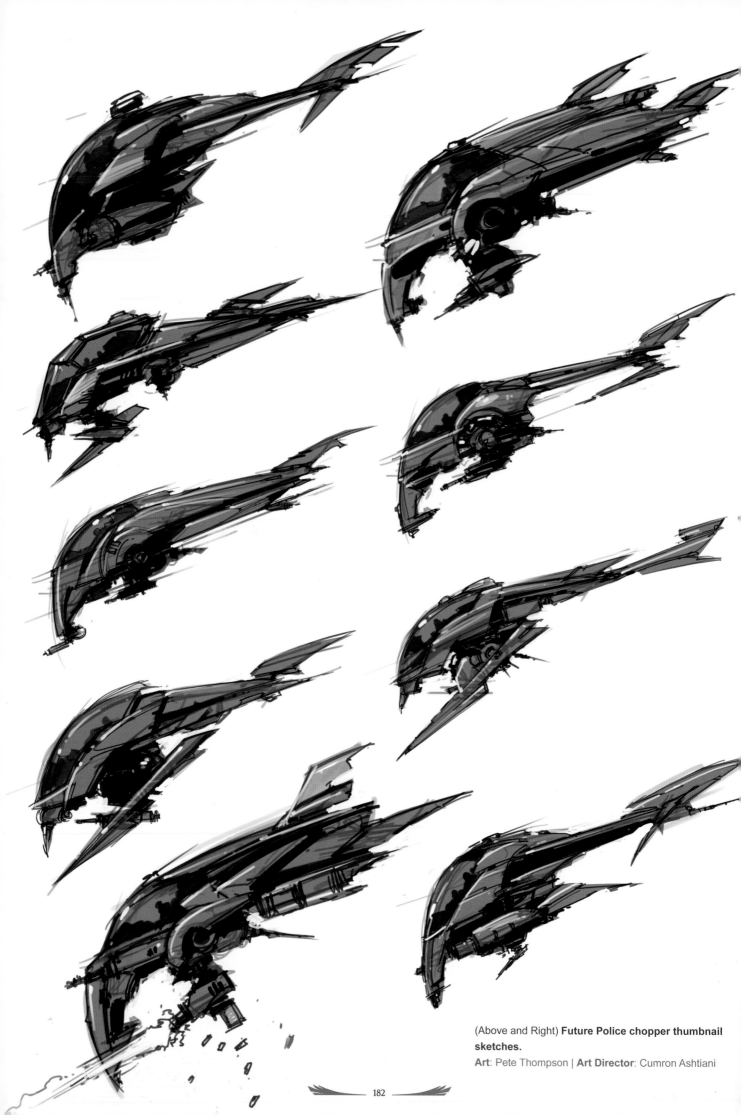

(Above and Right) **Future Police chopper thumbnail sketches.**
Art: Pete Thompson | Art Director: Cumron Ashtiani

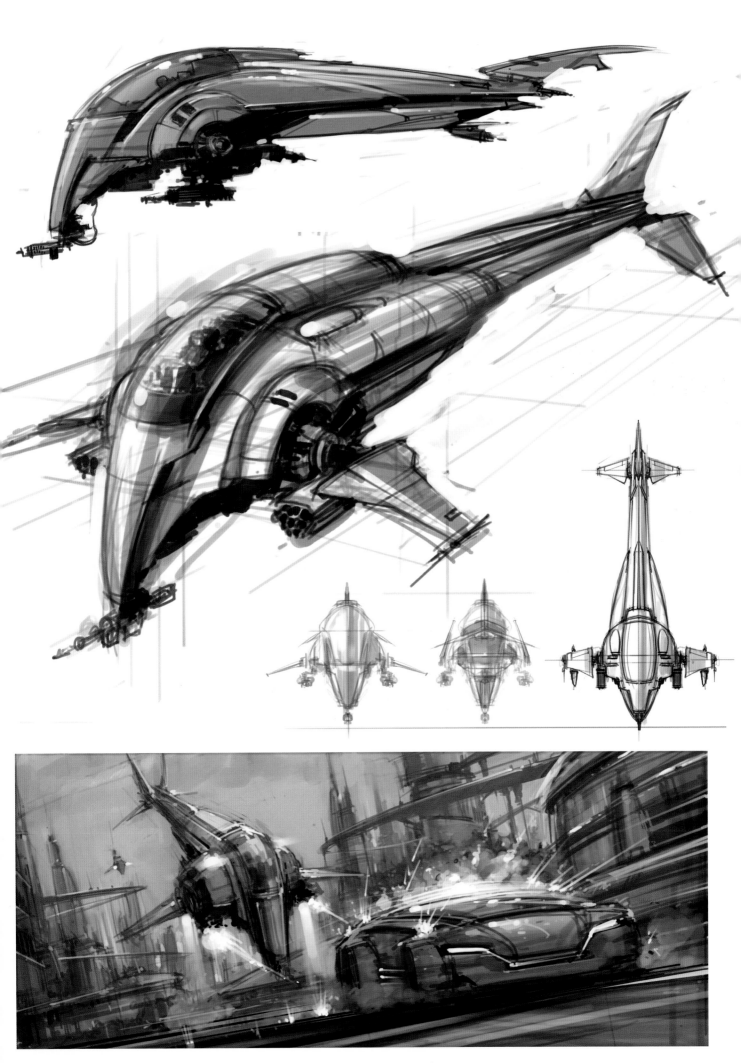

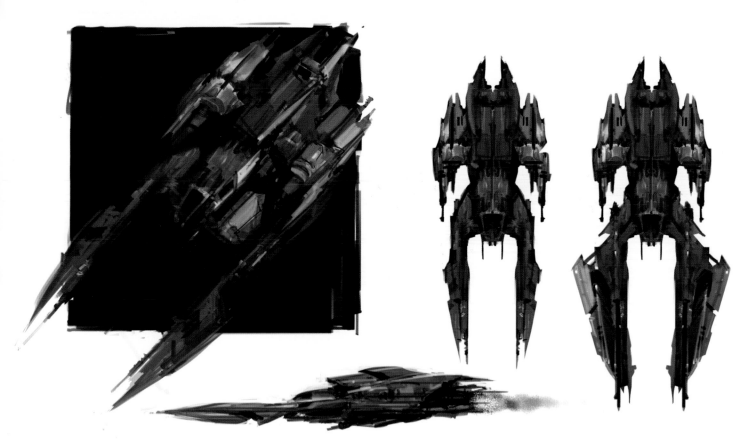

(Above) **Dropship thumbnails.**

Art: Pete Thompson | **Art Director**: Cumron Ashtiani

(Below) **Dropship thumbnails painted with a chisel-style Photoshop brush.**

Art: Pete Thompson | **Art Director**: Cumron Ashtiani

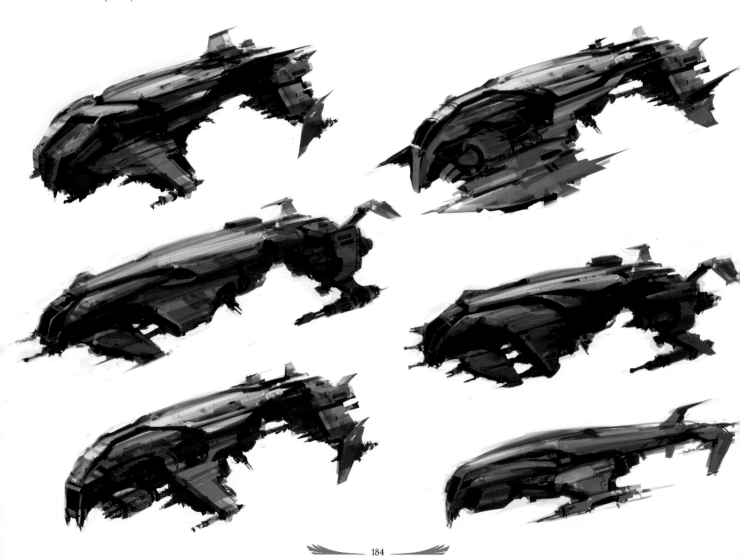

(Right) **Gun turrets used on the edges of the tracks in *Neo Racer* to take out stray competitors.**
Art: Pete Thompson | **Art Director**: Cumron Ashtiani

(Bottom) **Concepting military hardware is one of my favorite jobs. Not only do you need to come up with a good design but it's also consider the functionality of the machine.**
Art: Corlen kruger | **Art Director**: Cumron Ashtiani

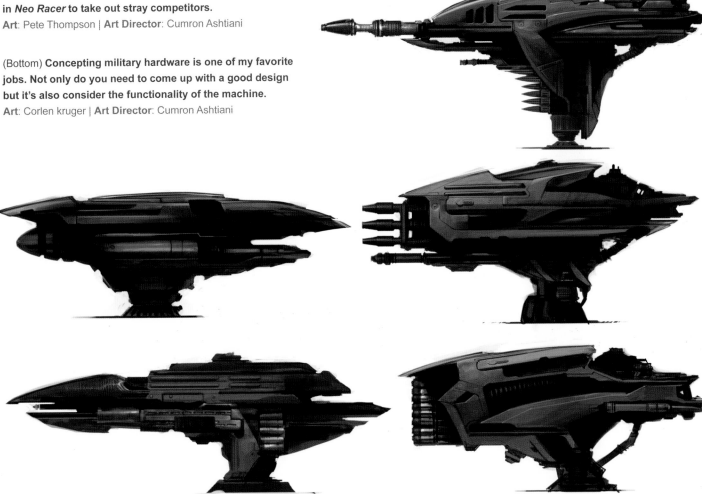

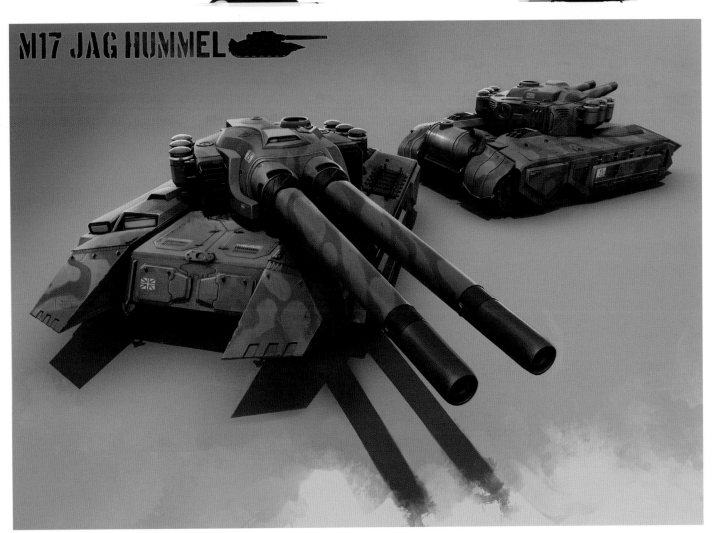

ATOMHAWK DESIGN
ARTIST PROFILES

CUMRON ASHTIANI

Prior to Atomhawk, Cumron worked for a number of high profile game development companies during his 13 year career. During the last 10 years, he has focused on artistic/creative direction and management across all platforms, playing a key role in the running of several studios and in the development of 11 shipped titles.

Cumron has provided art and creative direction from initial pre-production concept and development right through to the product end phase, including product marketing and advertising assets.

As well as being the company director at Atomhawk, he is responsible for the creative direction of internal projects and quality control of the work produced for clients. Cumron also has a wealth of experience in all aspects of game and interactive product development and is an accomplished 2D and 3D artist.

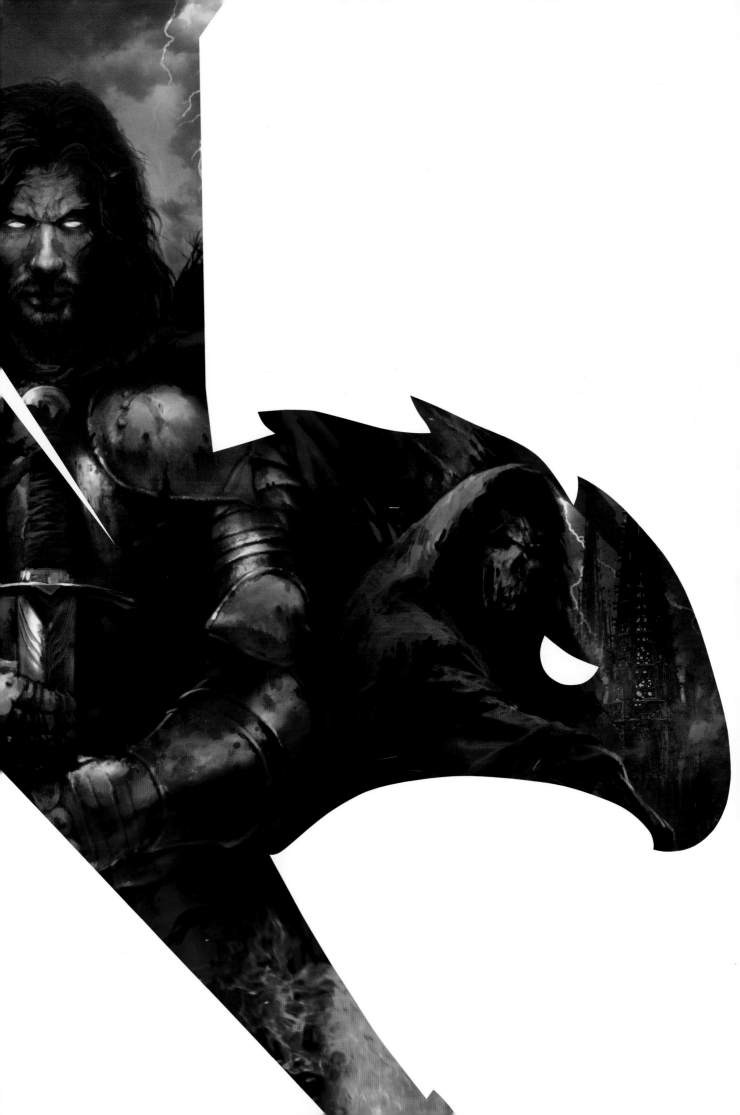

CORLEN KRUGER

Corlen has eight years industry experience, working on multiple platforms and media. He has amassed a variety of styles and skills to bring every project to life. Starting as a concept artist at I-Imagine Interactive, he was quickly promoted to the position of lead artist on the PSP title *Final Armada*. Moving over to Europe, he worked on *War Devil* before joining Midway to work on their flagship title, *Wheelman*.

Corlen not only delivers concept art in 2D format, but is also well trained in 3D packages like 3ds Max and ZBrush. Using these in combination with 2D art, he delivers concepts that are understood across the entire development discipline, which is the key to making pre-visual art that is actually achievable during production.

Apart from producing concept art, Corlen has won numerous accolades including the New Age Gaming cover art competition in 2002 and a regional illustration competition, "The Battle", held by GameHorizon in Newcastle. He has also been invited to submit work for the elite EXPOSÉ 3 art book and recently had work published by Brand Studio Press.

STEVE PICK

Steve has worked in the industry for almost 11 years, first with Jester Interactive on *Super Trucks* before being a major influence on the interface and icon design of *Music 3000*, as well as the creation of many of the 2D and 3D movie segments.

Following that, Steve was the lead environment artist on *TT Superbikes*, researching, overseeing and creating all building/structural assets. He also produced early interface concepts for the title and it was at this point that Steve started to specialize in GUI and graphic design.

In May 2004, Steve moved to Checkmate Solutions and, as a lead artist, lent his graphic design expertise to the user interface design for several *eJay* titles. When Steve joined Midway Studio - Newcastle at the start of 2006, he helped to refine and re-brand the user interface on the PSP version of *LA Rush* before designing, implementing and animating all UI and branding graphics on *Wheelman*.

Steve has a BA (Hons) degree in Design and Animation.

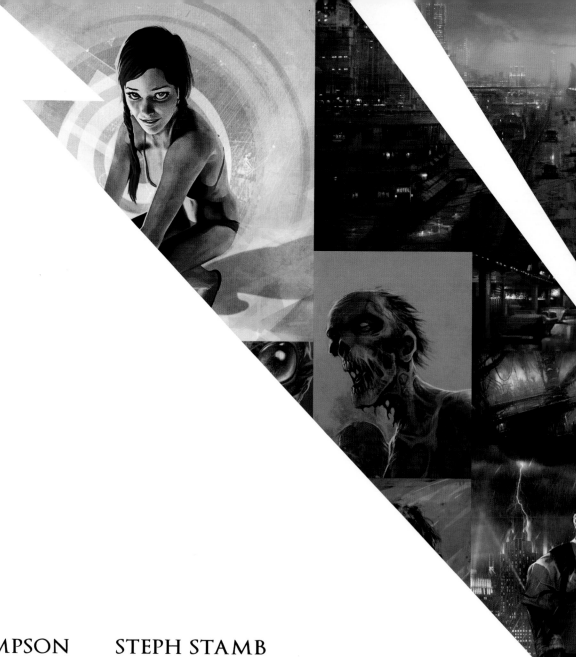

PETE THOMPSON

Pete joined the games industry in 2000, having already had a successful career as a freelance illustrator in the publishing, music and comic book sectors.

Pete has all the skills needed to fully visualize any AAA production and is fast becoming one of the UK's leading conceptual artists. During his time at Midway, he produced concept art, storyboards, marketing artwork and matte paintings for *TD Overdrive*, *LA Rush* and *Wheelman*.

Throughout the production of *Wheelman*, Pete delivered a whole host of concept pieces that fully illustrated the look and feel of the game and also took on the role of marketing illustrator, producing posters, promo art and box art for the game. Pete has often worked closely with Hollywood during his career and most recently worked with Vin Diesel's company, Tigon.

STEPH STAMB

Steph has nearly 10 years experience in the comic book world. During that time, he worked as an inker, penciller, colorist and cover artist on comics such as *Angel: Masks* and *Angel: Spotlight* (based on the popular *Buffy the Vampire Slayer* TV show spin-off) for IDW Publishing, *Gene Simmons House Of Horrors* for Simmons Comics/IDW and *Left On A Mission* and *Salvador* for Boom! Studios.

More recently, he created all the artwork for the four part Konami/IDW Publishing title *Silent Hill: Sinner's Reward*.

Steph joins Atomhawk as a senior concept artist and moved all the way from Sweden to the sunny North East of England (he must be crazy!).

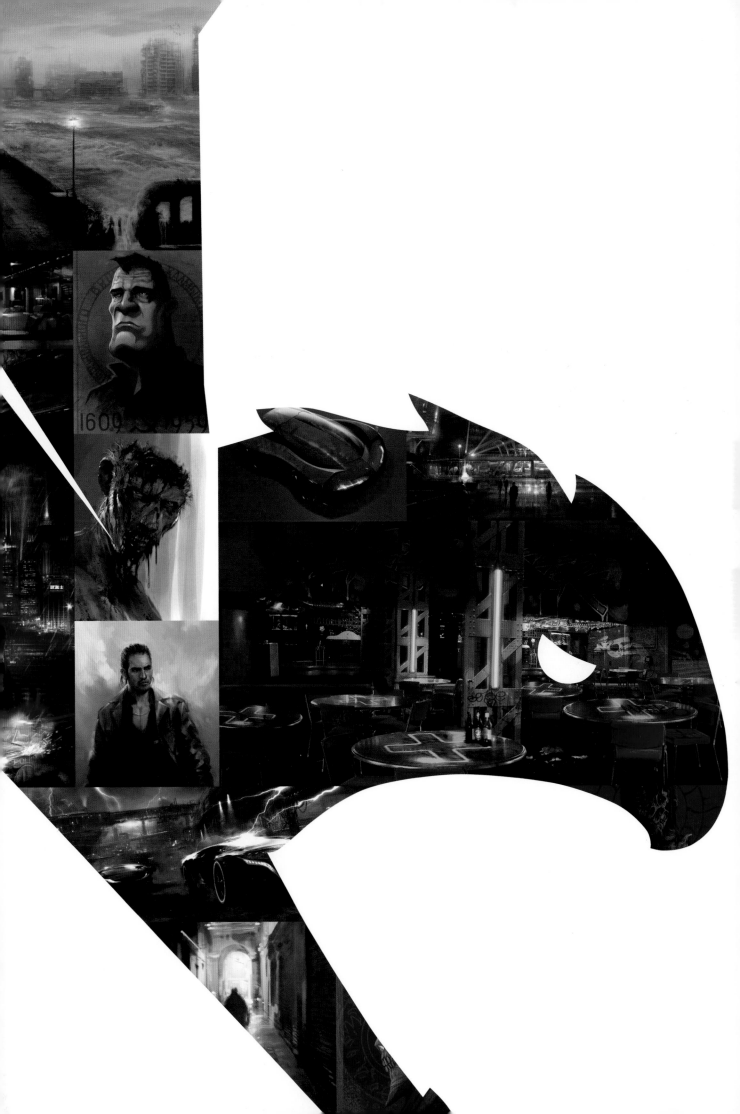

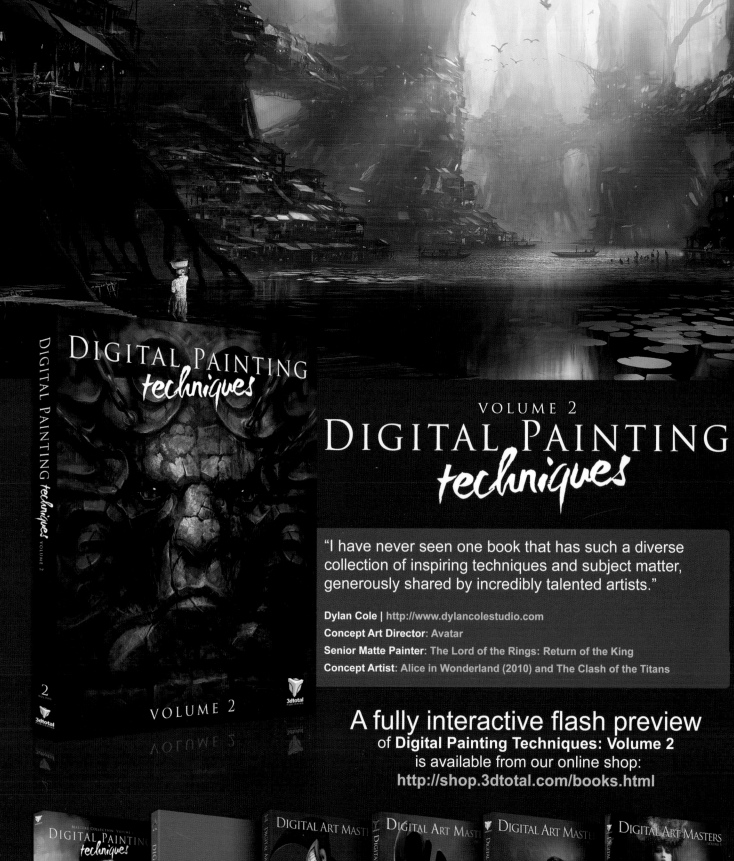